• LOCOMOTIVES OF THE •
GREAT NORTHERN RAILWAY

George Frederick Bird

Edited by John Christopher

AMBERLEY

The main text of this book was originally published by
the Locomotive Publishing Company in 1910.
This new edition edited by John Christopher, 2013.

First published 2013

Amberley Publishing
The Hill, Stroud
Gloucestershire, GL5 4EP

www.amberley-books.com

Copyright © G. F. Bird and John Christopher 2013

The right of G. F. Bird to be identified as the Author
of this work has been asserted in accordance with the
Copyrights, Designs and Patents Act 1988.

All rights reserved. No part of this book may be reprinted
or reproduced or utilised in any form or by any electronic,
mechanical or other means, now known or hereafter invented,
including photocopying and recording, or in any information
storage or retrieval system, without the permission in writing
from the Publishers.

British Library Cataloguing in Publication Data.
A catalogue record for this book is available from the British Library.

ISBN 978 1 4456 3415 9
E-book 978 1 4456 3422 7

Typeset in 10pt on 12pt Sabon.
Typesetting and Origination by Amberley Publishing.
Printed in the UK.

Contents

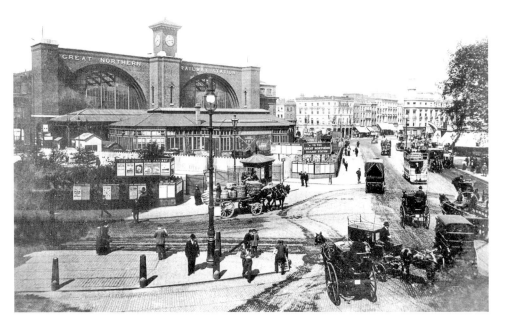

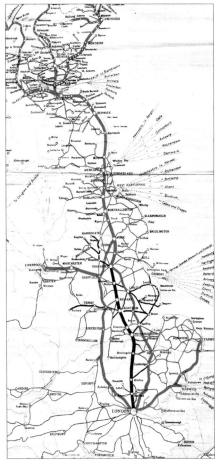

A view from the 1890s showing King's Cross station and forecourt onto Euston Road. Various structures were erected in front of the station, the most recent being British Rail's canopy. This area has now been cleared to create a new public square as part of the recent refurbishment. *(JC)* *Left:* The LNER's network spread across eastern England and up into Scotland. At its core was the GNR's line from London to Yorkshire and it remains a key part of the East Coast Main Line. *Below:* 'The end of the London Season – the exodus to the North.' An illustration from *The Graphic*, published in 1900.

Preface to this edition

They say that every major London station had its own instantly recognizable odour. For the Great Northern Railway's terminus and goods yard at King's Cross it was the distinctive smell of coal from the Nottingham, Lincolnshire and Yorkshire coalfields. The GNR had been the first railway to ship coal direct to London to feed the capital's insatiable appetite for the black stuff, and as a result the price of coal fell by almost half and the railway company prospered.

 The GNR hadn't had an easy start in life even though it was born of the great railway mania of the 1840s. By the time that the first prospectus for a railway linking London and Yorkshire was issued in 1844, it was already possible to make the journey by rail, albeit rather slowly via a circuitous route operated by a myriad of companies; the York & North Midland Railway, the North Midland Railway, the Birmingham & Derby Railway and the London & Birmingham Railway. The big idea behind the London & York Railway, as the GNR was called originally, was for a direct line passing through Peterborough, Grantham and Doncaster with a loop from Peterborough to take in Boston, Lincoln and Doncaster, and, via branches, Sheffield and Wakefield. The rival companies, in particular the L&BR, did everything they could to obstruct the passage of the London & York Railway Bill, and it wasn't until June 1846 that it finally received Royal Assent.

 The engineer Joseph Locke, a lesser-known contemporary of Brunel and Stephenson, conducted the initial survey, but it was under William Cubitt's guidance that construction work began on a stretch of the loop between Peterborough and Lincoln as this held the promise of bringing in much needed revenue for the fledgling company. At first the connecting railway companies, upon whom the GNR relied on running powers over their line, did their utmost to hinder progress, but gradually new relationships were built with the lines to the north of York. The GNR's main line from London to Peterborough was constructed by Thomas Brassey and at the London end temporary terminus opened in 1850 at Maiden Lane – on the edge of what became the King's Cross goods yard – while the tunnels taking the railway under the Regent's Canal were completed. The permanent terminus at King's Cross opened in October 1852. It was, and still is, a magnificent building despite being overshadowed by the later arrival of

its gaudy neighbour, the Midland Railway's terminus and hotel at St Pancras. Criticised in some quarters for its plainness at the time of completion, the twin spans of King's Cross were a full 100 feet longer than the glass roof at Paddington, making it the largest station in the world for a while. It is a no-nonsense engineering structure, reflecting the nature of the railway, much criticized by the Victorians and much admired today. In the last few years the station has enjoyed a remarkable makeover complete with a new concourse area linking the station with the curved facade of the Great Northern Hotel, and the redundant King's Cross goods yard has been redeveloped for other uses including an art college.

With time the GNR formed new alliances with the other railway companies. By the 1860s the railway was not only covering most of Yorkshire but also reaching new territory via an agreement with the MS&LR to run trains into Manchester, and also from Doncaster to Leeds, with further expansion taking it into Nottinghamshire, Derbyshire and, in the 1870s, Staffordshire and Cheshire. The line from London to York remained the backbone of the GNR and the East Coast Anglo-Scottish route to Scotland was completed when their lines linked with the North Eastern Railway near Doncaster and also with the North British Railway at Berwick-on-Tweed. Express trains departing from King's Cross at 10.00 a.m. for Edinburgh soon became known as the 'Flying Scotsman'.

In 1923 the GNR ceased to exist. It was subsumed within the London & North Eastern Railway (LNER) as part of the grouping of Britain's numerous independent railways. The LNER had an extended network with 6,590 miles of track covering the eastern side of England and reaching up into Scotland, but as the map on page 4 shows it had at its core the GNR's line from London to York.

'King's Cross by night' – an atmospheric scene depicted on a postcard, *c.* 1900.

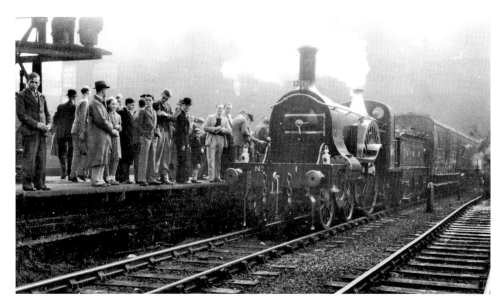

A crowd gathers around GNR No.1 which made a return to King's Cross during the 1952 centenary celebrations. A total of fifty-three of these Stirling 8-footers were built at the company's Doncaster works between 1870 and 1895. No.1 is now in the National Railway Museum's collection. *(JC)* See page 160 for list of preserved GNR locos

GNR locomotives

The company's first Locomotive Superintendant was Benjamin Cubitt, another of the Cubitt clan, but his tenure was very short as he died in 1848 after only two years in the job. His first order had been for fifty 2-2-2 engines from Sharp Brothers of Manchester, and these were known as the 'Small Sharps', most of which were later rebuilt. Cubitt's successor, Edward Bury, was also in the post for only two years. Bury ordered thirty 0-6-0s, fifteen each from Hawthorn and E. B. Wilson, but was forced to resign after it was discovered that he had placed orders for parts with his own firm at a higher price than that offered elsewhere. With Bury's departure the GNR enjoyed a succession of very capable Locomotive Superintendents who each stamped their mark on a stable of locomotives that earned the company a reputation for speed and efficiency.

Archibald Sturrock, a Scotsman born in Dundee, had been Daniel Gooch's assistant at the Great Western Railway and had become Works Manager at Swindon before he moved to the GNR in 1850 to take up the role of Locomotive Superintendent, a post he held until 1866. During that time he designed more than a dozen classes of passenger and goods locomotives for the rapidly expanding railway. His successor was Patrick Stirling, another Scot, who came from an engineering family, with father, brother and a son who were all railway engineers. Stirling was Locomotive Engineer to the Glasgow & South Western Railway before he joined the GNR in 1886. Renowned for his 8-foot singles, 4-2-2s, he also produce a long list of other designs during his tenure of almost thirty years, most notably the 2-2-2s and also the 0-4-4 tanks for suburban services.

He died in office in 1895.

His successor was Henry A. Ivatt. Born in Cambridgeshire, he had learned his trade as an apprentice at the Crewe works of the London & North Western Railway before moving to Ireland to work as Locomotive Superintendant on the Great Southern & Western Railway at Inchicore. Ivatt's tenure at the GNR lasted until 1911. It was a time of important strides in locomotive design and Ivatt introduced the first 4-4-2 'Atlantic' type into Britain. Another innovation was the use of Walschaerts valve gear – invented by the Belgian mechanical engineer Egide Walschaerts – to regulate the flow of steam to the pistons. Ivatt retired just one year after G. F. Bird's updated account of the locomotives of the GNR was published. His successor was Nigel Gresley and the latter years of the GNR are covered in the postscript to this edition.

John Christopher

About this book

George Frederick Bird's *The Locomotives of the Great Northern Railway, 1847–1910*, is a revised 1910 edition of the book originally published in 1903 by the Locomotive Publishing Company. As is evident it covers, more or less, the period going up to the end of Henry Ivatt's time as Locomotive Superintendent. Bird goes into great depth in his descriptions of the locomotives which are accompanied by his own line drawings of each type, and the result is a unique catalogue of the company's locomotives during that period.

The text is reproduced here in its entirety apart from some judicious editing to improve the flow. This has mainly involved deleting the prosaic and excessive use of Mr for individuals and Messers before company names, for example, plus the occasional smoothing out of dated phraseology. The technical information, line drawings and tables, have all been retained with units of measurement standardized wherever appropriate. These are given in their original Imperial units. For reasons of quality only a few of the original photographic plates have been included, and instead this new edition has been augmented by a number of the best photographs and images of the GNR's locos from other sources. See acknowledgments on page 160.

Locomotives of the Great Northern Railway 1847–1910 is the first in a new series of books from Amberley Publishing on the locomotives of Britain's pre-grouping railways. More will follow on the post-grouping and post-nationalisation eras.

Preface to the original 1910 edition

In presenting a history of the various types of locomotives which have been constructed for the Great Northern Railway, the compiler is aware of many deficiencies in the work. So far from this being a history of the line, the following pages cannot claim to comprise anything more than a somewhat brief catalogue of locomotives, many of which have earned fame in the annals of railway development. To have dealt with them as fully as might be is not in the power of the compiler, and equally beyond the limits of space allowable in a publication of this character. The utmost that can be urged is that, principally owing to the disinterested assistance of many kind friends, the writer has been enabled to produce what is, so far as he is aware, the first approximately complete list of the locomotives built for the Great Northern Railway from its opening as a small branch line in Lincolnshire until the present date.

It is largely due to the same kindly help that the letterpress is so fully illustrated by outline drawings of engines, the particulars from which the drawings have been built up being obtained from a variety of sources, ranging from old note books to quite recent photographs. As regards the earlier engines, the main groundwork of fact was derived indirectly from that *doyen* of locomotive superintendents, the late Archibald Sturrock, but much valuable assistance has also been given by friends who have freely placed their storehouses of information at the writer's disposal. Notable among these must be mentioned E. L. Ahrons, to whom the writer is indebted for a number of items of information, especially as regards the engines of twenty and thirty years ago, and whose first-hand knowledge of many of the engines extends back to 1876.

The writer is indebted to the late Patrick Stirling for some details as to the period covered by his efficient control of the GNR locomotive department, but as regards details of dimensions and not a few photographs of that and the present time, thanks are especially due to H. A. Ivatt, the present chief of the Locomotive Department, who has most courteously acceded to every most tiresome appeal for information.

It does not fall within the scope of the historical sketch to which this is a preface to dwell at length on the influence exercised on the Great Northern Railway by its three superintendents of the locomotive department. The somewhat heterogeneous collection of locomotive stock introduced by Sturrock was in accordance with then

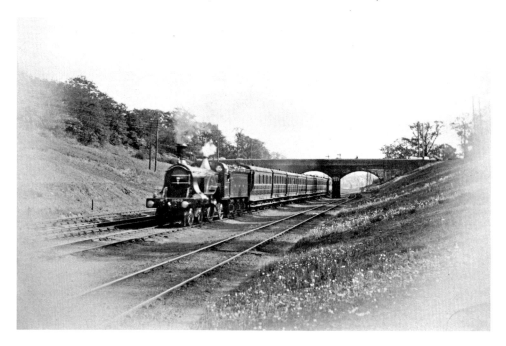

Mainline express No. 1003, Works 671, built at Doncaster in 1894. *(TH)*

existing conditions, and admirably fulfilled the requirements of the time. Stirling took over the command at a period when a change of policy was eminently desirable, and his complete scheme of standardisation, which was, moreover, capable of constant adjustment to more strenuous conditions of service, had a marked effect on the efficiency of the locomotive department. Towards the close of his career, however, the remarkable and sudden increase in speed and weight of express trains became so exacting as to require a thorough departure from conservative traditions, and when Ivatt took charge in 1896 he was at once confronted with a serious problem in the task of bringing the locomotive department into closer touch with traffic requirements. How he has grappled with the difficulty, by introducing from time to time new locomotives of quite modern capacity, which have shown him to be instinct with resource and originality, this history may serve to indicate. It is safe to prophesy that the future of the locomotive department of this line is assured so long as it remains under the control of one who has proved himself so eminently capable of adapting his methods to new and decidedly exacting circumstances.

It is to be recorded with regret that since the publication of the first edition of this little book Archibald Sturrock, the first locomotive superintendent of the Great Northern Railway, has passed away at the ripe age of ninety-two. Though, with his retirement from that important position, Sturrock's engineering career may be said to have ended, he took a great interest still in locomotive matters, and he was good enough to express kindly appreciation of the writer's work in compiling this history.

G. F. Bird

1

Introduction, 1847–1850

There is no intention to give a history of the rise and growth of the Great Northern Railway. That has already been done, and were it not so, the telling of so romantic a story as the elevation of what was, at its origin, a small local line in Lincolnshire into one of the great trunk lines of the United Kingdom, with the battles that were waged around it, and the legislation that had to be encountered in the process, could not well be compassed in the limited space here available. For the present purpose all that need be said of the beginning of this important through system of communication between London and the North can be of the briefest character. The first portion of what is now the Great Northern Railway was opened on 1 March 1848, and extended from Grimsby to Louth. Then followed other sections, forming piece after piece of a fairly homogeneous whole, but it was not until 14 October 1852, that the first train ran from King's Cross terminus northwards along the present East Coast route.

So far for the history of the line. From the very beginning it happened that the Great Northern had to do that which it has so notably accomplished ever since-to show uncommon qualities of speed, for from the outset of its career it entered into active competition with established alternative routes for the main prize constituted in the through traffic to Scotland. As a consequence, the locomotives placed upon the line have always represented first-class practice, the passenger engines being of the speediest types possible, while the equally important mineral traffic passing over the line has also made a demand for exceptionally powerful goods locomotives.

The first of the Company's engines to be put to work were fifty built by the firm of Sharp Brothers & Co., of Manchester, who were formerly known under the style of Sharp, Roberts & Co., subsequently becoming Sharp, Stewart & Co., Ltd., of Atlas Works, Glasgow, and now one of the three component firms comprised in the North British Locomotive Co., Ltd. These engines, which were numbered in the company's books from 1 to 50, were delivered to the GNR during the years 1847, 1848 and 1849, and, as can be gathered from the accompanying illustration, *Fig. 1*, were of the builder's well-known design of the period. They had cylinders 15 inches in diameter, with a 20-inch stroke, and a pair of single driving wheels 5 feet 6 inches in diameter, with leading and trailing wheels each 3 feet 6 inches in diameter, the wheelbase being 12 feet 8

inches, of which 5 feet 9 inches separated the leading and driving wheel centres, and 6 feet 11 inches separated the driving and trailing wheel centres. The boiler barrel was 10 feet in length, with a diameter of 3 feet 6¾ inches, and contained 147 tubes 10 feet 5 inches long and 1¾ inches in diameter. The inside firebox measured 3 feet in length by 3 feet 6½ inches in breadth, and the heating surface was distributed as follows: firebox 57.9 sq. ft; tubes 690.3 sq. ft; total, 748.2 sq. ft. The weight of these 'Little Sharps' was 18 tons 8½ cwt. At a subsequent date equalising levers connected the springs of the leading and driving wheels. These levers were not, however, introduced until sometime after 1850, in which year the device was patented by Hawthorn. A number of the 'Little Sharps' were converted into tank locomotives in the year 1852, as will be shown more particularly in due course.

Following the engines already mentioned came a class which were always known on the line as the 'Small Hawthorns', so named after their builders, R. & W. Hawthorn, of Newcastle-on-Tyne. There were twenty of these engines, numbered consecutively with the first lot, of which Nos 51–62 were delivered during the years 1848 and 1849, and Nos 63–70 during 1850. The illustration, *Fig. 2*, showing No. 51 of this class, indicates the chief features, and points the fact that except in matters of detail these engines were of the firm's standard pattern. Nos 61–70 differed from the others in having no domes, but they all had cylinders measuring 15 x 21 inches and driving wheels 6 feet in diameter, the leading and trailing wheels being 3 feet 6 inches in diameter, and at distances of 7 feet and 6 feet 9 inches respectively from the driving wheel centre, the total wheelbase thus being 13 feet 9 inches. The boiler barrel was 10 feet in length and 3 feet 10 inches in diameter, containing 173 tubes each of 1¾ inches diameter, and the internal firebox measured 3 feet 10 inches in length by 3 feet 6 inches in breadth. Heating surface formed a total of 907 sq. ft of which sixty-eight were apportioned to the firebox, and 839 to the tubes. The weight of these engines was 27 tons 1 cwt. Nos 52–57 were for a time lent to the East Kent Railway, afterwards a portion of the London, Chatham & Dover Railway, and were the first engines at work on that particular line.

Passenger traffic on the infant line being provided for to the extent shown, orders were given to supply some engines for the goods department. Accordingly, two classes of

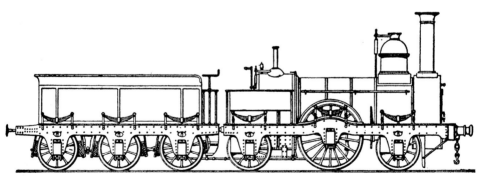

Fig. 1.

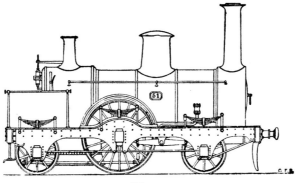

Fig. 2.

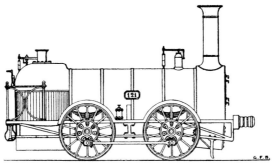

Fig. 3.

four-coupled engines were soon put to work, the one set having four wheels only, all coupled, while the others ran on six wheels, the leading and driving wheels being coupled. Of the former, six were built by Bury, Curtis and Kennedy, and were all at work in 1848, receiving the railway company's Nos 121–126, and, as can be seen from the accompanying illustration of No. 121, *Fig. 3*, were of the well-known 'Bury' type of the period, having inside cylinders measuring 15 x 24 inches, four-coupled wheels 5 feet in diameter, the bar-frame, which was an integral factor of the type, and the modified circular, dome-topped firebox casing. Six other engines of almost the same pattern, numbered from Nos 127–132, were built in 1848 and 1849 by William Fairbairn & Sons, of Manchester, probably under contract with Bury, who frequently sub-let part of their orders. The accompanying drawing of No. 127, *Fig. 4*, with its tender, shows the main features of these engines, which had 15 x 24 inches cylinders, and 5 feet 1 inch coupled wheels standing on a wheelbase of 7 feet 8 inches The tender had four 3-foot wheels on a 7 feet 5 inches wheelbase, the total wheelbase of engine and tender being 27 feet 11 inches, with a length over buffers of 39 feet 5 inches.

As can readily be understood, these twelve engines did not distinguish themselves to any praiseworthy degree by their capability for dealing with main-line traffic, which on this particular line, at all events, was of a heavier character than they were competent to work. Sturrock, therefore, afterwards converted them into six-wheeled, front-coupled engines, by the simple process of extending the framing rearwards, and

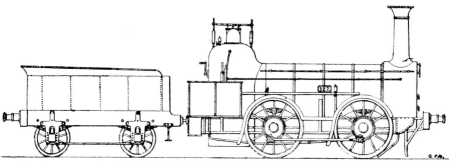

Fig. 4.

adding a pair of 3-foot trailing wheels under the footplate. At the same time, he further dispensed with the tenders, providing Nos 121–126 with saddle tanks carried over the barrel of the boiler, in the manner shown in the accompanying- illustration *Fig. 5*, and by this addition giving them a total weight of 29 tons 6 cwt, while Nos 127–132 had side tanks.

The six-wheeled goods engines already mentioned were Nos 101–115, and were built by R. & W. Hawthorn in 1848. The illustration, *Fig. 6*, here given of No. 101 shows the leading features of this class, which had four wheels coupled in front, with equalizing levers connecting the springs, and a pair of smaller trailing wheels. These wheels were respectively 5 feet and 3 feet 6 inches in diameter, the driving-wheel centres being 7 feet 6 inches apart and the total wheelbase 14 feet; the cylinders measured 15 x 24 inches. With a boiler barrel 10 feet long and 3 feet 10 inches in diameter, containing 166 tubes of 2-inch diameter, and an internal firebox 3 feet 6 inches long by 3 feet 5 inches broad, there was a total heating surface of 970 sq. ft, of which the firebox contributed 75 and the tubes 895 sq. ft. The weight of these engines was about 26 tons.

In the first week of January, 1849, Bury, Curtis & Kennedy delivered to the company a passenger engine, No. 100, which claims some attention. As can be seen from the illustration, *Fig. 7*, it was not of the standard pattern of the firm, being carried on six wheels, while the shape of the firebox also differed from that almost invariably associated with the 'Bury' engines. The maker's No. of this engine was 359, and it had inside cylinders 15 x 22 inches, a pair of leading wheels 4 feet 3 inches, and four coupled wheels 5 feet 9 inches in diameter respectively. During 1855 and 1856 this engine was rebuilt, having in the first-named year broken its crankshaft and run off the rails, and as it issued from the shops it presented quite a changed appearance, the inside bar frames being concealed by the provision of a new plate framing outside the wheels, the external aspect of the engine as thus converted closely approximating to that of the coupled passenger engines subsequently built with the Nos 71–75, which will be referred to later. At the same time the cylinders had their diameter increased to 16 inches Some years later in 1871, this No. 100 was again renewed with wheels of the same diameter as those originally placed under her and still later, in 1875, she was provided with a new set of wheels the leaders being 4 feet 6 inches and the drivers 6 feet in diameter, respectively, thus raising the whole engine by about 3 inches.

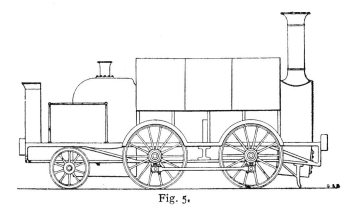

Fig. 5.

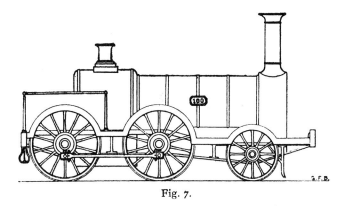

Fig. 6.

Fig. 7.

Four locomotives were purchased from Peto, Brassey & Betts in 1849 and 1850, to which were given the GNR Nos 133 and 159–161. When at work on the GNR No. 133 presented the general appearance shown in the accompanying illustration, *Fig. 8,* having four driving wheels of 5 feet diameter coupled in front, and a pair of 3 feet 6 inches trailing wheels. The wheelbase was 14 feet 6 inches, of which 8 feet 3 inches divided the driving wheel centres. Inside cylinders measuring 15 x 24 inches, outside

bearings throughout, a raised firebox and a dome placed well forward on the boiler barrel, and equalizing levers between the driving springs, were features of this engine, and Nos 159–161 were apparently of much the same general design and dimensions. All these engines were built by C. Tayleur & Co.

Five engines which received the GNR Nos 162–166 were also purchased a year or two later. Engine No. 162 was purchased from a Yorkshire line, and was originally built by Kitson. No. 163 was a standard Hawthorn double-framed goods, with 5-foot driving wheels and 16 x 24-inch cylinders, built in 1850. Nos 164 and 165 were standard Wilson goods engines of similar dimensions to No. 168, described and illustrated on page 22, and were built in 1852. No. 166 was a single-framed goods engine, built by Shepherd Todd of Leeds in 1850, with 16 x 24 inch cylinders and 5-foot driving wheels each of which was built up of a solid disc instead of with spokes. It had single inside frames, the coupling rods being connected directly with the wheels with crank pins. All these engines came from the Yorkshire railway already referred to, and did good service. No. 165 was lately running at Bradford, and more recently still was stationed at Ardsley, and is the oldest goods engine on the GNR.

So far, the goods engines built for the Great Northern had consisted of four-coupled types, but in 1850 a notable movement was made in the putting to work of a six-

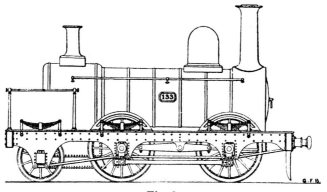

Fig. 8.

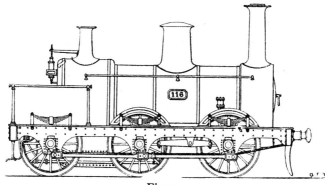

Fig. 9.

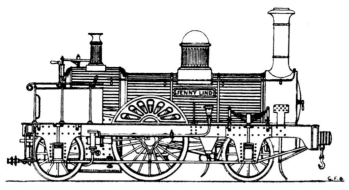

Fig. 10.

coupled engine, which was followed during that and the following year by a number of similar locomotives. These had inside cylinders, outside frames and axle bearings, and equalizing levers between the leading and driving springs. Other leading details in their construction may be seen from the accompanying illustration, *Fig. 9*, of No. 116. In all there were thirty-one engines built of this class, fifteen being built by R. & W. Hawthorn and sixteen by E. B. Wilson & Co. Of these the former firm built Nos 116–120 in the year 1850, and Nos 134–143 (maker's Nos 739–748) in 1850 and 1851, while Wilson's engines, of the same dimensions, but differing in details of fittings, as was customary at the time, bore the Nos 144–158 and 167, and were built and delivered in 1850 and 1851. Nos 116–120 had cylinders 16 x 22 inches and driving wheels 5 feet in diameter, equally distributed over a total wheelbase of 14 feet. The other engines of the class had cylinders also 16 inches in diameter, but with a stroke of 24 inches The boiler barrel was 10 feet in length, with a diameter of 3 feet 10 inches, and contained 158 tubes of 2-inch diameter. The internal firebox measured 3 feet 10½ inches in length by 3 feet. 3½ inches, and the heating surface was – firebox 78, tubes 815, total 893 sq. ft.

In 1850 and 1851 two passenger engines which had been ordered from E. B. Wilson & Co. were put to work, bearing Nos 201 and 202. They were built in accordance with the firm's speciality in single driving engines, with inside bearings to the driving wheels and outside bearings to the leading and trailing wheels, this conjunction of details, together with others less conspicuous, constituting what was known as the 'Jenny Lind' pattern, over which some heated discussions have at times been centred. These two engines for the GNR had driving and carrying wheels of 6 feet and 4 feet respectively, and had cylinders 16 inches in diameter, with an original stroke of 20 inches, which was subsequently lengthened to 22 inches, when they were rebuilt some years later by Stirling. The accompanying illustration of the original *Jenny Lind, Fig. 10*, may be taken as representing Nos 201 and 202 on the GNR when built. Neither of these engines, however, bore the name-plate shown here on their prototype, and they also probably presented a few minor differences in matters of detail.

Archibald Sturrock, 1850–1866

Up to this period in its history the Great Northern Railway can scarcely be said to have had an actual locomotive superintendent. At the outset Cubitt, brother to the well-known contractor, did indeed virtually occupy that position for a few months, and on his death Edward Bury, whose engagement on the London & Birmingham Railway had terminated at the close of the year 1846, also for a brief space took over the locomotive department of the GNR. But it was soon felt that Bury's position could not fail to be one of considerable delicacy, in view of his dual capacities as an official of a railway company and a member of a firm of locomotive builders; and in 1850 a new arrangement was suggested, whereby the services of Archibald Sturrock were secured, and that gentleman was definitely installed as locomotive engineer. Sturrock had previously gained upwards of ten years' experience in the Great Western's Works at Swindon under Daniel Gooch, and there can be no doubt that the excellent training thus acquired fitted Sturrock in a most eminent degree to undertake the duties of his new appointment on a railway to which the qualities of speed and power in its locomotive stock were absolutely necessary for a continued and prosperous existence. From the start the new locomotive engineer kept two main ideas strongly to the front in providing engine-power for the railway, those two ideas being the vital influence of the firebox in determining the capability of an engine, and the need of a high boiler pressure to develop the full capacities of the machine. Accordingly we find that in all the engines built to his specifications there was an unusually large provision of heating surface, especially as regards the firebox, which, as Gooch had always maintained, is the true measure of the power of a locomotive; while from the outset he adopted what, at that time, was the comparatively high pressure of 150 lbs to the square inch, as the standard working pressure of all the locomotives turned out to his orders.

The first passenger locomotive built for the GNR Company to Sturrock's instructions was No. 71, which began work in 1851, and was one of twenty constructed to the same leading dimensions. Of these Nos 71–75 were built by R. & W. Hawthorn, and Nos 76–90 by E. B. Wilson & Co., and the two accompanying illustrations, *Figs. 11 and 12*, showing respectively Nos 71–76, indicate that, while in details each firm still continued to follow its own practice, the general dimensions of the railway company's locomotive engineer were closely adhered to. These twenty engines were all built to the

following chief particulars: cylinders 16 x 22 inches; leading wheels 3 feet 6 inches, four-coupled driving wheels 6 feet in diameter; wheelbase 15 feet, of which 7 feet 3 inches divided the centres of the coupled axles; boiler barrel 10 feet in length, with a diameter of 3 feet 9½ inches, containing 157 tubes of 2-inch diameter; internal firebox, length 4 feet 6 inches, width, 3 feet 3½ inches; heating surface: firebox 102 sq. ft, tubes 904 sq. ft, total 1,006 sq. ft; boiler pressure 150 lbs; weight 27 tons 18 cwt.

Ten engines of unusual design were built by Longridge & Co., and delivered to the railway company during the years 1851 and 1852, though it appears that they were actually ordered prior to Sturrock's assumption of office on the line. They were of practically the same type as the well-known 'Folkestone' of the South Eastern Railway, and were built in accordance with one of T. R. Crampton's patents, a principal feature of the design consisting 'in the boiler resting upon three points: one on the centre of a cross-spring, which bears upon the axleboxes of the driving wheels at the back of the firebox, and one on each side in the front, on compensating springs, each of which springs bears upon the two axleboxes of the small supporting wheels.' In the case of the GNR engines, the large reversed springs at each side, which, in the original specification spanned the interval between the two sets

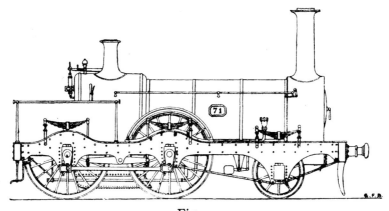

Fig. 11.

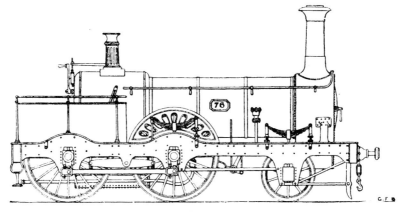

Fig. 12.

of leading wheels, were not employed, each of the four leading axleboxes having its own spring, with equalizing levers between the two on each side, this method of suspension being, for all practical purposes, the same as that above quoted. An important feature of the design consisted in the use of inside cylinders, which necessitated the employment of a 'dummy' crank axle in front of the firebox, with outside cranks coupling it to the driving wheels at the extreme rear of the engine. These engines bore the GNR Nos 91–99 and 200, and one of them had the honour, at seven o'clock on the morning of 14 October, 1852, to draw the first train out of King's Cross terminus on its way to York. The illustration of No. 91, *Fig, 13*, shows the general external appearance of these engines as originally built. They were speedily found, however to be wholly unsuitable for the service they were intended to work, one very vital reason undoubtedly being the small proportion of weight available for purposes of adhesion, consequent on the position of the driving wheels. Sturrock, therefore, undertook the task of altering the arrangement of wheels to a more usual design, and in course of time they were all modified to the condition shown in our second illustration of No. 91, *Fig. 14*, in which the driving wheels are shown in the normal position, with the

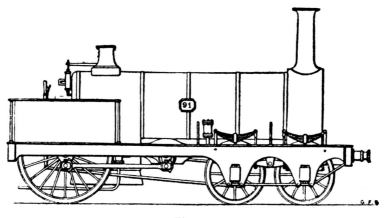

Fig. 13.

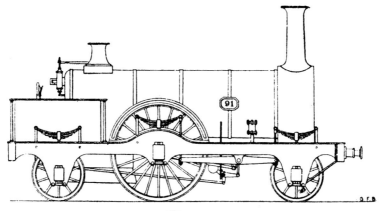

Fig. 14.

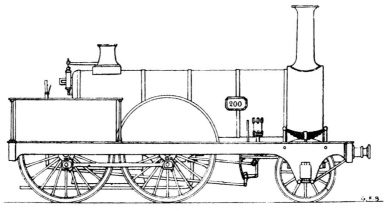

Fig. 15.

crank axle in front of the firebox casing, one pair of the carrying wheels being removed from the front of the engine to a more suitable place immediately behind the firebox. In this form the engines had outside bearings to all the wheels, and the driving axle had inside bearings as well. One of the engines, No. 200, passed through an intermediate stage, which is shown in the accompanying illustration, *Fig. 15*, being for a short period a four-coupled engine, having in its outside appearance a strong resemblance to the handsome coupled engines afterwards put upon the line by Patrick Stirling; but this form only existed for a comparatively short period, and the engine was subsequently reconstructed in the single-driving form to which the others had been transformed. In their new condition these ten engines became known as the 'converted Cramptons', and did excellent service for many years. The dimensions of the converted engines were: cylinders 15 x 21 inches; driving wheels 6 feet 6 inches; carrying wheels 3 feet 6 inches in diameter; wheelbase: leading to driving wheels, 9 feet 6 inches, driving to trailing wheels 7 feet, total 16 feet 6 inches; boiler barrel 10 feet in length by 4 feet diameter, containing 168 tubes 2 inches in diameter, inside firebox 4 feet 2 inches x 3 feet 5 inches; heating surface: firebox 97 sq. ft, tubes 875 sq. ft, total 972 sq. ft; weight in working order 28 tons 7 cwt.

The next engines put upon the line were a number of six-coupled goods locomotives of considerable size and power. Thirty of these were delivered in the years 1851 and 1852 by E. B. Wilson & Co., with the GNR Nos 168–197, and ten during 1852 and 1853 by W. Fairbairn & Sons, with the Nos 198, 199 and 300–307. The accompanying illustration, *Fig. 16*, which shows No. 168, will give an idea of the leading external characteristics of Wilson's engines, which were, indeed, of a type that was subsequently adopted to a large extent by different railway companies. With six-coupled wheels having a diameter of 5 feet, cylinders measuring 16 inches in diameter with a stroke of 24 inches, and a total adhesive weight of 29½ tons, it will be seen that this class of goods locomotive was exceptionally powerful for the period at which it first made its appearance. The three pairs of wheels were equally divided over a total wheelbase of 15 feet 6 inches, and all had outside bearings in frames measuring 23 feet 9 inches over the buffer beams, these frames being of the 'sandwich' pattern with a centre of sapling ash 10 inches deep by 3¾ inches broad, having on each side an iron plate 7/16 inches thick. In

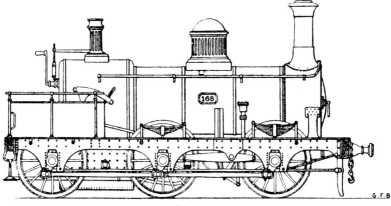

Fig. 16.

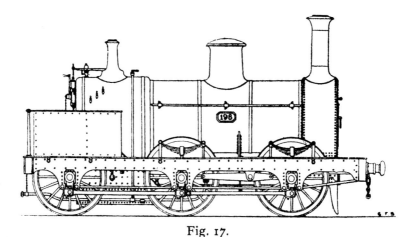

Fig. 17.

addition, the crank axle had two inside bearings between the wheels, in two iron frame-plates which extended from the cylinders to the firebox. A peculiarity about the boiler consisted in the adoption of a slightly oval section, the barrel having a vertical diameter of 4 feet 3 inches, while the horizontal diameter was only 4 feet 1 inches. Inside this barrel were 187 tubes of 2-inch diameter and 10 feet 9³/₁₆ inches in length between the tube plates. The firebox casing, which was of the raised pattern, had an outside length of 5 feet 2 inches, and a width of 4 feet 3 inches, while the copper firebox itself, which was provided with a transverse mid-feather, measured in its two divisions respectively a length of 2 feet 0¼ inches each, with a common width of 3 feet 7 inches, and a uniform height of 5 feet 2 inches above the grate bars, all inside measurements. This firebox had a grate area of 14.5 sq. ft. The engines of this class weighed 26½ tons empty, and 29½ tons in working order, the weight being distributed as follows: leading wheels 10½ tons, driving wheels 11½ tons, and trailing wheels 7½ tons.

In *Fig. 17* is shown the general design of No. 198, which was one of the ten

locomotives of the class built by William Fairbairn & Sons. Apparently these differed slightly from the earlier engines of the type not only in general appearance but also in some dimensions. For example, the boiler barrel seems to have been of a circular section 10 feet 7 inches in length, with a diameter of 4 feet 4 inches, and contained only 184 tubes. The firebox had internal measurements of 4 feet 6 inches in length by 3 feet 10½ inches in breadth, with a grate area of 15 sq. ft, and the heating surface formed a total of 1,109.3 sq. ft, of which the firebox accounted for 116.3 sq. ft, and the tubes for the remaining 993 sq. ft. While the total wheelbase remained the same as in the Wilson engines, it was unequally divided, the driving axle being 1 inch in advance of the central position, thus giving divisions of 7 feet 8 inches and 7 feet 10 inches between the leading and driving, and driving and trailing wheels respectively. The total weight of the engine is given as 30 tons 11 cwt, and the capacity of the tender tank 1,400 gallons of water.

Within a very short space of time orders were given for a further twenty goods locomotives of the same general design, but with wheels 5 feet 3 inches in diameter, and cylinders measuring 16½ x 24 inches, and slightly larger dimensions throughout. Of these, Nos 308–317 were built by R. Stephenson & Co. in 1851 and 1852, and Nos 318–327 by Nasmyth & Co. in 1852 and 1853 (builder's Nos 100–109).

During the years 1852 and 1853, twelve fine engines were delivered to the railway company by R. & W. Hawthorn, which became known as the 'Large Hawthorns'. They received the company's Nos 203–214. In external appearance, as can be seen from the illustration, *Fig. 18*, which shows No. 203, they greatly resembled the No. 51 class, but were of larger dimensions throughout. Nos 203, 213 and 214 were dome-less, as shown in the accompanying illustration, while others had domes of the shape shown in preceding drawings of Hawthorn engines. Leading dimensions of these twelve locomotives were as follows: diameter of driving wheels 6 feet 6 inches, and of leading and trailing wheels 4 feet; wheelbase: leading to driving wheels 7 feet 9 inches, driving to trailing wheels 7 feet 3 inches, total 15 feet; cylinders 16 inches diameter with 22 inches stroke; steam ports 14 x 1½ inches; exhaust ports 14 x 3½ inches; diameter of

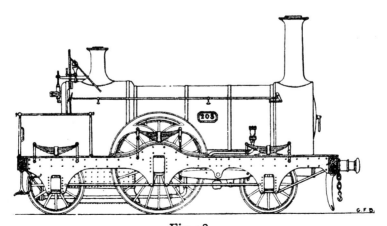

Fig. 18.

blast pipe 4¾ inches; boiler barrel, consisting of ½ inch plates, length 10 feet, diameter 4 feet, containing 171 tubes each 10 feet 5 inches in length, with an outside diameter of 2 inches; firebox casing 5 feet 1¼ inches long and 4 feet wide; inside firebox, which was provided with a transverse mid-feather, 4 feet 6 inches long and 3 feet 5 inches wide; heating surface: firebox 114 sq. ft, tubes 874.4 sq. ft, total 988.4 sq. ft; grate area 13.64 sq. ft. The total weight of each engine of the class in full working order was 27 tons 16 cwt, and the capacity of the water tank in the tender was 1,500 gallons. No. 210 of this class subsequently earned considerable distinction on one memorable occasion by charging right through a MS&LR goods train on the dangerous level crossing just south of Retford Station, thus carrying the 'Flying Scotsman' of the period safely through an obstacle which it could not avoid. Mr Michael Reynolds describes this incident thus:

> The down Scotch express was going down Retford bank, signals all clear, when Oliver Hindley saw a train going east from Sheffield to Lincoln, which would meet him on the level crossing. He could not stop, and with that clear mind which is so marked in Englishmen in time of danger, he put on full steam, and sent Mr Sturrock's beautiful express engine clean through the goods train, scattering the trucks like match splinters, and carrying all safe. When asked about the matter Hindley said he could not keep clear, so he would clear away his obstruction. There is no doubt that, had he hesitated or feared, many lives would have been sacrificed. No. 210 engine carried the dents and scars like an old warrior, and looked handsomer than ever for this brush with the enemy of express trains.

Closely following the fine engines just mentioned came one still finer, which enjoyed the distinction of being the only specimen of its class. This noteworthy engine was No. 215, an illustration of which, with its original tender, is here given in *Fig. 19*, and concerning which Sturrock wrote a brief description some ten years ago to the following effect:

> An engine with 7 foot 6 inch driving wheels, a four-wheeled bogie in front, and a pair of carrying wheels in rear, was delivered to the Great Northern Railway on 6 August, 1853, and having a large tender, could and did run 100-mile lengths at the highest present speeds. This engine was constructed to prove to the directors of the Great Northern Railway that it was quite practicable to reach Edinburgh from King's Cross in eight hours by only stopping at Grantham, York, Newcastle and Berwick. This service was not carried out, because there was no demand by travellers for nor competition amongst the railways to give the public such accommodation.

No. 215 was built by R. & W. Hawthorn, and was an eight-wheeled engine having outside bearings to all the wheels, including those of the bogie, a large raised firebox with a mid-feather, and no steam dome. The driving wheels had no flanges. It had a six-wheeled tender of large capacity, which, as is shown in the illustration, had originally a hooded seat provided at the rear in a similar manner to the old broad

gauge tenders on the Great Western Railway. The leading dimensions of the engine were: diameter of driving wheels 7 feet 6 inches, and of bogie and trailing wheels 4 feet 3 inches; wheelbase: bogie wheels 7 feet 2 inches; hind bogie wheels to driving wheels 6 feet 4½ inches; driving to trailing wheels 8 feet 2 inches, total wheelbase 21 feet 8½ inches; cylinders 17 x 24 inches; boiler barrel 12 feet long by 4 feet 4 inches diameter, containing 240 tubes 12 feet 5½ inches long by 2 inches diameter; internal firebox 5 feet 5 inches x 3 feet 9 inches; heating surface: firebox 155.2 sq. ft, tubes 1,564.0 sq. ft, total 1,719.2 sq. ft; weight of engine empty 32 tons 11 cwt 3 qrs, in working order 37 tons 9 cwt 2 qrs. The tender was on six wheels of 4 feet 3 inches diameter, and carried 2,505 gallons of water, its weight in working order being 33 tons.

As originally built, this engine does not appear to have been an unqualified success. Its blast-pipe orifice was only 3¾ inches in diameter, which was subsequently increased to 4½ inches. At first it caused great trouble by the ease with which it left the metals in going round sharp curves. This tendency was undoubtedly due to the design of the bogie, the sandwich frame of which made a very close fit with the main frame of the engine, and in damp weather the wood on both frames swelled to such an extent as to bind them together, thus neutralizing the effect of the bogie. Eventually the wood was cut well away, and iron plates were provided to give the necessary sliding surfaces, and with this increased freedom of action to the bogie, the engine seems to have given no further trouble in the way of derailments. No. 215 ran upon the GNR until the year 1870, when it was broken up, and the driving wheels were utilized for a new engine, No. 92, which was then built, and to which further reference will be made in due course.

During 1853 and the two or three years immediately following, Sturrock provided no fewer than sixty-three six-coupled goods engines with cylinders 16 inches x 24 inches and 5 foot 3 inch driving wheels. These were supplied by different makers, as follows; Nos 328–332 by R. & W. Hawthorn (maker's Nos 858–862), in 1853 and 1854; Nos 333–337 by Kitson & Co., in 1853; Nos 338–347 by E. B. Wilson & Co., in 1854; Nos 348–353 by Sharp, Stewart & Co. (maker's Nos 811–816); Nos 354–356 by Sharp, Stewart & Co. (maker's Nos 820–822), and Nos 357–362 by Sharp, Stewart & Co. (maker's Nos 826–831), all in 1854; Nos 363–367 by the Vulcan Foundry Co. (maker's Nos 367–371), in 1854; Nos 368 and 369 by E. B. Wilson & Co. in 1853; Nos 370–380 by the same firm in 1854; Nos 381–385 by Kitson & Co. in 1855; Nos 385–389 by Sharp, Stewart & Co. (maker's Nos 910–913) in 1855; and No. 390,

Fig. 19.

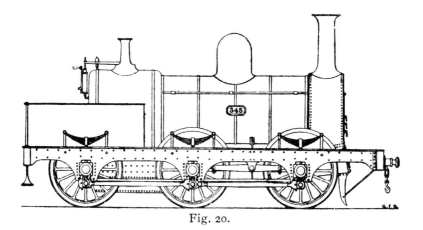

Fig. 20.

by the same firm (maker's No. 914) in 1856. The accompanying illustration, *Fig. 20,*
shows No. 348 of this class, the leading dimensions throughout being practically the
same as follow: diameter of coupled wheels 5 feet 3 inches, the axles being equally
divided over a wheelbase of 15 feet 6 inches; cylinders 16 x 24 inches; boiler barrel
10 feet 7 inches in length with a diameter of 4 feet 3 inches, containing 209 tubes of
2-inch diameter; heating surface: firebox 122.75 sq. ft, tubes 1,176.45, total 1,299.20
sq. ft; capacity of tender tank 1,400 gallons; weight of engine 33 tons 10 cwt.

The company also acquired five locomotives which were originally built for the Leeds,
Bradford & Halifax Junction Railway, which were given the GNR running numbers
395–399. Nos 395–396 were Kitson's standard double-framed goods-engines, with
5 foot wheels, and Nos 397 was also a Kitson goods engine, but with 5 feet 3 inch
wheels. No. 397 was employed on shunting work at Bradford, in its converted form
as a saddle-tank, until 1890, when it was scrapped. At that time its cylinders had been
enlarged to 17¼ inches by 24 inches. Nos 398 and 399 were built by Hudswell &
Clarke, in 1863, and were standard, six-coupled, double-framed goods engines, with
5-foot wheels and 15 x 23 inch cylinders. No. 399 (builder's No. 14) is illustrated in *Fig.*

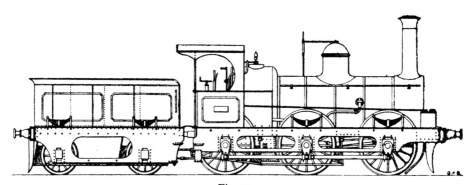

Fig. 21.

21.

In 1855 the Great Northern acquired by lease the small local line rejoicing in the extensive title of the Ambergate, Nottingham & Boston & Eastern Junction Railway, and at the same time took over the entire locomotive stock of that railway, which consisted of no fewer than nine engines. These, numbered consecutively from 1–9 on the AN&B&EJR, became Nos 218–222 and 391–394 in the books of the GNR. Nos 218–220 (Ambergate, etc., Nos 1–3) were three small tank engines each running on four wheels, and had been built by E. B. Wilson & Co. under Crampton's patents. The general design of these singular little engines is shown in the illustration, *Fig. 22*, being that, in fact, of a number of similar machines that were supplied to various railways at about this period. They had inside cylinders 11 inches in diameter with a 17 inches stroke, driving a 'dummy' crank axle which was connected by means of outside cranks and coupling rods with the four 5-foot driving wheels which carried the engine. The tanks had a capacity for 400 gallons, but the limited power and small weight, 16 tons, rendered these engines possibly some of the few bad 'bargains' made by the GNR.

No. 221 (Ambergate No. 4) was a 'Large Hawthorn', with 6 feet 6 inch driving wheels, and 16 inch by 22 inch cylinders, and was therefore practically identical with the previously acquired GNR engines, Nos 203–214. No. 222 (Ambergate No. 5) again had its prototypes on the line, since it was one of E. B. Wilson & Co.'s 'Jenny Lind' pattern, but with 6 feet 3 inch driving wheels, and cylinders only 15 x 20 inches The remaining engines acquired, Nos 391–394 (Ambergate Nos 6–9), also were by the Wilson firm; Nos 391, 393 and 394 being six-coupled engines, having 5-foot driving wheels and 16 x 24 inch cylinders, and standing on a wheelbase of 15 feet 4 inches equally divided. They were almost identical in external appearance with Nos 168–197, which have already been illustrated and described. Their dates were respectively 1850, 1855 and 1854. No. 392 was also built by Wilson, in 1855, but had a small pair of leading wheels and only four-coupled 5-foot driving wheels, with 16-inch cylinders.

Two locomotives were added to the company's stock in 1854 by purchase from C. C. Williams, and they received Nos 216 and 217. They were four-coupled passenger engines of the type shown in the accompanying illustration, *Fig. 23*, having leading

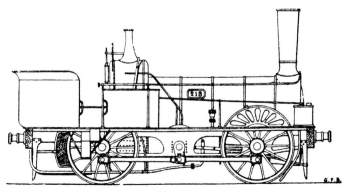

Fig. 22.

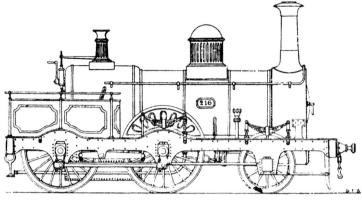

Fig. 23.

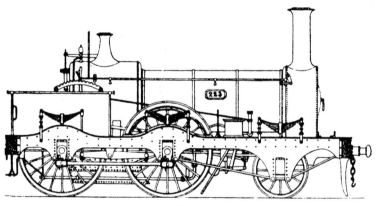

Fig. 24.

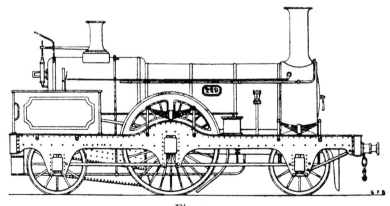

Fig. 25.

wheels 3 feet 9 inches and driving wheels 5 feet 9 inches diameter respectively, and cylinders 16 inches diameter with a 22-inch stroke. These engines, as can be gathered from the drawing, were built by E. B. Wilson & Co.

This same year, 1855, saw the first appearance of six handsome four-coupled passenger engines built to Sturrock's design by R. & W. Hawthorn, which bore Nos 223–228. They were, as usual, constructed with double frames and outside bearings to all the axles, and it will be noticed in the appended illustration, *Fig. 24*, showing No. 223, that equalizing levers were applied to the springs of the coupled wheels, as was Hawthorn's general practice in four-coupled engines. The leading dimensions were as follows: leading wheels 4 feet and coupled wheels 6 feet 6 inches in diameter respectively; wheelbase, from leading to driving wheels 8 feet 3 inches, from driving to trailing wheels 7 feet 6 inches, total 15 feet 9 inches; cylinders 16½ x 22 inches; boiler barrel 10 feet long with a diameter of 4 feet, containing 160 tubes 10 feet 5 inches long with 2 inch diameter; internal firebox 4 feet 8 inches by 3 feet 5 inches; heating surface: firebox 110 sq. ft, tubes 872 sq. ft, total heating surface 982 square ft; grate area 14.92 square ft; weight in working order about 33 tons.

Following these in numerical order came a set of twelve passenger engines which might almost be regarded as Sturrock's masterpiece in designing. These were single driving engines of generous dimensions and fine proportions, which must strike the observer as being well in the front rank of locomotives so far as grace of appearance is concerned, while their performances abundantly proved that in no way were workmanlike qualities of speed and power sacrificed to obtain a satisfactory outline. These twelve engines bore the Nos 229–240, Nos 229–232 being delivered by Kitson & Co. in 1860, Nos 233–236 by Sharp, Stewart & Co. (makers' Nos 1159–1161 and 1215) in 1860 and 1861, and Nos 237–240 by R. Stephenson & Co. in 1860, the whole being charged in the company's books at a total of £35,000. The accompanying illustration, *Fig. 25*, of No. 229 shows several interesting features, one being the great length of the firebox, which was provided with a longitudinal mid-feather, while the position of the leading wheels right forward under the centre line of the smoke-box and chimney is also noteworthy, as it is a practice that has since been adopted without any exception all GNR six-wheeled passenger engines. A further detail, not apparent in the drawing, was the employment of hoops on the jaws of the cranks, which at the time was a somewhat unusual precaution. The leading dimensions of these splendid engines were: diameter of driving wheels 7 feet, and of leading and trailing wheels 4 feet 3 inches; wheelbase: leading to driving wheel centres 9 feet 6 inches, driving to trailing wheel centres 8 feet 6 inches, total 18 feet; cylinders 17 x 22 inches; length of boiler barrel 10 feet, diameter 4 feet, containing 164 tubes of 2-inch diameter; length of firebox casing 7 feet 4 inches; heating surface: firebox 177 square ft, tubes 883.6 sq. ft, total 1,060.6 sq. ft; capacity of tender tank 2,400 gallons; weight of engine only, 34 tons 12 cwt, of which 13 tons 6 cwt 3 qrs rested on the driving wheels.

In 1863 the Great Northern Railway was suddenly called upon to provide locomotive power for the working of its trains through the portion of the Metropolitan Railway over which they possessed running powers, and this necessity being unexpectedly brought forward, found the company in some difficulty, as at the time they had no

tank engines which were specially fitted for the purpose. There were, however, a certain number of the 'Little Sharps' which had already been converted into passenger tank locomotives by Sturrock, in 1852–53, which were utilized as makeshifts pending the provision of engines suitable for 'Underground' traffic. The main features in the conversion thus effected consisted in the lengthening of the frames to the rear of the driving wheels, and placing the trailing wheels further back to the extent of 3 feet 1 inch, thus increasing the normal wheelbase of 12 feet 8 inches to 15 feet 9 inches. This extra length of framing allowed of the addition of a water tank and coal bunker, and, as is above stated, a number of the 'Little Sharps' were converted in this manner, so as to present the external appearance indicated in the accompanying illustration, *Fig. 26,* showing No. 9, which was one of those so treated. The following are the numbers of the engines thus converted, with the dates of conversion:

Engine No.	*Date*
19	January 1852
40	March 1852
46	March 1852
45	April 1852
10	April 1852
1	May 1852
2	May 1852
6	May 1852
9	May 1852
18	June 1852
39	July 1852

Two others, Nos 23 and 12, were also converted, the former into a front-coupled tender engine, and the latter into a front-coupled tank. In the earlier conversions a certain degree of end play was allowed to the trailing axles to permit of the easier

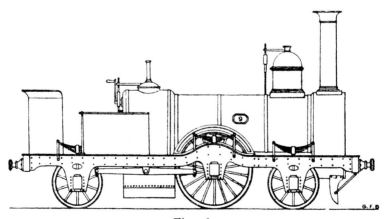

Fig. 26.

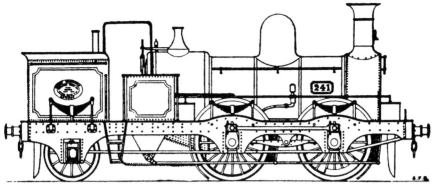

Fig. 27.

negotiation of sharp curves such as are necessitated in underground work; but subsequent rebuilds were provided with radial axleboxes to the rear wheels, which gave so much satisfaction as to result in the construction of a new type of locomotive embodying that as a principal feature.

These new engines were specially designed by Sturrock for the working of underground traffic, and were built in 1865 by the Avonside Engine Co., of Bristol (maker's Nos 607–616). They bore the GNR Nos 241–250, and were of the type shown in the accompanying illustration, *Fig. 27*, of No. 241, having four-coupled wheels in front, a single pair of trailing wheels with radial axleboxes at the rear, and a large tank and coal bunker directly over the trailing wheels. Condensing was provided for by means of a long pipe running below the footplate into the tank. The leading dimensions of the engines were: diameter of coupled wheels 5 feet 6 inches, and of trailing wheels 4 feet; wheelbase: leading to driving wheel centres 7 feet 6 inches, driving to trailing wheel centres 11 feet 9 inches, total 19 feet 3 inches; cylinders 16½ x 22 inches; boiler barrel, length 10 feet, diameter 4 feet; length of firebox casing 4 feet 6 inches; total heating surface 867.1 sq. ft; total weight in working order, 39 tons 12 cwt 2 qrs.

So successful did the engines prove that another ten were supplied in 1866, Nos 270 to 274 by Neilson & Co., of Glasgow (maker's Nos 1311–1315), and Nos 275–279 by the Avonside Engine Co. Those built by Neilson had a 12 inch longer wheelbase, and weighed about 30 cwt more than the first lot put on the rails, and were of the general design shown in the accompanying illustration of No. 270, *Fig. 28*.

During his successful career at the head of the locomotive department of the GNR, Sturrock attempted to solve a problem that was at the time exercising many minds – the procuring of more adhesive and tractive force by the utilization of the dead weight of the tender. While many inventors coupled the tender to the engine in such a manner as to distribute part of its weight upon the trailing wheels of the engine, Sturrock proceeded on much bolder lines, and patented an arrangement whereby the tender itself constituted a separate locomotive, deriving its steam from the same boiler as supplied the engine cylinders. In effect, his 'steam tender' ran on six wheels connected by means of outside cranks and coupling rods, the axle of the middle pair of wheels

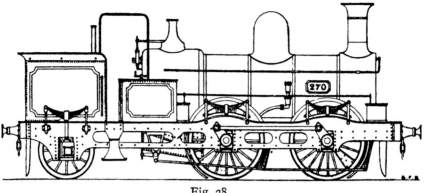

Fig. 28.

being cranked instead of straight, and rotated by means of two 12 inch by 17 inch cylinders which were fitted under the framing, between the leading and middle pair of wheels. *Fig. 29* shows the external appearance of one of these tenders. Steam was received by means of suitable pipes direct from the engine boiler, and after serving its purpose was condensed, the operation being described in Zerah Colburn's *Locomotive Engineering* in the following terms:

> The exhaust steam from the cylinders is delivered into a tubular condenser, surrounded by the water in the tank, consisting of fifteen tubes 2 inches in outside diameter, about 12 feet 8 inches in length, fixed into a reception box at each end. The first box receives the exhaust steam and delivers it through the tubes; the second is fitted with a waste pipe to carry off the uncondensed steam.

Apparently there were two distinct sizes of steam tenders built, one having 4 foot 6 inch wheels, and weighing 29 tons 8 cwt with the tanks full, and the others having 4-foot wheels, and weighing 27 tons 15 cwt in running condition. The wheelbase of

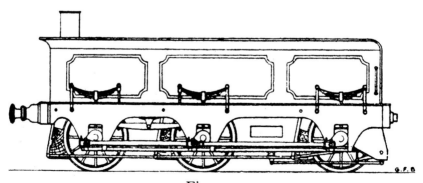

Fig. 29.

both was the same, leading to driving wheel centres 8 feet 5 inches, driving to trailing wheel centres 6 feet 8 inches, total 15 feet 1 inch, with a total length over the buffer beams of 21 feet 7 inches.

At the close of the year 1863 Sturrock made his first experiment in this direction by taking the tender of the old Sharp single No. 46, and converting it into a steam tender of the kind just described. In this form it was tried with a number of engines on the Great Northern Railway, and also appears to have been lent to the Manchester, Sheffield & Lincolnshire Railway Company, who subsequently, by the way, ordered six steam tenders from Neilson & Co. in 1865. The first GNR locomotive definitely provided with a steam tender was No. 391, and almost immediately afterwards Nos 393 and 394 were also so fitted, certain alterations being made in them to allow for the additional tax put upon the boiler by the introduction of two new cylinders. These changes comprised the enlargement of the firebox, the provision of a second regulator in the steam dome, and a re-arrangement of the feed pumps to permit of the pumping of hot water. The engines were put to work on the London and Peterborough division, and at once showed themselves to be capable of hauling loads of from forty to forty-five loaded coal wagons over the ruling gradients of 1 in 200 on the main line, while on the level stretches of the Lincolnshire loop line they proved quite equal to sixty wagons, the ordinary loads hitherto worked on these two sections of the line being thirty and thirty-five wagons respectively.

Following the apparently successful result of these trials, it was resolved to extend the type, and a number of new goods engines being wanted at about this time to meet the growing requirements of the goods and mineral departments, the order was given that they were all to be built with steam tenders. No fewer than seventy engines were comprised in this class, all of the standard six-coupled type, having driving wheels 5 feet in diameter, cylinders 16 inches in diameter, with a stroke of 24 inches, and in general dimensions were practically almost identical with the former engines of Sturrock's design, as can be seen from the illustration, *Fig. 30*, except for the provision of a firebox considerably larger than those formerly fitted, which extended well behind the trailing axle, and consequently had its grate sloping somewhat steeply from back to front. The grate area was in some as much as 261 square feet. These engines, which weighed 35 tons apiece, and the contract price for which with tender was £3,750 each, were delivered to the railway company in the order and by the makers named: Nos 400–409 by Kitson & Co., Nos 410–419 by R. & W. Hawthorn (maker's Nos 1248–1257), Nos 420–429 by Neilson & Co. (maker's Nos 1151–1160), Nos 430–439 by R. & W. Hawthorn (makers' Nos 1258–1267), all in the year 1865: and Nos 440–449 by Neilson & Co. (makers' Nos 1171–1180), Nos 450–455 by the Vulcan Foundry Co. (maker's Nos 554–559), Nos 456–460 by the Avonside Engine Co. (maker's Nos 620–624), and Nos 461–469 by R. & W. Hawthorn (maker's Nos 1325–1333), all in 1866. The leading dimensions of Nos 450–455 were: cylinders 16 x 24 inches; coupled wheels 5 feet diameter, distributed equally over a 15 feet 6 inches wheelbase; boiler barrel 9 feet 10 inches long, 4 feet 2 inches diameter, containing 180 tubes of 2-inch diameter; heating surface: firebox 112.96 sq. ft, tubes 969.3 sq. ft; total 1,082.26 sq. ft; grate area 23.58 sq. ft.

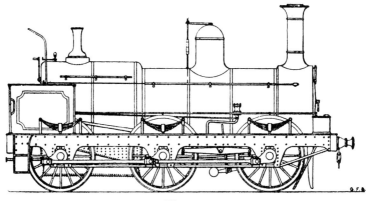

Fig. 30.

Before the whole of these goods engines were delivered, however, it was discovered that, while the steam tenders might be considered a mechanical success, they were scarcely so satisfactory from an economic point of view. It was found that engines provided with them could haul trains which were largely in excess of the requirements of the time, and which, moreover, were of such a length as to be extremely unwieldy in handling; and this was, naturally enough, a serious difficulty on a line on which there exists a frequent necessity to shunt goods trains in order to clear the way for express traffic. It was also found that the repairs bill for these engines and tenders reached an uncomfortably high figure, though there can be little doubt that this result was greatly contributed to by the carelessness of the men in charge, who viewed the question from their own standpoint, and could indeed hardly be expected to regard otherwise than with considerable disfavour an arrangement which gave them an additional 'engine' to superintend. As a consequence of these disadvantageous experiences, it was decided to stop the output of steam tender engines, and orders were given to the makers that those engines still building were to be stripped of the steam gear of the tenders prior to delivery. At the time of this decision fifty of these steam tenders were on the line, but within a few years the entire lot were improved out of existence by Sturrock's successor, and the engines rebuilt with larger cylinders.

Early in 1866 a need arose for new engine power in order to deal with the growing goods traffic between the over-ground railway at King's Cross and the goods yards round about Farringdon Street and Blackfriars, which necessitates a large amount of tunnel work on a road having gradients of 1 in 35 and 1 in 39. Accordingly, two very powerful engines were obtained from the Avonside Engine Co., of Bristol, one of which was put to work early in 1866 and the other a few months later. They were numbered in the railway company's books as Nos 472 and 473, and No. 472 bore upon it the maker's No. 633. These two engines were in general design and leading dimensions almost exactly similar to two previously supplied to the Vale of Neath Railway, and were, as can be seen in *Fig. 31* – which is an illustration of No. 472 – side-tank locomotives with eight-coupled wheels and outside cylinders. The wheels were

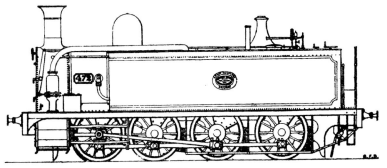

Fig. 31.

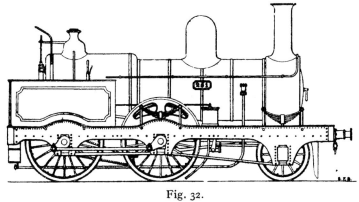

Fig. 32.

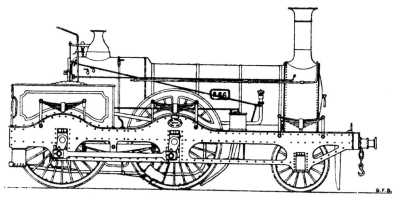

Fig. 33.

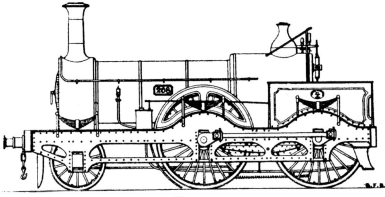

Fig. 34.

4 feet 6 inches in diameter, and were distributed over a wheelbase of 15 feet 10 inches, the spacings being 4 feet 10 inches, 5 feet 5 inches, and 5 feet 7 inches respectively, starting from the leading end. Both leading and trailing wheels were allowed a transverse play of ⅝ inches, subject to the control of an arrangement of check springs patented by Slaughter & Caillet. The cylinders drove the third pair of wheels, as can be seen from the illustration, and they were of somewhat unusual size, having a diameter of 18½ inches and a stroke of 24 inches, thus allowing of the exertion of considerable tractive force – 152 lbs for every lb of effective steam pressure. A boiler of ample dimensions, the barrel measuring 13 feet 8½ inches in length and 4 feet 4 inches in diameter, and containing 184 tubes each 2½ inches in diameter, produced a total heating surface of 1,550.1 sq. ft, of which 100 sq. ft were contributed by the firebox and the remaining 1,450.1 sq. ft by the tubes. It will be noted that provision was made for the condensation of steam in working through the tunnels, and that the side-tanks were of unusual size. Each engine weighed a total of 56 tons in working order, which was so equally divided over the four pairs of wheels that the load on the rails under no one wheel greatly exceeded 7 tons. Both engines were broken up in 1880.

In 1866 ten powerful locomotives, of the four-coupled passenger class, were delivered to the railway by Sharp, Stewart & Co., which received the Company's Nos 251–260 (maker's Nos 1667–1676). These were in many respects similar in detail to the large single-wheel engines built by the firm six years earlier, having 'hoops' on the crank-axle webs, unusually large fireboxes, and leading wheels placed well forward. They had one feature, however, distinct from their predecessors, in the form of a big steam dome on the centre of the boiler barrel. The illustration *Fig. 32* shows No. 251, will afford a general idea of their appearance. The leading dimensions were: diameter of leading wheels 4 feet and of four-coupled wheels 6 feet; wheelbase: leading to driving wheel centres 9 feet 7 inches, driving to trailing wheel centres 7 feet 6 inches, total 17 feet 1 inch; total length over buffer-beams 25 feet 7 inches; cylinders 16½ x 22 inches; boiler barrel, length 10 feet, diameter 4 feet, containing 157 tubes of 2 inch diameter; length of firebox casing 7 feet 2 inches; weight (empty) 33 tons 14 cwt, in working order 36 tons 4 cwt; capacity of tender 2,400 gallons. All these engines were subsequently

rebuilt by Stirling, and performed useful work for many years. They are now all broken up, with the exception of No. 258.

But the engines just mentioned, handsome though they were, and powerful too, were scarcely 'out' before they were eclipsed by engines handsomer and more powerful. These six later comers were the last passenger engines designed by Sturrock for the GNR, and, indeed, before they were put into actual service their designer had practically ceased his connection with the locomotive department of the line. They were numbered from 264–269, Nos 264–266 being built by John Fowler & Co. (maker's Nos 747–749), in 1866; and Nos 267–269 by the Yorkshire Engine Co. (maker's Nos 1–3), in 1867. *Fig. 33* shows the leading features of the first three, the chief dimensions being: diameter of leading wheels 4 feet 3 inches, and of four-coupled wheels 7 feet; wheelbase: from leading to driving wheel centres 9 feet 7 inches, and from driving to trailing wheel centres 8 feet 6 inches; total wheelbase 18 feet 1 inch; cylinders 17 x 24 inches; boiler barrel, length 10 feet 1 inch, diameter inside smallest ring 3 feet 10 inches, containing 167 tubes of 2-inch diameter: heating surface: firebox 121 sq. feet, tubes 907 sq. ft, total 1,028 sq. ft; grate area 19.7 sq. ft; capacity of tender 2,500 gallons. The other three engines, built by the Yorkshire Engine Co., differed slightly in external appearance from their predecessors, as can be seen from *Fig. 34*, which shows No. 268, and it is possible that to some small degree the dimensions were also different, but in the main it may be taken that the figures already given apply to both sets of engines. These locomotives did not enjoy a very long career in their original form, however, for, as will be more particularly noted later on, Stirling took an early opportunity to rebuild them, and in the process converted them into single engines with flush-topped boilers. In this new form they entered on quite a new lease of life, and for many years they were ranked among the most useful engines on the line. They are now nearly all broken up.

Two remarkably 'pretty' little six-coupled tank engines were taken over by the GNR from the West Yorkshire Railway. These were built, in 1867, by Manning, Wardle & Co., of Leeds. They received the company's Nos 470 and 471 (maker's Nos 250 and 251), and the former also bore on its side-tanks the name *Marquis*, being apparently

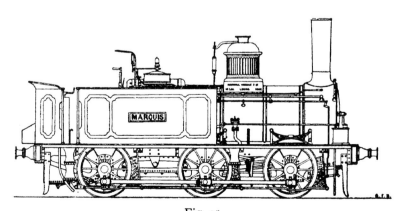

Fig. 35.

the only engine on the line which had the distinguishing feature of a name. This name had been conferred on it prior to its delivery to the railway. *Marquis* is shown in *Fig. 35.* Though a set of large-scale drawings which were published in Zerah Colburn's *Locomotive Engineering* give different measurements from those contained in the letter-press, the following are generally taken to be the correct dimensions of these engines: diameter of driving wheels 4 feet 2 inches; total wheelbase 15 feet 3 inches; cylinders 15 x 22 inches; total heating surface 782.5 sq. ft; grate area 10.75 sq. ft; total weight, empty 22½ tons; in working order 27 tons. In addition to the side tanks there was a well-tank below the foot-plate, the three together containing a total of 831 gallons. These two engines were generally typical of a considerable number brought out at about the same time by the makers, several of which were employed on Welsh railways, while others went to large ironworks, collieries and similar establishments, where their handiness and power would prove extremely desirable. No. 470 was stationed at Bradford, and No. 471 at Leeds, and in 1872 both were rebuilt as saddle tanks, though retaining the same frames, wheels, etc.

From the West Yorkshire Company were also obtained three engines, which were allotted GNR Nos 261–263. Of these, No. 261 was said to be a Sharp single, which had originally been built for the East Lancashire Railway. Nos 262 and 263 were also passenger engines, of Wilson's build, with four-coupled wheels 5 feet 6 inches in diameter and double frames. They were, therefore, probably not unlike No. 216, already illustrated.

In December, 1866, a new epoch was marked in the history of the GNR by the retirement of Mr Sturrock from the post of locomotive engineer, after a praiseworthy reign lasting upwards of sixteen years.

Opposite page:
No. 708, a Stirling 2-4-0 which is also shown in the drawing, *Fig.75* on page 85. *(CMcC)*
No. 22, Works No. 120, is a G-class 4-2-2 built in 1874. *(TH)*
No. 548, Works No. 240, from 1878. *(CMcC)*

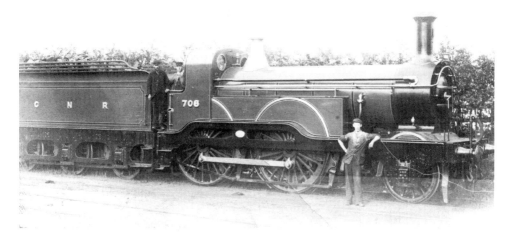

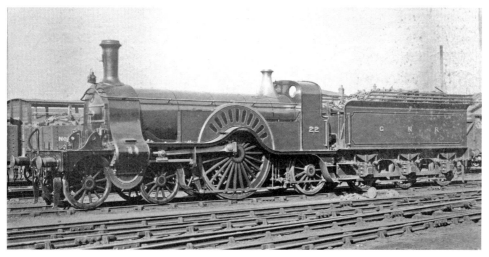

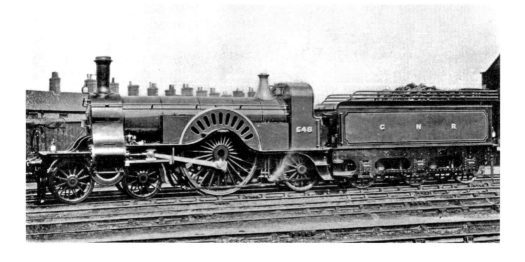

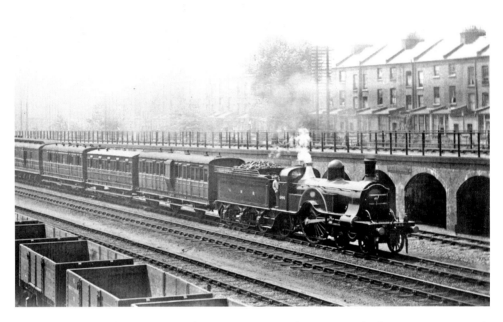

Two G-class 4-2-2 locomotives: *Above,* No. 544, Works No. 230, built in 1877, *(TH)* and, *below*, the earliest of the class, No. 3, Works No. 82, which was built in 1872. *(CMcC)*

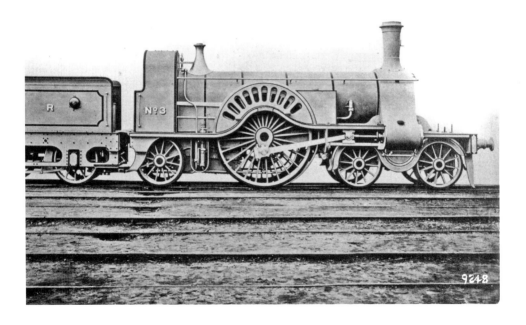

3

Patrick Stirling, 1866–1872

Archibald Sturrock's successor on the line was Patrick Stirling, at that time forty-six years of age. Mr Stirling was born at Kilmarnock in 1820, and at the age of seventeen began a five years' apprenticeship at the Dundee Foundry. After serving his full period, he remained at the same works for a year as journeyman, and in 1843 left to enter into employment at the Vulcan Foundry, Warrington. From there, after a short stay, he obtained the post of foreman at the works Neilson & Co., of Glasgow, where he undoubtedly received much valuable experience, which stood him in good stead in later years. Fresh from Neilson's, he became locomotive superintendent of the Bowling & Balloch Railway – a small concern perhaps, but still another stepping-stone onwards and upwards. His next move was something in the nature of a divergence, for he quitted the railway to work with the shipbuilding firm of Laurance Hill, Port Glasgow; but subsequently he went as foreman to R. & W. Hawthorn, thus returning by degrees to his proper sphere. After eighteen months' employment with the Newcastle firm, in 1853 he once more took over the duties of a locomotive superintendent, this time on no less important a line than the Glasgow & South-Western Railway; and now he was able to show a direct contradiction to the usual application of the proverb anent a 'rolling stone'. He had, in fact, gathered sufficient 'moss, in the shape of a varied experience and sound judgment arising therefrom, to occupy his new position with honour until 1866, when the vacancy on the GNR was offered to him, and he transferred his services from the Glasgow & South-Western, on which he had controlled the locomotive department for thirteen years, to the English line. As successor to Sturrock he held this, his last appointment, for not quite twenty-nine years. On 11 November, 1895, he was, while still practically in 'full harness', removed from the scene of his labours by death, being then in the seventy-six years old.

On assuming the reins of government in the locomotive department, in succession to Sturrock, Stirling at once set about the task of bringing the engine power of the line up to the requirements of the rapidly-increasing traffic. His first order was for twenty four-coupled passenger locomotives, which were delivered on the railway in the following order:

Date	Engine Nos	Builder	Builder's Nos
1867	280–285	Avonside Engine Co.	725–730
1868	286–289	Avonside Engine Co.	731–734
1868	290–299	Yorkshire Engine Co.	54–63

The leading dimensions were: cylinders 17 inches in diameter by 24-inch stroke; diameter of leading wheels 4 feet 1 inch, and of coupled wheels 6 feet 7 inches; wheelbase: leading to driving wheels 9 feet 6 inches, driving to trailing 8 feet 3 inches; total 17 feet 9 inches; boiler 3 feet 10½ inches in diameter, with its centre 6 feet 11 inches above the rails; inside firebox 4 feet 8¾ inches long by 3 feet 4½ inches wide by 4 feet 10 inches deep; 206 tubes of 1¾ inches diameter; heating surface: firebox 94 sq. ft, tubes 991½ sq. ft, total 1,085½ sq. ft. The weight of No. 295 is given as – empty 32 tons 6 cwt; in working order, 34 tons 9 cwt 3 qrs, of which the distribution was as follows: leading wheels 10 tons 11 cwt 3 qrs; driving wheels 11 tons 11 cwt; trailing wheels 12 tons 7 cwt. Another set of weights, applying particularly to No. 289, giving a total of 37 tons 4 cwt, distributed as follows: leading wheels 11 tons 3 cwt; driving wheels 13 tons 5 cwt; and trailing wheels 12 tons 16 cwt, probably denotes a later period of the engines' history, after they had been partially rebuilt and supplied with larger boilers; and to the same extent it must be understood that *Fig. 36* does not claim to depict No. 281 actually as she was when originally built, though it is sufficiently indicative of the general characteristics of the class. In rebuilding, Stirling modified sundry details to the standard patterns shown in the drawing, and effected minor alterations, which will be referred to in clue course. These engines are noteworthy on more than one account. Not only were they Stirling's maiden production in his new sphere of office, but they served also to mark the dividing line between the old and the new practice of the railway. Hitherto all passenger engines on the GNR had been designed with double frames giving outside bearings to all the axles; many if not all, had been fitted with boilers having raised firebox casings, many also had carried steam domes on the boiler barrels, and, above all, there had been no marked uniformity of design, and certainly no attempt at reducing the stock to a few well-chosen types. This latter point is distinctly apparent in a glance at the illustrations,

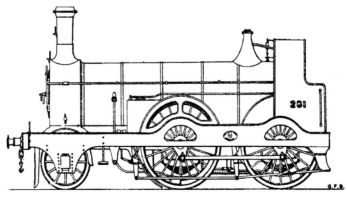

Fig. 36.

already given, of Sturrock's engines. Stirling, on the other hand, at once began to exercise a firm, controlling hand over the entire stock, and to impress the stamp of one fixed design on every engine that he placed upon the metals, so that, no matter by whom any locomotive was built, there was no longer occasion to pick out the lettering of the tender in order to determine to what line a GNR engine belonged. No great length of time elapsed therefore, after his taking command, before the locomotive stock assumed a vastly improved appearance as regards uniformity of style, and that style the neatest and least ostentatious of any in the United Kingdom or elsewhere.

The distinctive features which Stirling introduced upon the locomotives of which he had charge, and which appeared first upon all engines which he himself designed, and afterwards, so far as was possible, on all rebuilds or renewals of his predecessor's engines, were chiefly the following: he decided that all six-wheeled express passenger locomotives should henceforth have inside bearings only for the driving or driving and coupled wheels, as the case might be, and outside bearings only for the smaller carrying wheels. For goods, mixed traffic and tank engines he adopted inside frames and axle-bearings throughout, reinforcing the running and foot plates by means of a deep angle iron outside the wheels, extending from one buffer beam to the other. In place of the various types of boiler hitherto in us e he adopted one distinctive pattern with slightly varying dimensions to suit different classes of locomotives – having three telescopic rings, with the firebox casing fitting over the largest one. Externally the result was a flush-topped boiler having at the leading end a smokebox of great neatness by reason of his system of providing it with a light covering with counter-sunk rivets. Once for all Stirling discarded a steam-dome, substituting for it a perforated pipe running the whole length of the boiler, and having the regulator fitted inside the smoke-box. A chimney of distinctive design, and a handsome brass casing for the safety-valves, placed rather to the rear of the centreline of the firebox, were the only projections along the top of the boiler during the many years of Stirling's reign. Over the footplate he provided a much-needed cab for the enginemen, and this also, after a short tentative use of a trial pattern, soon became standardized. As time went on the locomotives to be built were still further brought to the pitch of economic perfection by the introduction of standard types designed on the interchangeable system. The same size of boiler was adopted for various classes, details of the cylinders and motion became common to several different types, and so on throughout the whole gamut of design. And with all these improvements came an almost painful degree of neatness of appearance. The open-work splashers, which Stirling affected in what may be termed his youth, had their openings gradually blocked in, while newer engines simply had plain semi-circular sheets above the running plate, with a polished brass rim running round the outer edge. No rod communicating between the footplate and any of the mechanism in front of the cab was allowed to be in sight if it could possibly be concealed behind the frames, the bearing springs were generally placed quite out of sight, and the two sand-boxes on either side of the driving wheels, which were soon adopted, still further served to give an air of simplicity and neatness to the whole machine.

So far for the general lines of Stirling's practice. But, shortly after his succession to Mr Sturrock, the making of a new epoch came about in another respect. As has been shown, all

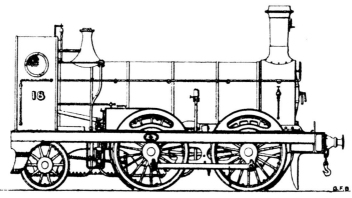

Fig. 37.

locomotives hitherto built for the GNR had been obtained from 'outside' firms. The new locomotive superintendent, however, speedily put matters into such a condition that the Company was able to build engines at its own works at Doncaster. Three locomotives were produced from these new shops towards the close of the year 1867, and since that date, while a certain number of engines have still from time to time been supplied by outside firms, the greater portion of the stock has been turned out from Doncaster Works, the number at the time of writing having attained nearly to the respectable total of 1,000.

Doncaster No.1 engine was as already mentioned, delivered on the rails at the latter end of 1867, and was fittingly enough the pioneer of a new type. It was specially designed by Stirling for working 'mixed' traffic, ranging from heavy excursion to fast goods work, and for this the class has proved to be of such great utility that 153 locomotives of this type were eventually put to work. Engines of this type run most of the fast passenger train services in the West Riding division of the line. As can be seen from the accompanying illustration, which shows the first of the class, these 'mixed' engines ran on six wheels, of which the leading and driving pairs were coupled, while a small pair of independent wheels under the cab bore the weight of the trailing encl. *Fig. 37*, however, represents only the first three of the series in actual details, these being the three engines built at Doncaster in 1867,

It will be noted that the square-sided cab with a circular window was the trial pattern first adopted by Stirling, which subsequently was replaced by the more familiar design already shown in the preceding figure. No. 18 and the two immediately following were distinguished from later editions by having only one large opening in each splasher, instead of two of the type shown in *Fig. 36*, and also by having a black beading round the splasher instead of the one of polished brass subsequently adopted. The leading dimensions of the first engines of this new class were: cylinders 17 inches in diameter with a 24-inch stroke; diameter of coupled wheels 5 feet 7 inches, and of trailing wheels 3 feet 7 inches; wheelbase: leading to driving axle 7 feet 3 inches, driving to trailing axle 7 feet 11 inches, total 15 feet 2 inches; overhang of frame at leading end 4 feet 10½ inches, and at trailing end 2 feet 7 inches; boiler barrel: length 10 feet; diameter outside smallest ring 3 feet 10½ inches; height of centre above rails 7 feet; firebox

casing: length 5 feet 6 inches, depth at front 5 feet 1 inch, and at back 4 feet 7 inches; heating surface: firebox 100 sq. ft, tubes 975 sq. ft., total 1,075 sq. ft; grate area 16.25 sq. ft; total weight in working order 31 tons 18 cwt, distributed as follows: leading wheels 11 tons 14 cwt., driving wheels 14 tons, and trailing wheels 6 tons 4 cwt.

The first series of these useful engines consisted of forty-six, which were built in the years from 1867–1874 inclusive, with the following works and running numbers:

Date	Doncaster No.	Engine No.	Date	Doncaster No.	Engine No.
1867	1	18	1870	54	65
1867	2	23	1870	57	200
1867	3	40	1870	58	35
1868	12	44	1870	59	64
1868	15	49	1871	63	85
1868	16	9	1871	67	32
1868	17	38	1871	70	30
1868	19	218	1871	72	203
1868	20	220	1871	173	68
1869	22	76	1871	76	83
1869	23	205	1872	81	46
1869	24	11	1872	85	13
1869	25	31	1872	87	52
1869	28	19	1872	90	71
1869	33	17	1872	91	75
1869	35	82	1873	98	16
1869	39	27	1873	99	50
1870	42	56	1873	106	508
1870	43	54	1873	109	509
1870	45	58	1873	112	77
1870	47	59	1873	114	81
1870	52	15	1874	124	73
1870	53	25	1874	126	219

Stirling's next design was for a six-coupled goods engine, and here again he at once fixed upon a standard pattern which, with a few trifling modifications of detail, and an increase in dimensions and power, was subsequently repeated without further revision, until at the present time nearly 300 of his goods engines are in use on the line. Those first delivered consisted of twenty locomotives built by outside firms:

Date	Engine Nos	Builders	Builder's Nos
1867	474–478	John Fowler & Co.	871–875
1868	479–483	John Fowler & Co.	876–880
1867	484–493	Neilson & Co.	1356–1365

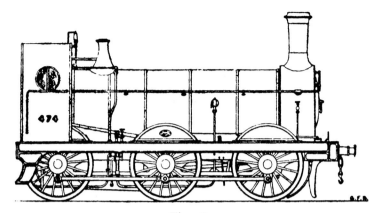

Fig. 38.

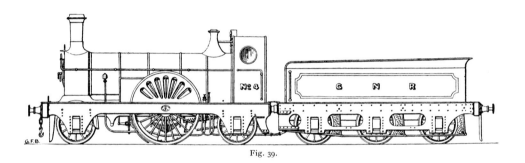

Fig. 39.

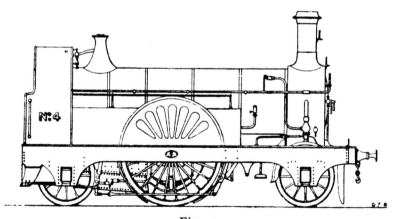

Fig. 40.

In the illustration of No. 474, *Fig. 38*, are seen the leading features of this class of engine, including the inside cylinders, inside frames and axle bearings, and the deep angle iron running from buffer beam to buffer beam outside the wheels. The cab shown was the pattern first tried by Stirling, and was fitted to all the earlier engines of his design; but in 1869 or 1870 he modified it into the shape more generally associated with GNR locomotives, which has already once been shown in *Fig. 36*, and is further abundantly illustrated in those drawings subsequently to be reproduced in dealing with Stirling's term of office. Of these early goods locomotives the chief dimensions are comprised as follows: cylinders 17 x 24 inches; diameter of six-coupled wheels 5 feet 1 inch; wheelbase: leading to driving 7 feet 3 inches, driving to trailing 8 feet 3 inches, total 15 feet 6 inches; boiler barrel 10 feet in length, with a diameter outside the smallest ring of 3 feet 10½ inches, containing 206 tubes each 1¾ inches in diameter; heating surface: firebox 94.25 sq. ft, tubes 985.5 sq. ft, total 1,079.75 sq. ft; total weight in working order 32 tons 11 cwt. The trailing springs consisted of six volute springs arranged in two wrought-iron troughs placed transversely, one of which was secured to the frames below the footplate, while the other took its seating at each end on the tops of the axleboxes.

From the first Stirling held very pronounced opinions in respect to the peculiar suitability of single driving wheels for the conduct of express passenger traffic, holding that while a single pair of driving wheels could be made to furnish ample adhesion, there could be no doubt as to the superiority in freedom and economy which would result from the abolition of the usual coupling with a second pair of wheels. Accordingly it is not surprising to find that he had been but a few months at the head of the locomotive department before he designed a new type of engine embodying his favourite theory. This type consisted originally of twelve engines, all turned out at the Doncaster works of the GNR during the years 1868 to 1870, with odd numbers, the full list being given below:

Date	Doncaster No.	Engine No.
1868	4	6
1868	5	222
1868	6	41
1868	8	4
1868	9	21
1868	11	14
1869	26	55
1869	27	61
1869	32	63
1869	34	215
1870	48	37
1870	51	39

As can be seen from *Fig. 39*, which shows them as originally built, these engines were in their main design virtually enlarged copies of the famous 'Jenny Lind,' having inside bearings only to the driving wheels and outside bearings only to the leading and trailing

wheels. The earlier engines of the class had the square cab first employed by Stirling, and ordinary spring lever safety valves; but these, together with the later ones, were subsequently modified in this respect, receiving the standard GNR cab and Ramsbottom's valves inside a brass valve casing, as is shown in the second illustration, *Fig. 40*, which shows No. 4 as supplied with a new boiler and brake fittings, with other alterations in external appearance that need no special reference. According to official statements of the period, the leading dimensions of these fine engines were: cylinders 17 x 24 inches; diameter of driving wheels 7 feet 1 inch, and of leading and trailing wheels 4 feet 1 inch; wheelbase: from leading to driving wheel centres 9 feet 6 inches, from driving to trailing wheel centres 7 feet 6 inches, total 17 feet; total length of frame plates 23 feet 3½ inches, with an overhang in front of 3 feet 0½ inches, and at back of 3 feet 3 inches; height of top of frame above rail level 4 feet 2 inches; boiler barrel: length 10 feet 2 inches, diameter outside smallest ring 3 feet 10½ inches, height of centre above rails 7 feet 2 inches, containing 192 tubes each measuring 10 feet 5⅞ inches between tube plates, with a diameter of 1¾ inches; length of firebox casing 5 feet 6 inches, distant from driving wheel centre 1 foot 10⅝ inches; inside fire-box 4 feet 10 inches long at bottom and 3 feet 4½ inches wide at bottom, with an average height above the grate of 4 feet 6¼ inches; boiler pressure 130 lbs per sq. in; heating surface: firebox 89.5 sq. ft, tubes 922.25 sq. ft, total 1,011.75 sq. ft, grate area 16.4 sq. ft. Total weight in working order 33 tons, distributed as follows: Leading wheels 10 tons 8 cwt, driving wheels 14 tons, trailing wheels 8 tons, 12 cwt; weight empty 30 tons 5 cwt. The capacity of the tender was 2,500 gallons of water. It should be noted that the cylinders, which originally provided a tractive force of only 82.57 lbs per lb of effective steam pressure, were subsequently replaced by new ones of 17½-inch diameter. One engine differed from the rest by being fitted with 192 tubes of the small diameter of 1⁹⁄₁₆ inch still placed at the same pitch, from centre to centre, as the larger ones. Stirling found this boiler quite as efficient as the others, and the innovation bore fruit ultimately in designing the boilers of the 8-foot bogie engines, of which an extended mention will be made in due course.

The next new type introduced by Stirling consisted of a class of six-coupled saddle tank locomotives similar in general appearance to his tender goods engines, but of slightly smaller dimensions throughout. These engines were eight in number, and were built in the following order:

Date	Doncaster No.	Engine No.	Date	Doncaster No.	Engine No.
1868	7	392	1871	64	395
1868	10	124	1871	65	398
1868	13	162	1872	95	166
1869	37	396	1873	96	167

No. 392 had inside cylinders 17 inches in diameter with a stroke of 24 inches, and six-coupled wheels 5 feet 1 inch in diameter, the distance apart of the centres being: leading and driving 7 feet 3 inches, and driving and trailing 7 feet 6 inches, respectively, thus giving a total wheelbase of 14 feet 9 inches. The frame plates measured 23 feet 9½ inches from end to end, giving an overhang at the leading end of 4 feet 7½ inches, and

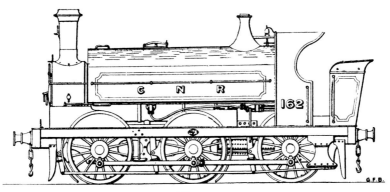

Fig. 41.

at the trailing end of 4 feet 5 inches. With a length of 10 feet 2 inches, and a diameter outside the largest ring of 3 feet 9 inches, the boiler barrel contained only 90 tubes, each of 2-inch diameter outside. The firebox shell was 4 feet 7 inches in length, and the centre of the boiler was pitched 6 feet 10½ inches above the rail level. Extending over the length of boiler and firebox was a saddle tank having a capacity of 975 gallons of water, while the coal was carried in a comparatively small bunker at the trailing end. *Fig. 41* shows the general external appearance of this class of engine.

For working the underground traffic it was soon found necessary to provide further engine power, but at first Stirling did not make any considerable change on the approved designs of his predecessor. Indeed, his earlier engines built for that service were of the same general type as those introduced by Sturrock in 1865 and 1866, being six-wheeled well-tank engines having four-coupled driving wheels under the barrel of the boiler, and an independent pair of trailing wheels, placed well back and fitted with radial axleboxes, to carry the tank and bunker. As can be seen from *Fig. 42*, which shows No. 119, the latest of the type, the principal change of design consisted in placing the main frames, and consequently the bearings of all four driving wheels, inside the wheels, this arrangement giving greater compactness to the appearance. The cylinders were 17½ inches in diameter with a stroke of 24 inches, and drove two pairs of wheels coupled in front, each 5 feet 7 inches in diameter, and placed with the axle centres 7 feet 3 inches apart. The total wheelbase measured 20 feet 3 inches, the trailing wheels, 4 feet 1 inch in diameter, being placed 13 feet in rear of the driving axle. Over all, the frame plates were 28 feet 11 inches in length, with an overhang of 5 feet 3½ inches at the leading end, and 3 feet 4½ inches at the trailing end. The boiler barrel was pitched at a height of 7 foot above the rails, and measured 10 feet in length, with a diameter outside the smallest ring of 3 feet 10½ inches, and the lire-box shell was 4 feet 10 inches long, with a depth below the centre line of the boiler of 5 feet 1 inch in front, and 4 feet 7 inches at back. A total heating surface of 917.5 sq. ft was provided in the following proportions: firebox 100 sq. ft, tubes 817.5 sq. ft, while the grate area was 14 sq. ft. At the trailing end was situated a well-tank having a capacity of 1,000 gallons, and a bunker to hold 30 cwt of coal. In working order, engines of this class weighed a total of 41 tons 13 cwt, distributed as follows: leading wheels 11 tons 16 cwt, driving wheels 14 tons 12

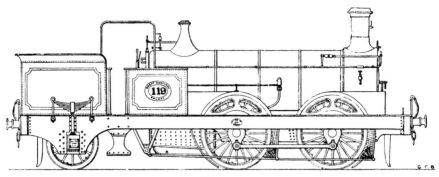

Fig. 42.

cwt, and trailing wheels 15 tons 5 cwt. To work through the tunnels an arrangement was provided for condensing on all engines of this class except the two first built, and to the same end the chimney was reduced in height, so that it had a clear height above the rail level of only 12 feet 7 inches. The class consisted altogether of thirteen engines built at Doncaster in the following order:

Date	Doncaster No.	Engine No.	Date	Doncaster No.	Engine No.
1868	14	126	1870	55	122
1868	18	127	1870	60	132
1869	21	125	1871	68	116
1869	30	123	1871	69	118
1869	31	131	1871	75	117
1869	40	129	1871	78	119
1870	46	121			

As is mentioned above, Nos 126 and 127 were not supplied with condensing apparatus, and these two engines were put to work in the West Riding division.

Next in order of issue from the Doncaster works came seventeen goods engines of practically identical dimensions with the No. 474 class already described and illustrated, with 17 x 24-inch cylinders, and six-coupled wheels of 5 feet 1 inch diameter. These were delivered in the following series:

Date	Doncaster No.	Engine No.	Date	Doncaster No.	Engine No.
1869	29	369	1872	86	86
1869	36	377	1872	88	197
1869	38	184	1873	100	151
1870	41	169	1873	104	152
1870	44	380	1873	111	186
1870	56	190	1873	113	171
1870	62	366	1873	115	193
1872	80	148	1873	116	193
1872	84	311			

Without repeating the detailed dimensions of this class of goods, it may be mentioned that the boiler barrel of the Doncaster-built engines was pitched with its centre 6 feet 10 inches above the rails, and that the angle of inclination of the cylinders in this type and in all front-coupled engines designed by Stirling was 1 in 8¾. Furthermore, it may be remarked for those that take interest in such matters, that in addition to the first three engines built at the company's works, all these early goods engines and the coupled passenger engines built 'outside', of the 280 class, originally had black beading round the splasher rims, which was in most cases afterwards changed to the standard brass beading subsequently adopted on all Stirling's engines.

At the period now reached by this history Sturrock's fine bogie engine, No. 215, was withdrawn from service after a long and distinctly honourable career, and was for the most part condemned to the scrap heap. The driving wheels, however, were too good to break up, and with these in hand Stirling built a new engine, also the only one of its class, the date and Doncaster number being:

Date	Doncaster No.	Engine No.
1870	49	92

Fig. 43, shows No. 92 to have been simply an enlarged example of the single-wheel engine already introduced by Stirling, the leading dimensions being: diameter of driving wheels with new tyres 7 feet 7 inches, and of leading and trailing wheels 4 feet 1 inch; wheelbase: from leading to driving wheel centres 9 feet 9 inches, from driving to trailing wheel centres 7 feet 9 inches, total wheelbase 17 feet 6 inches; total length of frame-plate 23 feet 9½ inches, of which 3 feet 0½ inches overhung at the leading end, and 3 feet 3 inches at the trailing end; height of top of frame above rail level 4 feet 2 inches; cylinders 17½ inches by 24 inches; boiler barrel: length 10 feet 6 inches, diameter outside smallest ring 3 feet 10½ inches, height of centre above rails 7 feet 4 inches, containing 192 tubes of 1¾ inches diameter; length of firebox casing 5 feet 6 inches, distance from centre of driving axle 1 foot 11⅝ inches; working pressure of boiler 130 lbs; grate area 16.4 sq. ft; total weight in working order 33 tons 12 cwt,

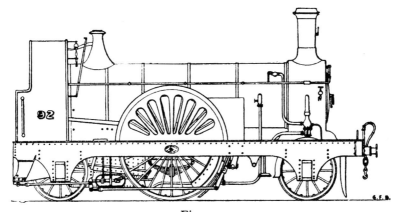

Fig. 43.

distributed as follows: leading wheels 10 tons 1 cwt, driving wheels 14 tons 16 cwt, and trailing wheels 8 tons 15 cwt. The success attending the introduction of this large engine led eventually to the building of a number of still more powerful engines of a similar general design, some sixteen years later, as will be seen in due course. No. 92 is now in the 'A' class, a new engine bearing the same number having been built recently by Ivatt.

There now came a period in the history of the GNR when the rapid increase in speed and in the weight of the trains required to maintain express service began to constitute a serious problem for the locomotive engineer. The coupled and single-wheel engines so far in existence were being taxed practically to the utmost limits of their power, and with still a steady increase of traffic it became necessary to design not only more engines, but more powerful engines than any hitherto put into service. As has already been mentioned, Stirling was ever a consistent advocate of no more than a single pair of driving wheels being employed for really fast work, the only apparent drawback being, of course, a relatively small adhesive power. This drawback, however, he considered to be largely exaggerated in importance, and for some little time he kept careful observation of the comparative working of the 7 feet single and 6½ feet coupled engines which he had already placed on the line, both classes having 17 x 24-inch cylinders, and being for all practical purposes of equal boiler power. The result confirmed his theories in a convincing manner, for he found that with trains of equal weight the single-wheel engine had 'the best of it'. In fact, the 7-foot singles generally beat the smaller coupled engines, in point of time, over such an exceptional test road as that from King's Cross to Potter's Bar, a distance of 12¾ miles, nearly all uphill, with gradients varying from 1 in 105 for two miles to 1 in 200.

Finding that sufficient adhesion could be obtained from a single pair of driving wheels, Stirling accordingly set to work to design a larger and more powerful engine than the 7-foot class, and selected as the basis of his calculations driving wheels having the unusual diameter of 8 feet, being satisfied, as he subsequently explained, that 'the larger the wheels the greater the adhesion to the rails'. Without pitching the boiler at a height which at that time would have been considered excessive, he found it impossible to clear the 14-inch cranks which were contemplated, so he had no alternative but to place the cylinders outside the frames. Again, he decided to lay them in a horizontal line with the driving wheel centres, to obviate the disadvantages of inclined outside cylinders, and this position, with the great overhang that it caused, and the considerable

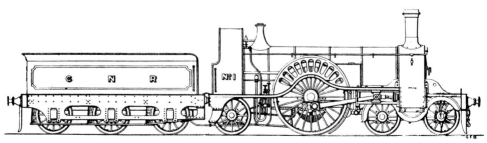

Fig. 44.

disturbance of weight resulting therefrom, which would have unduly loaded a single axle at the leading end, caused him to adopt a bogie with the axles sufficiently spread apart to allow the cylinders to be placed between the two sets of wheels. Considerable prominence is given to this chain of reasoning, which seems to have been that followed out by Stirling, in order to combat the theory sometimes put forward that Sturrock's No. 215 was the direct inspiration from which Stirling's No. 1 was derived. When it is remembered that Stirling never adopted the bogie for any class of express engine but this, preferring rather a rigid wheelbase of 19 feet 1 inch on his later single-wheeled locomotives, it is only reasonable to assume that his employment of the bogie was actuated by force of circumstances rather than by imitation of any previous design, to the same degree that he found it necessary in this case also to make a radical departure from his otherwise invariable practice of placing the cylinders between the frame-plates.

These engines, fifty-three altogether, were all built at Doncaster, the first to be turned out being appropriately enough allotted No. 1, thus displacing the 'Little Sharp' of 1847. No. 1 is shown in the illustration, *Fig. 44*, as originally built in the early part of 1870, being, as can be seen, an eight-wheeled locomotive having outside cylinders, inside frames and axle bearings, a leading four-wheeled bogie, a single pair of driving wheels, and a smaller pair of independent trailing wheels. With regard to the bogie, it may be noted here that Stirling did not place the pivot on which it turned equidistant from the two axles; but, on the contrary, the pivot was placed 3 feet 6 inches in rear of the leading axle centre, and only 3 feet in advance of the hind axle centre. The result of this unequal spacing was twofold. Not only was the weight on the bogie wheels so distributed as to lead up by gradations to the greater weight on the driving wheels, but another effect was produced in the easing of the bogie in negotiating curves, the leading wheels making a greater transverse movement, and the hind wheels a correspondingly less transverse movement than would have ensued from a more equal spacing.

In addition to the central pivot, the bogie had side bearings under each cylinder. At the rear end the engine was carried on five volute springs arranged much in the manner described as being adopted in the goods engines built a year or two earlier. The cylinders were each held in an opening formed in the corresponding frame, which was here deepened considerably for the purpose, and the opening was secured beneath the cylinder by means of a stay made to clip the frame like a hornplate stay. As regards the boiler feed, this was delivered, as shown in the illustration, at the side of the firebox casing in all the earlier engines of the class. The internal firebox had its crown slightly rounded and was secured to the outer casing by a number of round stays, each 7/8 inches in diameter, screwed into both firebox and casing, and then riveted over on the outside. An inclined copper mid-feather was adopted in place of the customary brick arch, and to this extent enhanced the direct heating surface of the firebox.

The leading dimensions of No. 1 were as follows: diameter of bogie wheels 3 feet 11 inches, of driving wheels 8 feet 1 inch, and of trailing wheels 4 feet 1 inch; wheelbase, bogie wheel centres 6 feet 6 inches, from hind bogie wheel to driving wheel centres 7 feet 9 inches, from driving to trailing wheel centres 8 feet 8 inches, from centre of bogie pin to centre of trailing wheels 18 feet, 5 inches total wheelbase 22 feet 11 inches; total

length of frame-plates 27 feet 7 inches, the overhand being 2 feet 2 inches in front and 2 feet 6 inches at back; length outside buffer beams 28 feet 1 inch, over all 29 feet 9 inches. Cylinders 18 inches diameter, 28 inches stroke; throw of eccentrics 3¼ inches, length of eccentric rods 5 feet 10 inches, length of expansion links (curved Stephenson pattern) 1 feet 4 inches, length of connecting rods 6 feet 10 inches; diameter of blast pipe 4¾ inches. Boiler barrel (in three rings) 11 feet 5 inches long, with a diameter outside the smallest rind of 3 feet 10½ inches, height of centre-line above the rails 7 feet 1 inch, containing 217 brass tubes 11 feet 8 inches long between plates, and with an outside diameter of 1⁹⁄₁₆ inches; boiler pressure 140 lbs per sq. in; thickness of plates (Yorkshire iron) ½ inch, lap-jointed, double riveted longitudinally, single riveted vertically and circularly; the firebox casing measured 6 feet 2 inches long outside, with a width at the bottom of 3 feet 11½ inches, increasing to 4 feet 1½ inches at the centre-line of the boiler; depth below centre-line of boiler at front 5 feet 1 inch, at back 4 feet 7 inches. The internal firebox of copper had its side and crown plates ½ inch link, the back plate being increased to ⅝ inch, and the tube plate to ¾ inch; at the bottom its length was 5 feet 5 inches, diminishing to 5 feet 4½ inches at the top; the mean width was 3 feet 3 inches, and the height 5 feet 10½ inches and 5 feet 4½ inches at front and back respectively. Distance of firebox casing from driving axle centre 1 foot 9 inches, length of smokebox inside 2 feet 8¾ inches, diameter across centre-line inside 4 feet 9 inches; heating surface; firebox 122 sq. ft, tubes 1,043 sq. ft, total 1,165 sq. ft; grate area 17.6 sq. ft. The weight of No. 1 in working order was 38 tons 9 cwt, distributed as follows: leading bogie wheels 7 tons, hind bogie wheels 8 tons, driving wheels 15 tons, and trailing wheels 8 tons 9 cwt. A tender to carry 3½ tons of coal and 2,700 gallons of water, and weighing in full condition 26 tons 10 cwt, was originally supplied, the total length of engine and tender over buffers being 50 feet 2 inches; but in course of time nearly all the class were provided with larger tenders having enhanced capacities for fuel and water.

In all, as has already been mentioned, a total of fifty-three engines were built of this type between the years 1870 and 1895. But while they were all practically of the one type, and while in general design the first and last of the class, separated by an interval of more than a quarter of a century, showed no difference save in the matter of details and a certain increase in weight and power, it will be more convenient, and perhaps more correct, to divide them into three batches, the dividing line in one case being marked by a distinct increase in dimensions, while in the other the division is of a somewhat arbitrary character. This arbitrary line may be drawn at the close of the year 1882. Up to that period, and possibly a few years later still, the leading dimensions already given will apply to all the 8-foot engines, with a proviso that in respect to some few details such alterations or modifications were effected as were necessary to bring these engines into line with the practice prevailing at any given date in respect to the locomotive stock built at Doncaster. These changes will generally be noted more particularly when the remainder of the engines of this class come under notice, and for the present it is sufficient to mention one item affecting the external appearance of the engine. Up to 1881 the driving-wheel splashers were all of the perforated type shown in the illustration of No. 1. In the course of time, however, the openings were blocked

in with thin plates, and No. 664, built in the year just mentioned, was turned out with perfectly plain splashers, and with a handsome brass oval date-plate on each splasher in place of the inconspicuous one so far adopted on these engines, which had been carried on the curved running plate immediately over the driving axle. This engine was sent by the railway company to take part in the memorable Stephenson Centenary Festival of that year.

The following is a list of the dates and numbers of the 8-foot bogie engines built up to the close of 1882, thirty-seven in all, to which the description and dimensions already given more particularly apply:

Date	Doncaster No.	Engine No.	Date	Doncaster No.	Engine No.
1870	50	1	1877	232	546
1870	61	8	1877	233	547
1871	66	33	1878	340	548
1871	77	2	1878	245	549
1872	82	3	1878	247	60
1873	105	5	1878	248	550
1873	107	7	1879	281	93
1874	120	22	1880	285	95
1874	150	48	1880	303	662
1875	165	34	1881	312	663
1875	170	47	1881	320	664
1875	185	53	1881	321	665
1876	195	62	1881	323	666
1876	212	221	1881	324	667
1876	215	94	1882	341	668
1877	219	69	1882	342	669
1877	220	98	1882	349	670
1877	230	544	1882	350	671
1877	231	545			

It is to be recorded with regret that, of the above, Nos 2, 8, 33, 48, 60, 62, 69, 98, 549, 550 and 662 have recently been condemned, as is further noted in due course.

In addition to the set of twenty coupled passenger locomotives built by 'outside' firms, which have already been described as Stirling's 'maiden' design on the GNR, two were put in hand at Doncaster in the following order:

Date	Doncaster No.	Engine No.
1871	71	261
1871	74	262

These were the only two of the class built at Doncaster, for almost immediately afterwards, as will be seen later on, a newer type with greater cylinder power was brought out, which became the standard pattern for the future.

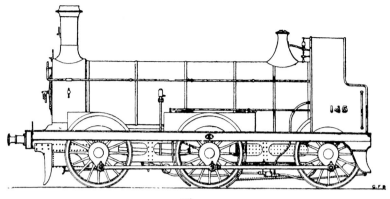

Fig. 45.

In 1871 Stirling designed and built at the Doncaster works six six-coupled engines of exceptional dimensions and power, the object he had in view in departing from his normal practice of the period being the conveyance of mineral trains between Doncaster and Peterborough by way of the loop-line through Lincoln and Boston, the distance being 100 miles and the contemplated gross load 687 tons. These engines were, in external appearance, as can be seen from *Fig. 45*, which shows one of the class, of Stirling's standard pattern, and they were built in the following order:

Date	Doncaster No.	Engine No.	Date	Doncaster No.	Engine No.
1871	79	174	1873	102	145
1872	83	376	1874	118	146
1873	97	158	1874	125	164

The cylinders were of large size, 19 inches in diameter, with a stroke of 28 inches, and were made in one casting with the valves underneath, as there was no room for them between the cylinders, and as a consequence motion was transmitted to the valve spindles by means of rocking-shafts. In order to avoid excessive inclination of the cylinders, single guide-bars were employed, placed above, so that the piston rods could be brought down as close as possible to the leading axle. Reversing was effected by means of a screw gear instead of the ordinary hand lever. The leading dimensions of these fine engines were as follows: diameter of six-coupled wheels 5 feet 1 inch; wheelbase 17 feet 7 inches. Total length of engine over buffers 28 feet 1 inch, distance between frames 4 feet 1½ inches, width outside frames 7 feet, width over footplate 7 feet 3 inches. Cylinders: 19 inches in diameter with a 28-inch stroke; distance apart of centres 2 feet 2½ inches; angle of inclination 1 in 11½; diameter of piston rods 3¼ inches; length of connecting rods 6 feet 9 inches. Boiler barrel 11 feet 4 inches in length with a diameter outside the smallest rind of 4 feet 3 inches; height of centre-line above rails 7 feet; length of internal firebox at top 5 feet 4½ inches, and at bottom 5 feet 5½ inches; width, 3 feet 4½ inches. The boiler barrel contained 232 tubes 11 feet 8 inches long, with an outside diameter of 1¾ inches, spaced at 2⅜ inch centres; heating surface: firebox 112 sq. ft, tubes 1,240 sq. ft, total 1,352 sq. ft; grate area 18.7 sq. ft.

The total weight of the engines, in road-worthy condition, was 40 tons, distributed as follows: leading wheels 14 tons, distributed as follows: leading wheels 14 tons; driving wheels 14 tons 15 cwt; and trailing wheels 11 tons 5 cwt.

These engines appear to have admirably fulfilled the purpose for which they were designed, taking loads of the figure already mentioned and running to time with great regularity on a relatively small coal consumption of about 46–47 lbs per mile. But, strange to say, Stirling had committed practically the same fault that his predecessor was guilty of when he introduced his 'steam tenders.' He had apparently overlooked the fact that there was no accommodation on the line for the shunting of a train of fifty-five wagons with an engine and tender attached, the sidings not being long enough. Accordingly, the average load had on this account to be reduced to fifty wagons or less, with an average gross load of 625 tons, and for this reduced weight a less powerful engine could be employed. Had it not been, more especially, for the double level crossing at Lincoln, which would not accommodate the extra length of train which these engines were built to work, the type would no doubt have been largely adopted; for many years they were stationed at Doncaster, but latterly Ivatt has transferred the majority of them to Ardsley, in order to work coal trains in the West Riding, where there are several severe banks of 1 in 50 to be negotiated. No. 164 was broken up in 1901, but the other five are still at work.

As was mentioned the two small tank engines built by Manning, Wardle & Co. for the West Yorkshire Railway, and subsequently taken over by the GNR, were, in 1872, passed through the Doncaster shops, and emerged rebuilt into saddle tanks while still retaining the original frames, wheels and motion.

Date	Doncaster No.	Engine No.
1872	89	471
1872	92	470

It is probable that the results of their working in this rebuilt form were instrumental in introducing a new and handy type of small-wheel saddle tank engine, which was first brought out about two years later, and will be referred to at length in due course.

The next class to make its appearance was a marked development of Stirling's early design of locomotive for working the underground suburban traffic to Moorgate Street and the South of London. While retaining the four 5 feet 7 inch driving wheels, coupled in front, this new class of engine had the trailing end carried on a four-wheeled bogie, thus constituting a much easier riding engine. At the same time the gross weight of the locomotive in full working order was actually less than that of the earlier six-wheeled type. The leading dimensions of these locomotives were as follows: cylinders 17½ inches in diameter with a stroke of 24 inches; diameter of driving wheels 5 feet 7 inches, and of bogie wheels 3 feet 1 inch; wheelbase: coupled wheels 7 feet 3 inches, driving wheels to leading bogie wheels 10 feet 3 inches, leading bogie wheels to centre of bogie pin 2 feet 3 inches, bogie pin to trailing bogie wheels 2 feet 9 inches, total wheelbase 22 feet 6 inches; over-hang of frame plates at leading end 5 feet 3 inches, and at trailing end 4 feet 3 inches from bogie pin, total length of frame plates, 27 feet.

The boiler was pitched with its centre 7 feet above the rail level, having a length of barrel of 9 feet 10 inches, and a diameter inside the smallest rind of 3 feet 9½ inches, and the firebox casing measured 4 feet 6 inches in length, with a depth below the centre line of the boiler of 5 feet 1 inch at the leading end, and 4 feet 7 inches at the back. The heating surface was: tubes 806 sq. ft, firebox 81 sq. ft, thus giving a total of 887 sq. ft. Over the bogie was a large tank and bunker having a capacity for 1,000 gallons of water and 30 cwt of coal. The total weight in working order was 40 tons 14 cwt 3 qrs, driving wheels 14 tons 14 cwt, and bogie wheels, 14 tons 10 cwt.

In all, forty-eight engines of this type were built at Doncaster between the years 1872 and 1881, their dates, works numbers and running numbers being as follows:

Date	Doncaster No.	Engine No.	Date	Doncaster No.	Engine No.
1872	93	120	1878	236	623
1872	94	128	1878	238	624
1873	198	504	1878	243	625
1873	110	505	1878	246	626
1873	117	506	1878	250	244
1874	119	510	1878	253	246
1874	123	507	1879	259	241
1874	129	511	1879	261	243
1874	131	512	1879	265	250
1874	140	513	1879	266	245
1874	144	514	1879	272	627
1874	147	515	1879	275	628
1874	152	516	1879	277	247
1874	153	517	1879	279	249
1875	173	528	1880	283	629
1875	178	529	1880	284	630
1875	184	530	1880	289	242
1875	189	531	1880	290	248
1876	194	532	1880	297	652
1876	198	533	1880	298	653
1876	203	130	1881	306	654
1876	206	159	1881	307	655
1877	234	621	1881	313	656
1878	235	622	1881	314	657

Of the list given above, however, more than one-half, from No. 621 onwards, were provided with larger tanks and bunkers at the trailing end, which also caused a corresponding increase of the total weight of the engines. The accompanying illustrations of Nos 517 and 246, *Figs. 46 and 47* respectively, show the leading external characteristics of these two classes of engine. It will be noticed that the earlier class had the number plates on the side sheets, while the later ones had them on the sides of the bunkers. Some of the earlier engines, however, among which were Nos

241, 245, 248, 507, 513, 515 and 516, were afterwards sited with larger bunkers, and then had the number plates removed to the position shown in *Fig. 47*. These engines, and those of the 126 class, together with rebuilds of Sturrock's Metropolitan engines, are only types on the GNR with brass number plates. Nos 510, 511, 513, 515, 528, 529, 531, 241–250, 621–628, 654 and 655 were fitted with condensing apparatus for working through the 'underground,' and were also provided with shorter chimneys, so as to pass the Metropolitan Railway loading gauge. The two engines, Nos 629 and 630, which are included in the foregoing list, should really be considered as a separate type, as they were of smaller dimensions than the rest, the driving wheels being only 5 feet 1 inch in diameter, and the cylinders 16 inches x 22 inches. They and the four engines built in 1881 had the closed type of splasher which subsequently replaced the perforated open pattern on all new classes of engine. It will be noticed that from 1878 these engines began to appropriate the numbers originally given to Sturrock's earlier Metropolitan passenger engines, which at about that period, or earlier, underwent a course of rebuilding and were relegated to the 'A' class, as will be seen almost directly.

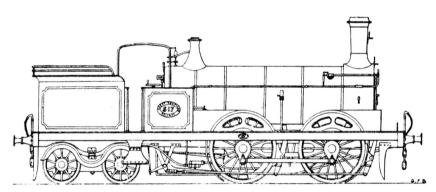

Fig. 46.

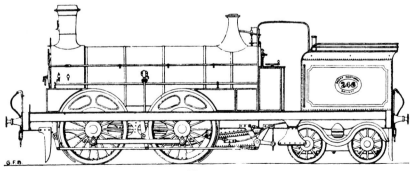

Fig. 47.

4

Stirling's Rebuilds

Reference has already been made in this history to a certain adaption of some of the earlier engines introduced by Sturrock in order to meet the more exacting requirements of a development of traffic. For the most part it is impossible to give any very detailed information on this subject, as the changes in question were made in no fixed order and in no definite degree capable of exact classification. For example, the 'little Sharps', the first passenger engines on the line, underwent several different kinds of transformation with a view to their adaptation to varying needs. A few, of which No. 9 has already been quoted and illustrated as an example, were adapted by Sturrock to work the underground traffic during a temporary stress of circumstances. Others, of which No. 23 was a well-known representative, underwent conversion, also under Sturrock's *regime*, into front coupled engines with the addition of a second pair of driving-wheels in front of the drivers. Engines of this type were employed, amongst other services, on the Leeds and Wakefield branch, when it was opened. A further process of development even took place with yet another series of these useful little engines, as can be seen from the accompanying illustration, *Fig. 48* which shows No. 12 converted into a front coupled engine having its wheel-base extended at the trailing end, with the addition of a tank and coal bunker. This transformation was probably not brought about until the early years of Stirling's reign, as is indicated by the chimney, but it is noteworthy that No. 12 retained its old boiler and cylinders. Four others were very similarly altered, though they required such additional work to be put upon them in the shape of new leading wheels, frames and boilers, together with new cylinders of the increased dimensions of 16 inch diameter and 24-inch stroke, as to justify them in emerging from the shops in all the glory of Doncaster Works number plates, in the following order:

Date	Doncaster No.	Engine No.	Date	Doncaster No.	Engine No.
1873	101	43	1874	139	20
1873	103	10	1874	142	42

Unfortunately no illustration is to hand to depict these rebuilds, which subsequently performed much useful service on local branch traffic, even long after they were

relegated to the 'A' class by the appropriation of their numbers to more modern engines in 1887 and 1888.

Two at least of the 'small Hawthorns' also underwent a complete transformation under Stirling's rule, to a degree that left little of the original design apparent. These were Nos 67 and 70, and the accompanying illustration, *Fig. 49*, shows No. 67 as a front coupled passenger engine having two pairs of 6-foot driving wheels, with clinders 17¾ inches in diameter and 24 inches in stroke. A distinctly interesting feature of the 're-build' is the adoption of outside bearings to all the wheels, with underhung springs, this being thoroughly at variance with Stirling's usual practice, as was also, indeed, the employment of outside frames of the type shown. Certainly, this fine powerful-looking engine seems to have little, save its number, to connect it with the 6-foot singles of 1848. No. 70 subsequently paid another visit to the shops, and emerged with 18 x 24 inch cylinders. As rebuilt, No. 67 was supplied with a six-wheeled tender, but No. 70 had a four-wheeled tender, as also had several other engines, including even some of Stirling's earlier 'mixed traffic' engines of the No. 18 class. Nos 67 and 70 were both broken up about two years ago.

The Wilson passenger engines of 1851 also contributed their share of survivals to come under the hands of the late locomotive superintendent. Nos 78, 79, 87 and 88 were of this number, of which four, Nos 79 and 87 were supplied with new frames in re-building. *Fig. 50* shows No. 79 as thus altered. Some of these engines retained their

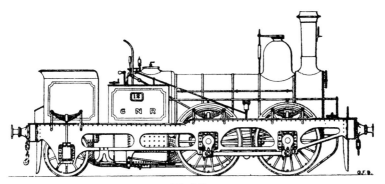

Fig. 48.

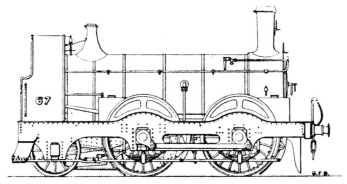

Fig. 49.

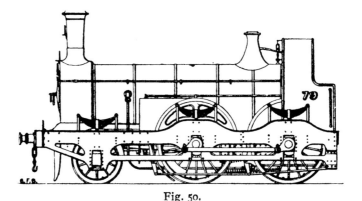

Fig. 50.

Fig. 51.

six-foot coupled wheels, with 16½ x 22-inch cylinders, while Nos 79 and 87 had their wheels enlarged to 6 feet 6 inches, with correspondingly larger cylinders, 17½ x 24 inches.

No. 263A, a Wilson four-coupled engine, was also rebuilt so as to greatly resemble the smaller engines of this series, *viz.*, Nos 78 and 88.

As details are not to hand of the date at which Stirling undertook these various rebuilds, and it would be difficult if not impossible to arrange them in absolute chronological order at this late period, it will perhaps be best to follow as nearly as can be the numerical order in dealing with them. Therefore, the next class to be mentioned is that known throughout their career as the 'converted Cramptons', Nos 91–99. The illustration, *Fig. 51,* shows these pretty little engines during the later days of their existence, together with the pattern of tender then in vogue. It may be mentioned that the 'converted Cramptons' took their share in the working of the GNR Manchester express during the 'fifties and early 'sixties, and with the light trains then usual they were accounted excellent performers.

The old Bury coupled engine, No. 100, had been rebuilt, with outside plate frames, as far back as 1855. It was again rebuilt in 1871 with the same sized wheels, and again in 1875 with 4-foot 6-inch leading and 6-foot coupled wheels. The engine was supplied with a new boiler as recently as 1891, and has only been broken up within the last year

or two. Latterly, it had cylinders 17½ x 24 inches.

Reverting to a lower order of service, the following of a numerical scheme leads to *Fig. 52*, in which can be seen Stirling's transformation of the early Hawthorn goods engines into a more powerful type better adapted to the requirements of his time. In No. 139A the tender was dispensed with, and in its place a saddle tank and a coal bunker at the trailing end added considerably to the adhesive weight, while the boiler and cylinder power were also enhanced to bring this engine and others of the same class up to date. The list of these converted engines was as follows: Nos 134, 139, 140, 144, 149, 155 and 397. They were all rebuilt with cylinders 17 inches by 24 inches, which were subsequently bored out to 17½ inches diameter, except No. 397, which was 17¼ inches only.

Nos 101–110, and 112–115, four-coupled goods engines, were rebuilt with 16-inch by 24-inch cylinders, and still retained their tenders. Some of them as rebuilt were fitted for working the Westinghouse brake, being employed at Doncaster for trial trips of the E. C. J. S. coaches. No. 111, however, was completely rebuilt as a saddle tank locomotive with new frames and six-coupled wheels, and was conspicuous as being the only six-coupled engine on the line in which the frames and running plate rose in a curve above the outside cranks. No. 112A is still employed at Doncaster in shunting at the carriage works, and is fitted with the Westinghouse brake.

Less drastic measures served to adapt No. 160 and some other engines of a similar type into fairly efficient 'mixed traffic' engines, as is shown in *Fig. 53*, for the chief change appears to have been the provision of a standard Stirling boiler and cab, with a slight increase in cylinder power. Nos 133 and 160 were so rebuilt with 16 x 24 inch cylinders, and were fitted with the Westinghouse brake, as in the case of the No. 101 class.

Most of the goods engines numbered up to No. 199 were rebuilt with 17-inch cylinders, and some of these, as Nos 177, 180, 165 and 192, are, or were quite recently, still at work under their old numbers. No. 180 had 18½ x 24 inch cylinders for many years.

Two very famous little engines, the two 'Jenny Linds', Nos 201 and 202, survived to come under Stirling's care, but unfortunately no illustration is forthcoming to show them at this period. The framing was slightly altered, and the tie-rods connecting the leading and trailing horn-plates were removed, so that as rebuilt these engines bore a somewhat close resemblance to Stirling's own six-wheel single-drivers of the No. 4 class.

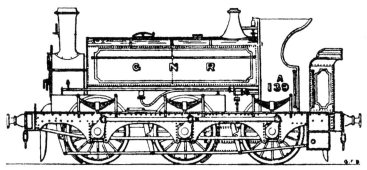

Fig. 52.

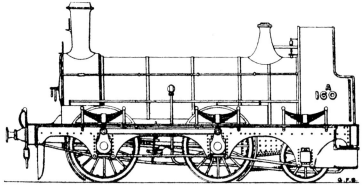

Fig. 53.

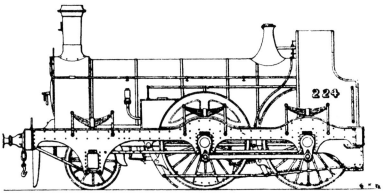

Fig. 54.

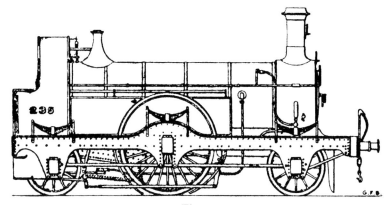

Fig. 55.

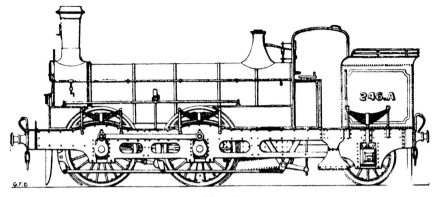

Fig. 56.

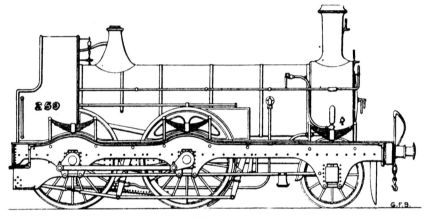

Fig. 57.

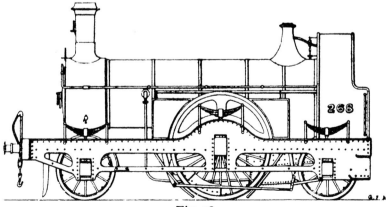

Fig. 58.

They still retained the old dimensions of cylinders, 16 x 22 inches, though the diameter was subsequently enlarged to the extent of 1 inch. No. 222, which was practically of the same class, appears to have dropped out of use comparatively early, and was broken up.

Unfortunately, also, an equally noteworthy class, Nos 203–214, must be passed over without any illustration or extended mention as regards their later years of service. This is a fate of which they are scarcely deserving, since they shared with the 'converted Cramptons' and the 'Jenny Linds' in establishing the GNR's reputation for speed at a very early date. In Stirling's time all these types were undoubtedly 'out-classed' as regards the best express services, but they were still able to work their way with fast local traffic, and so to justify their prolonged existence.

The Hawthorn coupled passenger engines, Nos 223–228, underwent due revision, being supplied with new boilers and 17 x 22 inch cylinders. In 1884 No. 224, which is shown in *Fig. 54*, was again overhauled. Some time prior to that overhauling it had been supplied with cylinders 17¼ x 24 inches. It was finally scrapped two or three years later.

Sturrock's fine 7-foot singles, Nos 229–240, in due course received new boilers as they became necessary, and some had their cylinders enlarged to 17 x 24 inches, this timely augmentation of weight and power serving to bring them well in line even with Stirling's earlier single engines. *Fig. 55* shows No. 235 as thus transformed. From 1885 onwards, however, they suffered a partial eclipse, being transferred into the 'A' class as the numbers gradually fell to the new 7-foot 6-inch single engines which Stirling introduced at that period. These engines have now all been scrapped, No. 231A being the last to undergo that fate.

Still preserving the numerical precedence, irrespective of class, the next change to be noted was in the earlier type of Metropolitan engines brought into being by Sturrock in 1865. As can be seen from the accompanying illustration of No. 246A, shown in *Fig. 56*, these engines underwent some considerable change since, in addition to the provision of new boilers, new frames also apparently became necessary. The design adopted for these was practically identical with that of the No. 270 class, already illustrated in its proper place. While on this subject, it may be mentioned that the No.

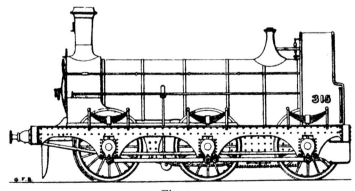

Fig. 59.

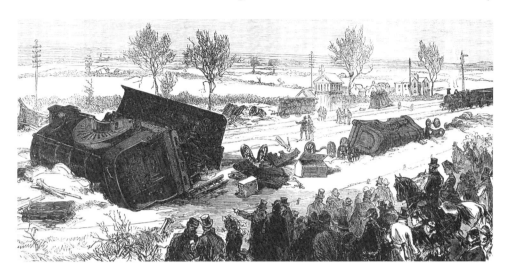

On 12 January 1876 the GNR locomotive No. 268 was involved in a collision at Abbots Ripton, at that time in Huntingdonshire but now in Cambridgeshire. The 'Special Scotch Express', which only later became known as the 'Flying Scotsman', struck a coal train during a blizzard. The coal train was being moved into the sidings to make way for the express, but both trains had been delayed by the bad weather. Thirteen passengers died in the accident, and many more were injured. No. 268 is shown in *Fig. 58*.

270 class also was rebuilt by Stirling with new boilers in 1879–81, and only underwent dissolution at the scrap heap after thirty-three years of honourable service.

The 6-foot coupled passenger engines, Nos 251–260, which throughout their career escaped the fatal brand of the 'A' to their running numbers, underwent the inevitable overhauling as regards their boilers, and made their appearance in the style shown as regards No. 259, illustrated in *Fig. 57*. With the exception of No. 255, which retained her 16½ x 22 inch cylinders, bored out to the extent of another ½ inch, these engines as rebuilt were fitted with 24-inch stroke. It is regrettable to learn that these engines are now broken up, with the sole exception of No. 258.

But their immediate successors, the famous 7-foot coupled engines which constituted Sturrock's latest design for the GNR, were less easily dealt with. It has been said that in their original state they 'could not keep their side-rods on'. At all events, they seem to have come to grief quite frequently through either the breaking or the bending of the coupling-rods, and possibly this consideration weighed more in Stirling's dealing with them than even his well-known predilection for a single-driver. In 1873, Nos 266 and 267 were converted into single-wheel engines, Nos 265 and 269 followed suit in 1875, and Nos 264 and 268 in 1878, all having the original cylinder dimensions 17 x 24 inches. They were all supplied with new boilers once again, in 1885–9. The alteration effected generally is indicated in *Fig. 58* which shows No. 268, an engine which is noteworthy as having been one of those involved in the fatal smash at Abbots Ripton. Nos 265 and 266 ran for a long time fitted with the Westinghouse brake, and worked between Doncaster and Peterborough, via Lincoln.

A certain number of goods engines underwent considerable rebuilding, which involved the supply of new plate frames among other details. These engines were: Nos 179, 302–306, 329, 331, 332, 360, 407, 408, 416 and 432. Others received new boilers and a general overhaul, as shown in *Fig. 59*, which illustrates No. 315 supplied with a standard Stirling boiler. In all cases, the diameter of the cylinders was consistently increased to 17½ inches in the process of rebuilding.

Having already illustrated the No. 400 class of goods engine and the 'steam tender' devised by Sturrock, in the proper place as originally built, it may be interesting to show a later phase of their development. Accordingly, this somewhat inadequate account of the rebuilds instituted by Stirling contains an illustration of No. 456, *Fig. 60*, showing it in its rebuilt form, with the original steam tender 'improved out of existence', or at least almost out of recognition, by Stirling. A number of these engines were specially rebuilt by Stirling with 18 x 26 inch cylinders, such, for instance, as Nos 401–405, 425, 429, 434, 440, 442, 446, 463 and 468, and possibly some others.

No. 456 was one of five locomotives built by the Avonside Engine Co. in 1866. Another engine of the same general type and dimensions, but differing in details, is shown in *Fig. 61*, No. 422, being one of twenty engines supplied to the GNR in 1865–6 by Neilson & Co., and afterwards rebuilt in the form shown in the illustration during the early years of Stirling's *regime*.

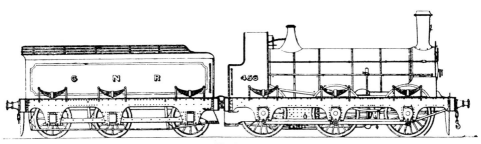

Fig. 60.

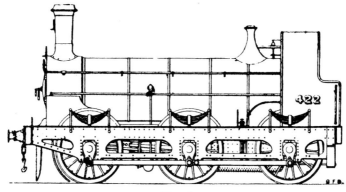

Fig. 61.

5

Patrick Stirling, 1874–1895

Reverting after this digression into the subject of 'rebuilds' to strict chronological order, the next design brought out by Stirling was embodied in half-a-dozen handy little tank engines which in general dimensions followed somewhat closely the pattern of the rebuilt Nos 470 and 471, already referred to. In external appearance, however, these new engines were essentially of Stirling's own design, as can be gathered from an inspection of the illustration, *Fig. 62*, which shows the first built, No. 136, all the details being in accordance with the standard fittings adopted at the period. The engines were all built at Doncaster Works in the following order:

Date	Doncaster No.	Engine No.	Date	Doncaster No.	Engine No.
1874	136	136	1874	149	399
1874	137	137	1875	175	605
1874	138	138	1875	176	604

It will be noticed that, oddly enough, the Doncaster and running numbers of the first three exactly agreed. These engines had inside cylinders 16 inches in diameter with a stroke of 22 inches and six-coupled driving wheels 4 feet 1 inch in diameter. The wheelbase was 14 feet 3 inches, the leading and driving axles being 7 feet 3 inches apart from centre to centre, and the frames measured 23 feet 4½ inches between the buffer beams, there being an overhang in front of 4 feet 8 inches, and at the rear of 4 feet 5½ inches. The boiler barrel measured 10 feet in length, with a diameter at the smallest ring of 3 feet 10½ inches, and it was pitched with its centre line 6 feet 5 inches above the rail level, the top of the chimney being 12 feet 9 inches above the rails. A comparatively small firebox was provided, the outer casing being only 4 feet 2 inches in length. The water supply amounted to 1,000 gallons, and was situated in a saddle tank on top of the boiler, while a bunker at the rear of the footplate was provided to carry a few cwt of coal. At the start these little engines were apparently intended chiefly for shunting work, for which their small heating surface and bunker capacity peculiarly adapted them, but they seem to have proved equal to local goods traffic also, and subsequently Stirling built further engines, having the same size of driving wheel, for special classes

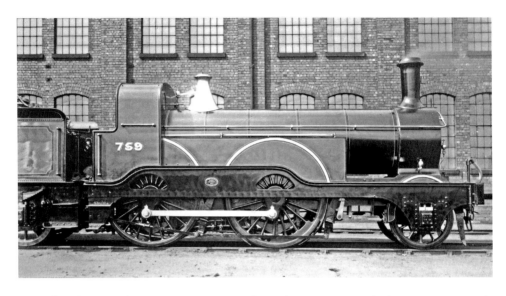

Two of Stirling's H-class 2-4-0s. No. 759 with Works No. 437 was built in 1887. No. 209, Works 378, is a slightly earlier loco from 1884. *(TH)*

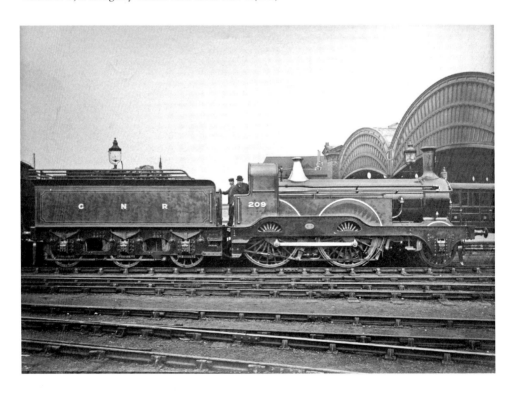

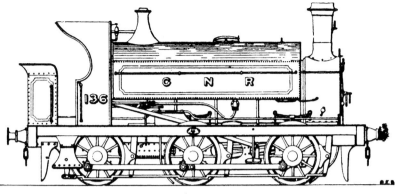

Fig. 62.

of work, to which attention will be drawn in due course.

In the same year, 1874, Stirling introduced an important innovation by the adoption of a new size for cylinders, 17½ x 26 inches, which subsequently became the standard for the coupled passenger engines and the six-coupled tender and tank goods engines. The first class to receive the enlarged cylinders was a set of thirty-six six-coupled goods engines which were built at Doncaster during the next seven years, their dates being as follows:

Date	Doncaster No.	Engine No.	Date	Doncaster No.	Engine No.
1874	121	372	1878	242	641
1874	122	373	1878	249	642
1874	132	354	1878	252	643
1874	133	198	1879	258	644
1874	155	196	1879	264	645
1875	156	173	1879	267	160
1875	159	340	1879	269	646
1875	161	365	1879	270	133
1875	163	141	1879	273	168
1875	167	163	1879	278	154
1875	169	339	1880	287	640
1875	171	187	1880	292	647
1875	181	328	1880	295	648
1875	182	194	1880	301	649
1876	199	312	1880	304	650
1876	200	314	1881	308	651
1878	237	310	1881	329	102
1878	239	393	1881	330	101

With cylinders 17½ x 26 inches and six-coupled driving wheels 5 feet 1 inch in diameter, these engines were in general dimensions almost exactly similar to the earliest goods locomotives designed by Stirling, while in external appearance also, as can be

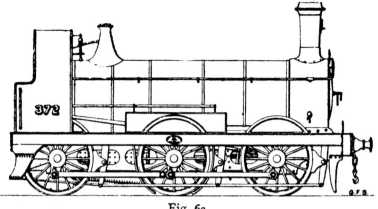

Fig. 63.

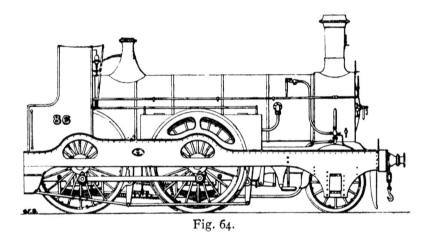

Fig. 64.

seen from the illustration, *Fig. 63*, there was little change to be noted. It is possible that, while the boiler dimensions remained unchanged, some difference in the heating surface was effected by altering the numbers and diameters of the tubes. Thus, the 206 tubes of 1¾-inch diameter, originally favoured by Stirling, were afterwards reduced to 186, and in some cases to 169, while the diameter was also reduced to 1⅝ inches.

A demand for new engine power to deal with the growing passenger traffic, as well as to supply the deficiency caused by the withdrawal of some of the earliest locomotives from a service for which they were no longer suitable, caused Stirling to build a further set of four-coupled passenger engines. The illustration of the first of these, No. 86, *Fig. 64*, indicates that the design was in all points very similar to that of Stirling's maiden effort in 1867. No. 86, however, led off the new departure with cylinders 17½ inches in diameter and 26 inches in stroke, the four-coupled wheels being 6 feet 7 inches in diameter, with their centres 8 feet. 3 inches. apart. The leading wheels were 4 feet 1 inch in diameter and 9 feet 8 inches in advance of the driving wheels, centre to centre, thus giving the exceptionally long wheelbase of 17 feet 11 inches. A total heating

surface of 992.8 sq. ft was provided, the firebox yielding 95 sq. ft and the tubes 897.8 sq. ft respectively. The weight of the engine in working order was 38 tons 12 cwt, apportioned as: leading wheels 12 tons, driving wheels 13 tons 16 cwt, trailing wheels 12 tons 16 cwt. Altogether nineteen engines were built to the same general design, the dates and numbers being:

Date	Doncaster No.	Doncaster No.	Date	Doncaster No.	Engine No.
1874	127	86	1879	257	263
1874	128	89	1879	263	51
1874	141	84	1879	271	96
1874	146	90	1879	274	99
1875	186	540	1880	291	223
1875	188	541	1880	294	97
1875	192	542	1880	300	207
1876	193	543	1881	309	226
1877	224	72	1881	310	212
1877	225	80			

The year 1874 also saw the introduction of a new type of goods engine, having its water supply provided in a saddle tank above the boiler, and the class at once proved so successful, both for local goods and other traffic, that it has constantly been added to by Stirling and his successor, until now there are upwards of 200 of these engines on the Great Northern Railway, all practically of the same type, though differing somewhat in dimensions, as in course of time an increase in weight and power has been desirable.

The first batch, thirty-five in all, were of the appearance shown in <i>Fig. 65</i>, and were of the following dimensions: the cylinders were 17½ inches in diameter with a stroke of 26 inches, inclined downwards towards the driving axle at a ratio of 1 in 8¾; the wheels, six-coupled, measured when new 4 feet 7 inches in diameter, and occupied a total wheelbase of 15 feet 6 inches, of which 7 feet 3 inches separated the leading and

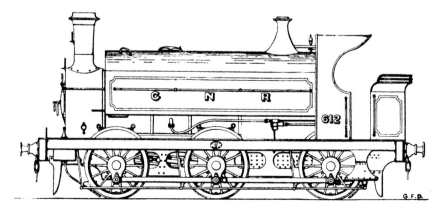

Fig. 65.

driving axles, and 8 feet 3 inches the driving and trailing axles, centre to centre; the frame-plates had a total length between buffer beams of 25 feet 4 inches, the overhang being in front 5 feet and at the rear end 4 feet 10 inches, and the footplate was at the standard height above the rails of 4 feet 2 inches. The firebox had its front-plate 1 foot 10½ inches in rear of the driving axle centre, and measured 5 feet 6 inches in length outside, with a depth below the centre-line of the boiler at either end of 4 feet 9 inches, and the boiler barrel was 10 feet 1 inch in length, with a diameter at the front ring of 3 feet 10 inches, its centre being pitched at a height of 6 feet 7 inches above the level of the rails. The saddle tank had a capacity for 1,200 gallons of water, and the engine weighed in full working order a trifle over 40 tons. The first engines, to which the above-dimensions particularly apply, were all built at Doncaster at the dates and with the numbers here given:

Date	Doncaster No.	Engine No.	Date	Doncaster No.	Engine No.
1874	130	494	1877	228	613
1874	134	495	1877	229	615
1874	135	496	1878	254	616
1874	143	497	1879	255	617
1874	145	498	1879	260	618
1874	151	499	1879	262	619
1875	177	500	1879	268	620
1875	180	601	1879	276	633
1875	183	602	1879	280	634
1875	190	603	1880	282	635
1876	213	606	1880	286	636
1876	214	607	1880	288	637
1877	217	608	1880	293	638
1877	221	609	1880	296	153
1877	222	610	1880	299	472
1877	223	611	1880	302	639
1877	226	612	1880	305	473
1877	227	614			

The six engines of this class built in 1874 had bunkers with sloping backs, similar to those of the earlier engines illustrated in *Fig. 41*, while some of the class were fitted with short chimneys and safety valve casings for the London Dock traffic.

A demand also arose about this period for those most useful 'mixed traffic' engines of which the 'Doncaster No. 1' was the prototype, and during the next few years, up to 1879, no fewer than seventy-five engines of this class were constructed, one-third of the number being built at Doncaster, while the remainder were supplied from 'outside'. The Doncaster-built engines had the following leading dimensions: cylinders 17½ inches in diameter with a stroke of 24 inches; driving wheels, coupled in front, 5 feet 7 inches, and trailing wheels 3 feet 7 inches in diameter respectively. The boiler barrel measured 10 feet in length with a diameter inside the front ring of 3 feet 9½ inches,

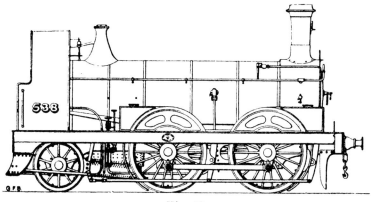

Fig. 66.

and contained 169 tubes 1⁵/₈ inches in diameter, the heating surface being: firebox 94.5 sq. ft and tubes 743 sq. ft, the total being 837.5 sq. ft. The weight of the engine in working order was 32 tons 3 cwt, distributed as follows: leading wheels 12 tons 7 cwt, driving wheels 13 tons 12 cwt, trailing wheels 6 tons 4 cwt. It is said that the wheelbase of these engines was only 14 feet 7 inches, of which 7 feet 3 inches divided the centres of the coupled wheels; but, while a few of the class may have been built of smaller dimensions, the majority appear to have had a wheelbase of at least 15 feet 2 inches, as in the No. 18 class; or possibly of 15 feet 3 inches, as in later engines of the same general type. The twenty-five engines built at Doncaster, of which *Fig. 66* shows the external appearance, bore the following dates and numbers:

Date	Doncaster No.	Engine No.	Date.	Doncaster No.	Engine No.
1874	148	74	1875	191	525
1874	154	36	1876	196	526
1875	157	519	1876	197	45
1875	158	518	1876	201	534
1875	160	520	1876	202	527
1875	162	521	1876	204	535
1875	164	26	1876	205	536
1875	166	28	1876	207	538
1875	168	522	1876	210	537
1875	172	523	1876	211	539
1875	174	24	1878	251	57
1875	179	29	1879	256	66
1875	187	524			

The fifty engines built 'outside' were of the same general type, as can be seen from *Fig. 67*, but no details are to hand save that the wheels and cylinders were identical with those of the Doncaster-built batch, and that the total heating surface was 843 sq. ft as regards the more numerous set. They were delivered in the following order:

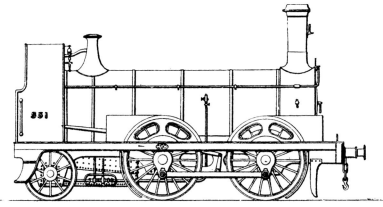

Fig. 67.

Date	Engine No.	Builders	Builder's No.
1875	551–556	Sharp, Stewart & Co.	2564–9
1876	557–562	Sharp, Stewart & Co.	2570–5
1876	563–572	Sharp, Stewart & Co.	2585–94
1876	573–580	Sharp, Stewart & Co.	2646–53
1876	581–600	Kitson & Co.	2059–78

Note that the engine and maker's numbers do not always run in strict agreement, as, for instance, engine Nos 563 and 564 bear maker's Nos 2586 and 2585 respectively. The weight of the engines built by Sharp, Stewart & Co. is given as 31 tons 13 cwt.

 From 1876 onwards a few small passenger engines were built for local services, having four wheels coupled in front and a smaller pair of trailing wheels under the footplate, the water supply being carried in a saddle tank on top of the boiler. Altogether six of these locomotives were built at Doncaster in the following order:

Date	Doncaster No.	Engine No.	Date	Doncaster No.	Engine No.
1876	208	501	1877	218	161
1876	209	502	1878	241	631
1876	216	503	1878	244	632

The illustration, *Fig. 68*, shows the chief features of the first four, while the following are their leading dimensions: cylinders 17½ inches in diameter and 26-inch length of stroke, coupled wheels 5 feet 1½ inches in diameter, trailing wheels 3 feet 7½ inches in diameter. The wheelbase measured a total of 15 feet, the coupled wheels being 6 feet 7 inches apart, centre to centre. Length of frame-plates between buffer beams 24 feet, the overhang being 5 feet 3 inches in front and 3 feet 9 inches at rear respectively. The boiler barrel was pitched with its centre-line 6 feet 9 inches above the rail level, and measured 9 feet 3 inches in length, with a diameter outside the smallest ring of 3 feet 10½ inches, while the outside firebox had a length of 4 feet 6 inches. The heating surface amounted to a total of 763 sq. ft, of which 74 sq. ft were contributed by the

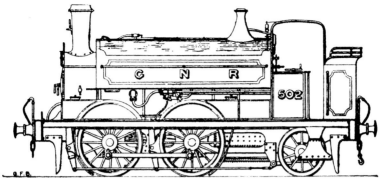

Fig. 68.

firebox and 689 sq. ft by the tubes, and the grate area measured 12¾ sq. ft. In the saddle tank there was a capacity for 800 gallons of water, while a fair supply of coal was provided for in a bunker at the trailing end 4 feet 6 inches high, 2 feet 6 inches long, and extending the whole width of the footplate. The total weight of these engines in working order amounted to 37 tons 5 cwt, allotted as follows: leading wheels 12 tons 13 cwt, driving wheels 14 tons 5 cwt, trailing wheels 10 tons 7 cwt. It should be noted that Nos 501–503 took the numbers hitherto appropriated by three small tank engines taken over from the Stamford & Essendine Railway in 1875 and broken up after about a year's service. No details are to hand respecting these original engines, except that they had cylinders 15 x 20 inches, 13 x 18 inches and 11 x 22 inches.

Nos 631 and 632 differed from the other four of the class in having cylinders only 16 inches in diameter, with a 22-inch length of stroke. Otherwise, except for a slightly smaller bunker capacity, they were for all practical purposes of the same dimensions and type as No. 502, as can be seen from the illustration, *Fig. 69*, showing No. 631.

A further number of coupled passenger engines was built during the years 1881–3, which differed from the preceding engines of the same type in no essential particular; and they are, for the purposes of this article, divided from the No. 86 class, already illustrated and described, for no other reason than that they were the first of the class to be provided with plain splashers. As can be seen from the illustration of No. 78, shown in *Fig 70*, they were in other details almost precisely similar to the earlier class, and were of the same general dimensions. This order consisted of nine locomotives having the dates and numbers given below:

Date	Doncaster No.	Engine No.	Date	Doncaster No.	Engine No.
1881	311	208	1882	343	201
1881	317	227	1882	344	202
1881	322	91	1883	351	699
1882	338	78	1883	352	700
1882	339	88			

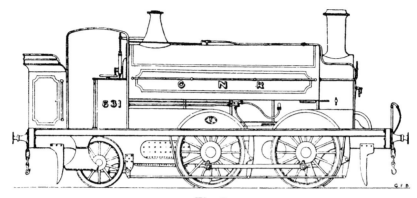

Fig. 69.

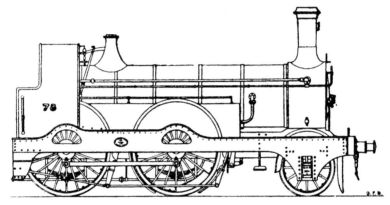

Fig. 70.

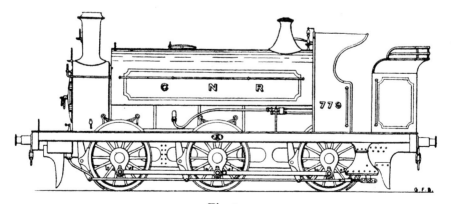

Fig. 71.

The success of the new type of saddle-tank goods engines (illustrated on a previous page) being now beyond question, Stirling proceeded in 1881 to build a considerable number of new locomotives of the same general type, but differing in a few dimensions, the tank capacity being smaller and the bunker larger than in the pioneers of the class. The cylinders still retained the original dimensions, 17½ inch in diameter with a stroke of 26 inches, and the six-coupled wheels were also of the same diameter, 4 feet 7 inches, and were spaced at intervals between centres of 7 feet 3 inches and 8 feet 3 inches from front to back. Overall, however, the new engines were longer than their predecessors, the frameplate measuring 26 feet 10 inches in length, with an overhang of 5 feet 6 inches at front and 5 feet 10 inches at back respectively. The boiler barrel, which was pitched with its centre-line 6 feet 7½ inches above the rails, measured 10 feet 1 inch long, with a diameter outside the smallest ring of 3 feet 10½ inches, and the firebox casing was 5 feet 6 inches long outside. A total heating surface of 798 sq. ft was apportioned as follows: firebox 83 sq. ft, tubes 715 sq. ft, and the grate area was 16 sq. ft. In full working order, with 1,000 gallons of water in the saddle tank, these engines weighed 42 tons 12 cwt, of which 14 tons 6 cwt were allotted to the leading wheels, 15 tons 8 cwt to the driving wheels, and the remaining 12 tons 18 cwt to the trailing wheels. The accompanying illustration of No. 779, *Fig. 71*, will afford an idea of the external appearance of these locomotives, and forty-three were built:

Date	Doncaster No.	Engine No.	Date	Doncaster No.	Engine No.
1881	315	672	1886	403	787
1881	316	673	1886	404	788
1881	319	674	1887	429	789
1881	325	675	1887	430	790
1881	326	676	1887	439	779
1882	332	677	1887	440	780
1882	333	678	1888	453	803
1882	334	679	1888	454	802
1882	335	680	1888	459	803
1882	340	681	1888	468	804
1883	353	688	1889	481	805
1883	354	689	1889	482	806
1883	355	690	1890	509	397
1883	358	691	1890	511	139
1883	359	692	1890	521	807
1883	360	693	1890	523	808
1885	387	781	1891	527	809
1885	388	782	1891	530	810
1885	399	783	1891	536	851
1885	400	784	1891	538	852
1885	401	785	1891	544	853
1886	402	786			

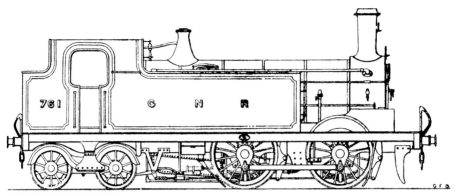

Fig. 72.

In 1881 Stirling brought out a new type of passenger tank engine for local and suburban services. These locomotives were eight-wheeled, having two pairs of driving wheels coupled in front and a trailing bogie, and they differed from the earlier design already illustrated in *Figs. 46* and *47* by having the water supply provided in side tanks with the coal bunker distinct behind the footplate. From an inspection of the illustration here given of No. 761, *Fig. 72*, it will be seen that the general design was very neat and compact, the arrangement of the side tanks, cab and bunker in one piece conducing greatly to that effect, and producing an ample shelter for the men in charge. These engines, sixteen in number, were built to the following dimensions: cylinders 17½ by 24 inches, diameter of driving wheels 5 feet 1 inch, and of bogie wheels 3 feet. The total wheelbase was 22 feet 6 inches, the coupled wheel centres being 7 feet 3 inches apart, and the bogie wheel centres 5 feet. From the leading wheel centre to the centre of the bogie pin measured 19 feet 9 inches, the bogie pin being placed 3 inches in advance of the centre of the bogie. The frames measured over all 29 feet 3 inches, the overhang being 5 feet 3 inches and 1 foot 6 inches at front and back respectively. Pitched with its centre line 7 feet 3 inches above the rails, the boiler barrel had a length of 10 feet 1 inch, and a diameter outside the smallest ring of 4 feet 0½ inches, while the firebox casing was 5 feet 6 inches long outside, with a depth below the centre line of 5 feet 2 inches and 4 feet 8 inches at front and back respectively. The heating surface of the tubes was 830 sq. ft. The two side tanks collectively had a capacity of 1,000 gallons of water and the bunker held 3 tons of coal, and with these supplies brought the total weight of the engines in working order up to the respectable total of 50 tons 4 cwt. Following is a list of the dates and numbers of the sixteen engines comprised in this group:

Date	Doncaster No.	Engine No.	Date	Doncaster No.	Engine No.
1881	318	658	1884	369	696
1881	327	659	1884	372	697
1881	328	660	1884	375	698
1881	331	661	1884	376	761
1882	336	682	1884	381	762
1882	337	683	1885	384	763

| 1884 | 363 | 694 | 1885 | 385 | 764 |
| 1884 | 365 | 695 | 1885 | 386 | 765 |

Nos 694–698 and 761 were fitted with condensing apparatus and low chimneys for working on the Metropolitan service. The others were all stationed at Bradford.

As the demand for engine power to work goods traffic was in excess of the supply possible from Doncaster, the Company ordered thirty-five goods locomotives very similar to the type illustrated in *Fig. 63*, having cylinders 17½ x 26 inches, and 5-foot 1-inch wheels, from 'outside' firms in the following order:

Date	Maker	Maker's Nos	Engine Nos
1882	Vulcan Foundry	954–68	716-30
1882	Dübs & Co.	1607–26	731–50

A new type of saddle-tank locomotives, substantially of the same general class as those described and illustrated by *Fig. 71*, but adapted in certain dimensions to suit the requirements of a special traffic, was brought out in 1882, four engines being built of the type in the following order:

Date	Doncaster No.	Engine No.	Date	Doncaster No.	Engine No.
1882	347	684	1884	364	386
1882	348	685	1884	366	687

While of the same general design as the previously mentioned class of goods tank-locomotives, these four engines were, apart from having wheels of 6-inch less diameter, slightly modified in detail, because, being intended to work trains over a portion of the Great Eastern Railway and kindred railways in the east-end of London, in the direction of Poplar, Royal Mint Street and Thames Wharf, it was necessary to reduce their vertical dimensions to suit the loading-gauges at that time in force between Thames Wharf and Stratford Low Level. With this end in view the boiler was pitched with its centre line no more than 6 feet 2 inches above the level of the rails, and the chimney and safety valve casing were also reduced so as to keep within a clear height above the rails of 11 feet 6 inches. These engines had the following leading dimensions: the cylinders, which inclined downwards towards the driving axle at the standard slope of 1 in 8¾, measured 17½ inches in diameter with a stroke of 24 inches. The three pairs of driving wheels were each 4 feet 1 inch in diameter, and were spaced over a total wheelbase of 15 feet 6 inches, with 7 feet 3 inches separating the leading and driving axle centres, and 8 feet 3 inches separating the driving and trailing axle centres. The two single frame plates each measured 26 feet 10 inches long, the overhang being 5 feet 6 inches and 5 feet 10 inches at leading and trailing ends respectively, while the footplate was at the standard height above the rails of 4 feet 2 inches. As usual, the boiler barrel consisted of three telescopic rings, having diameters of 3 feet 10½ inches, 3 feet 11½ inches, and 4 feet 0½ inches respectively, outside measurement, with a length of barrel 10 feet, the height of the centre line above the rails being 6 feet 2 inches, as already mentioned. The

outside firebox was 5 feet 6 inches long, and was 1 feet 10½ inches from the centre of the driving axle. Over the boiler and firebox was a saddle tank containing 1,000 gallons of water, and the coal was carried in a capacious bunker at the trailing end. The weight of these engines was slightly over 40 tons in working order.

It may be mentioned here that the loading gauge has been raised at Stratford Bridge in recent years, and that these engines, and others to be referred to later, have since been fitted with standard chimneys as they required renewal.

A further supply of mixed traffic engines becoming necessary, in 1882 Stirling brought out a modified design, in which the severity of his later patterns became apparent. The perforated splashers of earlier days were abandoned and more simplicity in outward appearance adopted. *Fig. 73* shows No. 103, the pioneer of the new type of engines, of which twelve were built during the years 1882 to 1885 inclusive, in the following order:

Date	Doncaster No.	Engine No.	Date	Doncaster No.	Encrine No.
1882	345	103	1884	373	105
1882	346	104	1884	374	106
1883	361	112	1885	391	107
1883	362	113	1885	392	108
1884	370	114	1885	397	109
1884	371	115	1885	398	110

In dimensions these engines differed slightly from those preceding them. The cylinders were still 17½ in diameter, with a stroke of 24 inches, and the front coupled driving wheels measured, when new, 5 feet 7½ in diameter the trailing wheels, however, being enlarged 6 inches to a diameter of 4 feet 1½ inches. The wheelbase was 15 feet 3 inch, of which 7 feet 3 inches separated the centres of the coupled axles, while the frame-plates measured 23 feet 8 inches over ends, the overhang being 4 feet 11 inches and 3 feet 6 inches at leading and trailing ends respectively. The boiler barrel measured 10 feet in length, with a diameter, outside the smallest ring, of 4 feet 0½ inches, and contained 186 tubes, each 1⅝ inches in diameter; while the firebox shell was 5 feet 6

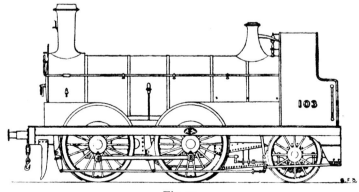

Fig. 73.

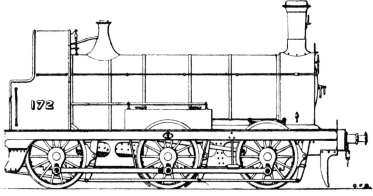

Fig. 74.

inches long outside, with a breadth at the frame-level of 4 feet 1 inch.

In 1883 Stirling designed a new class of six-coupled tender engines of unusual power, for working the mineral traffic in the West Riding, where the gradients are often as severe as 1 in 50, and the eight engines of this class were consequently known as the West Riding coal engines:

Date	Doncaster No.	Engine No.	Date	Doncaster No.	Engine No.
1883	356	374	1887	447	142
1883	357	172	1887	448	188
1885	395	185	1888	457	156
1885	396	189	1888	458	157

In general dimensions and in appearance, as can be seen from the accompanying illustration, *Fig. 74*, showing No. 172, these engines were practically of the standard type of goods engine, having 17½ x 26 inch cylinders, but a large increase in tractive force was obtained by reducing the diameter of the driving wheels down to 4 feet 7 inches. The engines of this type stood on a total wheelbase of 15 feet 6 inches, divided as usual into sections of 7 feet 3 inches between the leading and driving axles, and 8 feet 3 inches between the driving and trailing axles, centre to centre. The frame-plates were unusually long, 24 feet 5½ inches, with an overhang forward of 5 feet 2 inches, and behind of 3 feet 9½ inches, and as usual the height to the footplate was 4 feet 2 inches. Pitched with its centre line 7 feet 2 inches above the rails, the boiler barrel had a length of 10 feet 1 inch and a diameter outside the smallest ring of 4 feet 0½ inches while the firebox shell measured 5 feet 6 inches in length outside, and was distant 1 foot 10 inches from the driving axle centre. It will be seen that, like the large mineral engines designed by Stirling in 1872, these locomotives were built for a special traffic.

With the Doncaster works fully occupied, and a growing demand for further engine power for passenger traffic, the locomotive superintendent was compelled at about this date to order a number of standard coupled passenger locomotives from 'outside'. This order consisted in all of fifteen engines, built by Kitson & Co., of Leeds, with the following dates and numbers:

Date	Maker's No.	Engine No.	Date	Maker's No.	Engine No.
1883	2479–85	701–7	1884	2486–93	708–15

These engines were, as already stated, practically of standard design, at all events as regards the first seven of them, but in No. 708 a modification of the outside frame-plate was adopted to the extent shown in *Fig. 75*, and apparently the change was considered so satisfactory that a very similar modification was introduced into all engines of the class subsequently built at Doncaster. The leading dimensions of these 'outside' built engines were substantially in agreement with the standards then prevailing at the company's own works, the cylinders being 17½ inches in diameter with a 26-inch stroke, the coupled wheels being 6 feet 7½ inches in diameter, and the leading wheels 4 feet 1½ inches, while the distribution of the wheelbase was also in accordance with the figures already quoted. The boiler barrel measured 10 feet 2 inches in length with a diameter outside the smallest ring of 4 feet 0½ inches, and contained 186 tubes of 1⅝-inch diameter. The internal firebox was 4 feet 10½ inches long, by 3 feet 6 inches wide, and afforded a grate area of 16¼ sq. ft. In full working order these engines weighed a total of 38 tons 4 cwt, apportioned as follows: leading wheels 13 tons 16 cwt; driving wheels 13 tons 16 cwt; and trailing wheels 11 tons 13 cwt.

In addition to these fifteen engines, Stirling also put in hand at the Doncaster works further similar locomotives, with the newer pattern of frame, except for the fact that the perforations still retained the shape of the older Doncaster-built engines. These engines came out at intervals during the next three years:

Date	Doncaster No.	Engine No.	Date	Doncaster No.	Engine No.
1884	367	751	1886	408	228
1884	368	752	1886	421	216
1884	377	206	1886	422	225
1884	378	209	1886	423	755
1884	382	753	1886	424	756
1884	383	754	1886	425	757
1886	405	211	1886	426	758
1886	406	217	1887	437	759
1886	407	224	1887	438	760

Up to this period (1884) thirty-seven of the fine 8-foot bogie express engines, designed by Stirling, had been built, all practically identical in details with the original No. 1 of 1870, and with fourteen years' experience in service their designer saw no reason for materially altering the type when a demand for more express engines arose. The construction of a continuation of the class was accordingly entered on at Doncaster, and in the course of the next seven years ten more 8-footers were produced, making in all forty-seven built to the same general dimensions. Such alterations or modifications as were introduced into this second series were those of detail rather than of principle, being indeed a mere bringing-up of these fine engines into line with the practice prevailing at a given time in respect to all other locomotive stock turned out from Doncaster works. So far as external appearance is concerned, it is sufficient to compare

the accompanying illustration, *Fig. 76*, showing No. 778 as built in 1887, with the original No. l already given, to show how little modification became desirable in a space of seventeen years.

Otherwise, dealing with changes that are scarcely apparent in a drawing which shows only the external view of the locomotive, it may be well to refer more particularly to the slight character of the internal changes. Among the first of the alterations was an increase in the diameter of the trailing wheels to the extent of 6½ inches, and the substitution of Ramsbottom valves for the original spring-balance safety valves. In the framing, a slight change was made at the trailing end by the replacing of the cast-iron footplate originally used there, by stays made of plates and angle irons. At the leading end also a slight alteration was made to secure greater strength, and the framing of the bogie was modified in some details. For the later engines of the class a rather heavier driving axle was employed, no doubt in direct consequence of the gradual increase of weight on the driving wheels, the chief enlargement taking effect in the necks receiving the bearings, which were increased to 8½ inches in diameter, in place of the original 8 inches. The ordinary plate springs at first used to transmit the weight to the driving wheels were in the very latest engines abandoned in favour of a pair of Timmis' helical

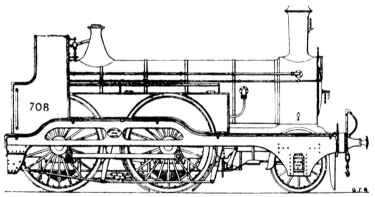

Fig. 75.

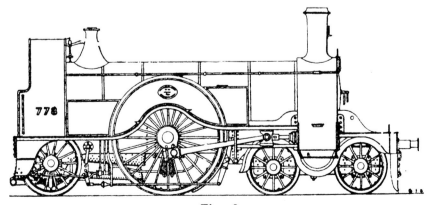

Fig. 76.

springs under each axlebox, while, on the other hand, the volute springs formerly adopted for the trailing wheels were replaced by plate springs slung under the axleboxes. So far as the boiler and firebox were concerned a few modifications were made and the later engines of the class were provided with the customary brick arch in the firebox in place of the sloping water mid-feather at first furnished for the same purpose, and the injectors were removed from the sides to the footplate end of the firebox, and thence delivered their feed to the middle of the boiler barrel by means of an internal tube which ran across the top of the inside firebox. The boiler barrel was slightly enlarged in diameter, but strangely enough, so it would seem, the heating surface was reduced by the reduction of the number of flue tubes to 174, of a diameter of 1¾ inches each, these figures henceforth constituting the standard throughout Stirling's continuance of office. These engines were built in the following order:

Date	Doncaster No.	Engine No.	Date	Doncaster No.	Engine No.
1884	379	771	1887	433	776
1884	380	772	1887	441	777
1885	393	773	1887	442	778
1885	394	774	1893	631	1001
1886	427	775	1893	632	1002

It may be interesting to note that Nos 1001–2 were originally allotted Nos 264–5, the idea then being to break up the old converted singles bearing those numbers. However, fortunately, for the two historic veterans, other counsels prevailed in the nick of time, and as a sign that they would be granted a further lease of life the two newer engines were in 1894 renumbered as is given above.

Having already dealt in some detail with the original No.1 of 1870, it may be instructive to notice closely the parallel dimensions here given of No. 776, built in 1887, with a view to seeing how little change was effected after an experience of seventeen years. The dimensions of No. 776 corresponding to those already given of No. 1 were: diameter of bogie wheels 3 feet 11½ inches; of driving wheels 8 feet 1½ inches; and of trailing wheels 4 feet 7½ inches. Wheelbase: bogie wheel centres 6 feet 6 inches; from hind bogie wheel to driving wheel centres 7 feet 9 inches; from driving to trailing wheel centres 8 feet 8 inches; from centre of bogie pin to centre of trailing wheels 19 feet 5 inches; total wheelbase 22 feet 11 inches. Total length of frame plates 27 feet 7 inches, with an overhang of 2 feet 2 inches in front, and 2 feet 6 inches at back; outside buffer beams 28 feet 1 inch; over buffers 29 feet 9 inches. Cylinders 18 inches in diameter, 28-inch stroke. Boiler barrel 11 feet 5 inches long, with a diameter outside the smallest ring of 4 feet; height of centre line above the rails 7 feet 3½ inches; containing 174 copper tubes, each 11 feet 9 inches long by 1¾ inches in diameter. Length of firebox casing 6 feet 2 inches; distance from driving axle centre 1 foot 9 inches; depth below centre line of boiler, in front 5 feet 1¾ inches, at back 4 feet 7¾ inches. Heating surface: firebox 109 sq. ft; tubes 936 sq. ft; total 1,045 sq. ft; grate area 17.75 sq. ft; boiler pressure 160 lbs per sq. inch. Total weight of engine, 45 tons 3 cwt, distributed as follows: leading bogie wheels 8 tons 2 cwt, hind bogie wheels, 9

tons g cwt, driving wheels 17 tons, and trailing wheels 10 tons 12 cwt. The tender in use for express work in 1887 contained 2,900 gallons of water and 5 tons of coal, and weighed when thus loaded 33 tons 7 cwt 3 qrs.

Specimens of these 8-foot engines have been exhibited on different occasions. No. 47 was at the Railway Jubilee Exhibition, held at Darlington in 1875; No. 664 took part in the Stephenson Centenary Exhibition at Newcastle in 1881; and No. 776 was shown, not only at the Newcastle Exhibition of 1887, but also at Edinburgh in 1890. No. 776, by the way, had the old 'built-up' chimney, and not the plain cast-iron pattern shown in the drawing of No. 778. With regard to power and speed, these engines have reflected the highest credit on the foresight of their designer, since even at the present day the locomotives which were planned more than thirty years ago are still dealing with the fastest and some of the heaviest traffic on a far from easy road, with ruling gradients of 1 in 200. During Stirling's long term of office, the use of pilot engines, or double-engine running, as it may preferably be called, was strictly forbidden, and yet trains of from ten to sixteen heavy six-wheeled coaches, giving loads behind the tender of from 150 to 240 tons, were drawn to and from King's Cross at booked speeds ranging from 45 to 55 mph, with regularity and success. The great increase in the weight of trains during the last few years, has, however, at last, begun to tell on locomotives never very superabundantly provided with boiler power, and 'pilots' are now often to be seen assisting the eight-footers. Even a later and larger edition of the same engine, which will be dealt with in due course, is almost equally overloaded in meeting present-day requirements, the defect in either case being a want of sufficient boiler power to maintain the maximum efforts now required.

As regards extreme speed, the records published of the now 'historic races' to Edinburgh in 1888, and to Aberdeen in 1895, give some remarkable instances. For example, on 20 and 21 August, 1895, respectively, engine No. 668 took a load, reckoned as 101 tons behind the tender, from King's Cross to Grantham, 105¼ miles, in 104 minutes 51 seconds and in 101 minutes respectively; while another, No. 775, on 19, 20 and 21 August conveyed the same train from Grantham to York, 82¾ miles, in 79 minutes 9 seconds, 78 minutes 9 seconds and 76 minutes respectively. In 1888, the best performances of the bogie singles had been, from King's Cross to Grantham, in 111 minutes 49 seconds, by No. 22, and from Grantham to York in 88 minutes, by No. 775, the champion also of the later so-called 'race'. Apart from these special runs, it is worth noting that the ordinary service of the GNR demands that on at least half-a-dozen occasions daily it is necessary for the engine to cover a distance of 60 miles in 60 minutes when running between the London terminus and Grantham, up or down, in order to keep time.

In dealing with the 8-foot bogie engines as originally designed by Stirling and brought out in the year 1870, it was suggested that he adopted the two main features, of outside cylinders and a leading bogie, as a matter of necessity, not of choice, and there appears to be proof of this theory in the fact that in 1885 he brought out an engine which, though on an enlarged scale throughout, was practically a repetition of the six-wheeled single driving engine of 1868, and which was, nevertheless, intended to perform exactly the same duty as the large bogie engines. This new engine, of which an illustration is given in the accompanying *Fig. 77*, was immediately followed by another of the same dimensions:

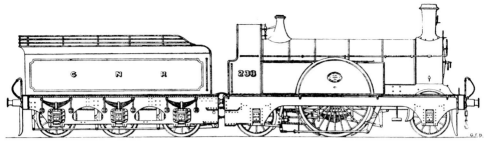

Fig. 77.

Date	Doncaster No.	Engine No.
1885	389	238
1885	390	232

The leading particulars of both these fine six-wheeled locomotives were as follows: diameter of driving wheels 7 feet 7½ inches, and of leading and trailing wheels 4 feet 1½ inches; wheel-base: leading to driving wheel centres 9 feet 9 inches, driving to trailing wheel centres 8 feet 1 inch, total 17 feet 10 inches; cylinders 18½ inches in diameter, with a stroke of 26 inches; boiler, all steel: length of barrel, 10 feet 6 inches, working pressure 150 lbs to the sq. inch, total heating surface 967.8 sq. ft; frames, of steel, 1¼ inches thick; total weight of engine in working order 39 tons 15 cwt, of which the driving wheels received 17 tons.

The two experimental engines fulfilling expectations, during the next few years ten more locomotives of the same type were turned out from Doncaster Works in quick succession:

Date	Doncaster No.	Engine No.	Date	Doncaster No.	Engine No.
1886	409	234	1887	446	239
1886	410	229	1888	455	231
1887	428	237	1888	456	233
1887	434	230	1888	469	235
1887	445	236	1888	470	240

It will be noted with some regret that these twelve engines took the numbers of Sturrock's fine 7-foot singles, which henceforth became relegated to the 'A' class.

The second series of these express locomotives were larger throughout than their two prototypes, being built so as to take boilers of the standard pattern supplied to the bogie engines of the same date, while their external appearance differed but slightly from that of No. 238, as can be seen from the accompanying illustration, *Fig. 78*, which shows No. 229. The leading dimensions were as follows: diameter of driving wheels 7 feet 7½ inches, and of leading and trailing wheels 4 feet 1½ inches; wheelbase: leading to driving wheel centres 10 feet 8 inches, driving to trailing wheel centres 8 feet 5 inches, total 19 feet 1 inch; length of frame-plates 25 feet 5 inches, with an overhang in front of 3 feet 1 inch, and at back of 3 feet 3 inches. Cylinders 18½ inches in diameter

with 26-inch length of stroke; boiler barrel 11 feet 5 inches in length with a diameter outside the smallest ring of 4 feet; centre line above rails 7 feet 6 inches, containing 186 tubes, each 11 feet 9 inches long with a diameter of 1¾ inches; working pressure 160 lbs per sq. inch. Heating surface: firebox 109 sq. ft, tubes 1,001 sq. ft; total 1,010 sq. ft, grate area 18.4 sq. ft. The firebox casing measured 6 feet 2 inches long by 4 feet 0½ inches wide at the bottom. The crank axle was forged of Siemens-Martin steel, with bearings 8¼ inches in diameter and 7 inches long, and with wheel seats of the large size of 9¾ inches. The motion consisted of the ordinary open slot link and eccentrics invariably adopted by Stirling. In full working order engines of this class weighed a total of 39 tons 14 cwt, apportioned as follows: leading wheels 11 tons 18 cwt, driving wheels 17 tons, trailing wheels 10 tons 16 cwt. Empty the engine weighed exactly 3 tons less, the weights then being 11 tons, 15 tons 14 cwt, and 10 tons respectively. The tender carried 2,900 gallons of water and 4 tons of coal and weighed 38 tons 10 cwt.

While cheaper both in first cost and in up-keep than the bogie engines, these six-wheelers were found to be quite as efficient in the conduct of the express traffic. If anything they have proved themselves faster than the larger engines, both as regards the maximum speed for individual miles and the average speed throughout a long run. During the 'races' to Edinburgh and Aberdeen respectively, in 1888 and 1895, these engines shared the running of the East Coast trains from King's Cross to York with the 8-foot singles, and the record run of 1888 was obtained with No. 233, which on 25 August 1888 covered the distance between London and Grantham, 105¼ miles, in 105 minutes, or at the average rate of 60.2 miles per hour. So far as coal consumption was concerned, there seemed to be little to choose between the two classes, and though sharing the running with the eight-footers the six-wheelers never superseded them. In fact, the two distinct classes were built, as it were, side by side, and more bogie engines were turned out from Doncaster, as will presently be seen, sometime after the building of the six-wheeled engines had ceased.

In 1886, after an interval of nearly five years, Stirling again found it necessary to provide additional six-coupled goods engines, and during the next eight years no

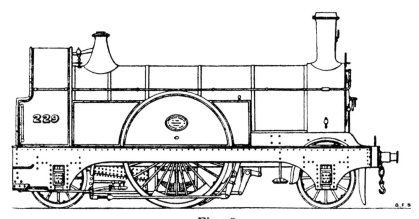

Fig. 78.

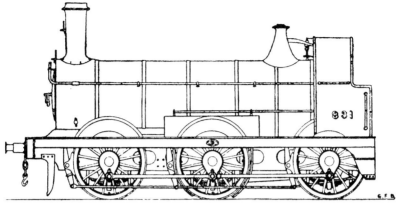

Fig. 79.

fewer than seventy-two locomotives of the class were built at the Doncaster works. They were generally of what might be termed Stirling's standard pattern as originally introduced in 1867, but brought up to date in external details and in some few dimensions. The accompanying illustration of No. 83r, shown in *Fig. 79*, conveys an idea of the appearance of these useful engines, the leading dimensions being as here given: cylinders 17½ inches in diameter with a stroke of 26 inches; diameter of six-coupled driving wheels, 5 feet 1½ inches; wheelbase: leading to driving wheel centres 7 feet 3 inches, driving to trailing wheel centres 8 feet 3 inches, total 15 feet 6-inches; length of frame plates 23 feet 11 inches, with an overhang of 5 feet 2 inches and 3 feet 3 inches at leading and trailing ends respectively. The boiler barrel was 10 feet 1 inch in length, with a diameter outside the smallest ring of 4 feet 0½ inches, and was pitched with its centre line 7 feet 2 inches above the level of the rails. It contained 174 tubes of 1¾ inches diameter and the firebox casing measured 5 feet 6 inches in length outside; the boiler pressure was 160 lbs per sq. inch. A total heating surface of 922.4 sq. ft was provided in the following proportions: firebox 92.4 sq. ft, tubes 830 sq. ft; and the grate area was 16.25 sq. ft. In full working order, engines of this class weighed 36 tons 10 cwt, divided as follows: leading wheels 12 tons 18 cwt, driving wheels 14 tons 8 cwt and trailing wheels 9 tons 4 cwt. The standard tender provided had a total weight of 34 tons 18 cwt 3 qrs, with its normal supply of 2,800 gallons of water and 5 tons of coal.

The dates, works and running numbers of the seventy-two engines comprised in this series of goods engines are given in the following table:

Date	Doncaster No.	Engine No.	Date	Doncaster No.	Engine No.
1886	411	791	1887	449	176
1886	412	792	1887	450	183
1886	413	793	1887	451	389
1886	414	794	1887	452	147
1886	415	795	1888	460	178
1886	416	796	1888	461	309

1886	417	797	1888	462	150
1886	418	798	1888	463	324
1886	419	799	1888	464	181
1886	420	800	1888	465	321
1887	431	322	1889	475	323
1887	432	307	1889	476	382
1887	443	199	1889	479	300
1887	444	320	1889	480	301
1889	487	488	1891	550	838
1889	488	135	1891	552	840
1889	493	170	1891	554	841
1889	494	195	1891	556	845
1889	495	191	1891	558	842
1889	496	383	1891	560	846
1890	501	342	1891	561	843
1890	502	347	1892	563	847
1890	503	175	1892	565	844
1890	505	391	1892	567	848
1890	514	378	1892	569	849
1890	515	370	1892	572	850
1890	522	831	1892	574	317
1890	524	832	1892	575	341
1891	529	833	1892	586	143
1891	533	834	1892	587	346
1891	537	835	1892	592	313
1891	539	385	1892	595	182
1891	541	836	1893	634	319
1891	543	379	1893	637	327
1891	545	837	1894	641	1011
1891	547	839	1894	645	1012

Nos 1011 and 1012 were originally allotted Nos 315 and 318 respectively, but subsequently received their numbers as given in the list, and the two old engines bearing the numbers 315 and 318 remained on the list of GNR stock for a little while longer, until Stirling's successor replaced them by new engines in 1898, as will be seen later.

Twenty-one new mixed traffic engines were put in order from 1887 onwards, built at intervals during the next eight years. In external appearance they were practically identical with No. 103, already illustrated in *Fig. 73*. They had cylinders 17½ inches in diameter with a stroke of 24-inches, with front-coupled driving wheels each 5 feet 7½ inches in diameter and a pair of trailing wheels 4 feet 11 inches in diameter. The total wheelbase measured 15 feet 3 inches, of which 7 feet 3 inches divided the centres of the coupled axles, and the frame-plates had a length of 23 feet 8 inches, with an overhang of 4 feet 11 inches and 3 feet 6 inches at leading and trailing ends respectively. The boiler barrel was 10 feet long, with a diameter outside the smallest ring of 4 feet 0½

inches, the centre line being pitched 7 feet 2 inches above the rail level, and it contained 174 tubes each 1¾ inches in diameter. The firebox casing measured 5 feet 6 inches long outside and the boiler pressure was adjusted to 160 lbs per sq. inch. Heating surface was provided as follows: firebox 92.4 sq. ft, tubes 823.6 sq. ft, total 916 sq. ft, and the grate area was 16.25 sq. ft. In working order the engines of this class weighed 35 tons 2 cwt, apportioned as follows: leading wheels 12 tons 16 cwt, driving wheels 14 tons, trailing wheels 8 tons 6 cwt. The tender was of the same weight and capacity as that allotted to the goods engines, previously described.

These mixed traffic engines bore the following dates and numbers:

Date	Doncaster No.	Engine No.	Date	Doncaster No.	Engine No.
1887	435	10	1893	611	357
1887	436	12	1893	616	358
1888	466	20	1893	620	957
1888	467	326	1893	625	953
1888	473	42	1893	626	954
1888	474	43	1894	663	955
1891	546	951	1894	664	956
1891	557	952	1895	685	958
1893	602	325	1895	686	959
1893	604	355	1895	687	960
1893	609	356			

Nos 951 and 952 ran for some months as Nos 67 and 70, and were renumbered in 1892.

Towards the close of the year 1888, Stirling brought out the first of his latest class of standard four-coupled passenger engines, which in all main essentials were almost identical with those which constituted his maiden design on the GNR more than twenty years previously. These later engines, which are illustrated by No. 870, shown in *Fig.*

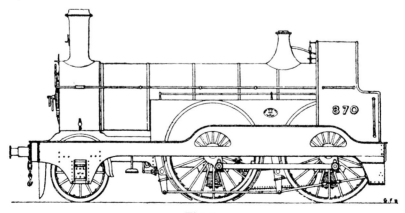

Fig. 80.

80, numbered fifty-six in all, and were of the general dimensions here given: cylinders 17½ inches in diameter with a stroke of 26 inches; diameter of leading wheels 4 feet 1½ inches, and of coupled wheels 6 feet 7½ inches; wheelbase: leading to driving wheel centres 9 feet 8 inches, driving to trailing wheel centres 8 feet 3 inches, total 17 feet 11 inches; length of frame plates 24 feet 11 inches, the overhang being 3 feet and 4 feet at leading and trailing ends respectively. The boiler barrel measured 10 feet 2 inches long, with a diameter outside the smallest ring of 4 feet 0½ inches, and was pitched with its centre line 7 feet 1 inch above the rail level. It contained 174 tubes each 10 feet 6 inches long and 1¾ inches in diameter. The firebox casing was 5 feet 6 inches long by 4 feet 0½ inches wide outside measurement, while the inner firebox measured 4 feet 9½ inches long by 3 feet 4½ inches wide. The boiler pressure was 160 lbs per sq. inch, and heating surface was apportioned as follows: firebox 92.4 sq. ft, tubes 836.9 sq. ft, total 929.3 sq. ft, while the grate area was 16.25 sq. ft. The total weight of engine in working order amounted to 39 tons, distributed as follows: leading wheels 11 tons 10 cwt, driving wheels 14 tons 4 cwt, and trailing wheels 13 tons 6 cwt. An unusually large tender was provided for these engines containing 3,500 gallons of water and 5 tons of coal, its weight as thus loaded amounting to no less than 40 tons 5 cwt 3 qrs, or considerably over a ton greater than that of the engine to which it belonged.

The fifty-six engines of this class were built and numbered as follows:

Date	Doncaster No.	Engine	Date	Doncaster No.	Engine
1888	471	210	1892	590	883
1888	472	204	1892	593	884
1889	477	811	1892	596	885
1889	478	812	1893	606	886
1889	483	813	1893	621	887
1889	484	814	1893	622	888
1889	485	815	1893	624	889
1889	486	816	1893	628	890
1889	489	817	1893	633	891
1889	490	818	1893	635	892
1889	491	819	1893	638	893
1889	492	820	1893	639	894
1889	497	213	1894	642	895
1889	498	214	1894	644	896
1890	508	79	1894	646	897
1890	510	87	1894	648	898
1891	532	861	1894	649	899
1891	534	862	1894	650	900
1891	540	863	1894	665	991
1891	542	864	1894	666	992
1891	549	865	1894	667	993
1891	553	866	1894	668	994
1892	578	867	1894	669	995

1892	579	868	1894	670	996
1892	581	881	1895	677	997
1892	584	882	1895	678	998
1892	585	869	1895	679	999
1892	588	870	1895	680	1000

In all, Stirling built no fewer than 139 engines of this class, a point to which particular attention is drawn, because, in general admiration of the several types of single-wheel express locomotives on the GNR, it is customary to lose sight of the fact that they were a minority as regards numerical importance, whatever may have been their influence in creating and maintaining the reputation of the line for speed.

A new type of front-coupled trailing bogie tank engine, specially fitted for working suburban traffic through the Underground to Moorgate Street, etc., was brought out at the close of 1889. Altogether, twenty-five engines were built of this class, together with four others of slightly different dimensions, and they were all provided with appliances for condensing steam in the tunnels, and were also built with shorter chimneys than usual, only 12 feet 7 inches above the rail level, to meet the exigencies of the Underground loading gauge. The external appearance of the engines is shown in the accompanying illustration of No. 931, *Fig. 81*. The leading dimensions of the twenty-five engines first built were as follows: cylinders 18 inches in diameter with a stroke of 26 inches, angle of inclination towards the driving axle 1 in 81, driving wheels (four-coupled in front) 5 feet 7½ inches in diameter, and bogie wheels 3 feet in diameter; wheelbase: coupled axles, centre to centre: 7 feet 3 inches, driving axle to leading bogie wheel axle, centre to centre, 10 feet 3 inches; bogie wheelbase 5 feet, with the bogie pin 3 inches in advance of the centre, thus giving a wheelbase from the leading wheel centre to the centre of bogie pin of 19 feet 9 inches; total wheelbase 22 feet 6 inches. Total length of frame plates 29 feet 3 inches, the overhang being 5 feet 3 inches at the leading end and 4 feet 3 inches at the trailing end, measured from the bogie pin; height of top of outer frame plates 4 feet 2 inches. The boiler barrel was 10 feet 1 inch in length, with a diameter outside the smallest ring of 4 feet 0½ inches, and

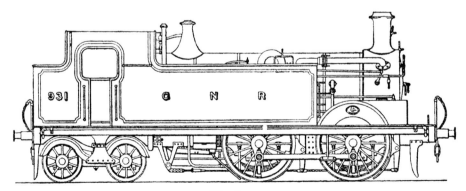

Fig. 81.

it was pitched with its centre line 7 feet 3 inches above the rail level; length of firebox casing 5 feet 6 inches. Heating surface and grate area were practically identical with those of the latest standard goods engines already described. Capacity of side tanks 1,000 gallons. Empty, engines of this class weighed 45 tons 4 cwt, while in full working order the total was 53 tons 9 cwt, distributed as follows: leading wheels 17 tons 7 cwt 2 qrs, driving wheels 17 tons 16 cwt, and bogie wheels 18 tons 5 cwt 2 qrs.

These engines were built at Doncaster and numbered in the order below:

Date	Doncaster No.	Engine	Date	Doncaster No.	Engine No.
1889	499	766	1891	531	829
1890	500	767	1891	535	830
1890	504	768	1892	582	931
1890	506	769	1892	583	932
1890	507	770	1892	589	933
1890	512	821	1892	594	934
1890	513	822	1892	598	935
1890	518	823	1893	601	936
1890	519	824	1893	607	937
1890	520	825	1893	610	938
1890	525	826	1893	614	939
1891	526	827	1893	617	940
1891	528	828			

Four more saddle tank locomotives, built specially for service on the line to Thames Wharf, with short chimneys, etc., were brought out at about this time, with the following numbers:

Date	Doncaster No.	Engine No.	Date	Doncaster No.	Engine No.
1890	516	134	1892	577	144
1890	517	140	1892	580	149

The engines built in 1892, of which the illustration, *Fig. 82*, shows the leading external features, differed from their predecessors of the same type in having the cab and bunker at the trailing end completely closed in, much after the style already adopted for the bogie tank locomotives dating from 1881 onwards, and to this extent afforded a much desired shelter for the men in charge. Their leading dimensions were as follows: cylinders, inclining downwards towards the driving axle at the usual slope of 1 in 8¾, 17½ inches in diameter with a stroke of 24 inches. The six-coupled wheels were each 4 feet 1 inch in diameter, and were distributed over a total wheelbase of 15 feet 6 inches, of which 7 feet 3 inches separated the leading and driving, and 8 feet 3 inches the driving and trailing wheel centres respectively. The two frame plates measured 26 feet 10 inches in length between buffer beams, the overhang being 5 feet 6 inches at the leading end, and 5 feet 10 inches at the trailing end. Pitched with its centre line 6 feet 2 inches above the rail level, the boiler barrel measured 10 feet in length, with a diameter

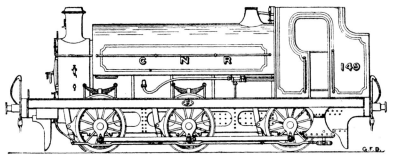

Fig. 82.

outside the smallest ring of 3 feet 10½ inches, and the firebox casing had a length of 5 feet 6 inches outside. The total heating surface was 798 sq. ft, the firebox contributing 83 sq. ft and the tubes 715 sq. ft; the grate area was 16 sq. ft. As in the previous engines of the same class, the saddle tank had a capacity of 1,000 gallons, and the engine in full working order weighed rather more than 40 tons.

The improved style of cab fitted to the class last dealt with was also adopted for the larger type of standard six-coupled goods tank engines from this time onwards; this was introduced in those built at Doncaster, the last to have an open cab being No. 853, as has already been mentioned, while the next running number, No. 854, started the new style. The completion of the series runs in the following order:

Date	Doncaster No.	Engine No	Date	Doncaster No.	Engine No.
1891	548	854	1892	564	858
1891	551	855	1892	568	859
1891	555	856	1892	570	860
1891	559	857			

Others were delivered from 'outside' firms, twenty in all:

Date	Engine Nos	Builders	Builder's Nos
1891	901–10	R. Stephenson & Co.	2751–60
1891	911–20	Neilson & Co.	4398–4407

All these saddle tank goods engines were built to the same general dimensions as were given in reference to the illustration of No. 779, *Fig. 71*, preceding.

In 1892 Stirling brought out a third series of his six-wheeled single express locomotives with 7½ feet driving wheels, eleven in all, thus completing a total of twenty-three of the same general type. In appearance and dimensions there was no conspicuous difference between the earlier and later sets of the series, as can be gathered from an inspection of the accompanying illustration of No. 876, *Fig. 83*, except for the fact that this particular engine and No. 873 were fitted with Davis & Metcalfe's patent exhaust steam injectors. No. 880 is supplied with Macallan's variable blast pipe. The

engines were built in the following order:

Date	Doncaster No.	Engine No.	Date	Doncaster No.	Engine No.
1892	562	871	1894	652	877
1892	566	872	1894	653	878
1892	571	873	1894	654	879
1892	573	874	1894	655	880
1892	576	875	1894	656	981
1894	651	876			

All the above were built to the following leading dimensions: the cylinders were 18½ inches in diameter with a stroke of 26 inches, except in Nos 871–875, which originally had 18-inch cylinders, subsequently enlarged to 18¼, 18¾; or 18½ inches. As in the earlier types, the driving wheels measured 7 feet 7½ inches in diameter with new tyres, and the leading and trailing wheels 4 feet 1½ inches in diameter, and the wheelbase consisted as before of two divisions, 10 feet 8 inches and 8 feet 5 inches, making a total of 19 feet 1 inch between the centre of the leading and trailing wheels. It should be noted, however, that this exceptionally long wheelbase was mitigated to some extent by special play in the leading axleboxes, which eased the engine on curved portions of the road, and the provision of side play has sometimes been understood to imply the use of radial axleboxes. As a matter of fact, the leading axleboxes had free play to the extent of 7/16 inches on either side of the centre line, thus giving a total freedom of 7/8 inches, but the traverse was at right angles to the line of the engine's motion, and in no sense what is implied by the use of the word 'radial'. The boiler of this class of engine carried a working pressure of 160 lbs to the sq. inch, and had a length of barrel of 11 feet 5 inches, and a diameter outside the smallest ring of 4 feet. It was pitched with its centre 7 feet 6 inches above the rail level, and the top of the cast-iron chimney was 13 feet 4 inches above the same datum line. The outside firebox had a length outside of 6 feet 2 inches, and a width at bottom of 4 feet 0½ inches, while the firebox itself measured internally 5 feet 5½ inches long and 3 feet 4½ inches wide, with a depth at the tube plate end of 5 feet 8½ inches, and at the firehole end of 5 feet 2½ inches There were 174 tubes measuring 11 feet 9 inches in length with a diameter of 1¾ inches,

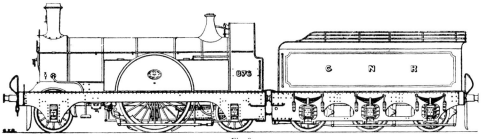

Fig. 83.

giving a heating surface of 936 sq. ft, which, added to the 109 sq. ft of the firebox, provided a total of 1,045 sq. ft. The grate area was 18.4 sq. ft. In full working order these engines weighed nearly a ton more than their predecessors, their distribution being: leading wheels 12 tons 4 cwt, driving wheels 17 tons 8 cwt, and trailing wheels 11 tons 1 cwt, or a total of 40 tons 13 cwt. The standard tender had a capacity for 3,500 gallons of water and 5 tons of coal, and weighed, when full, 40 tons 5 cwt 3 qrs; but some of the engines were subsequently provided with the largest tenders built for express traffic on the GNR, carrying 3,850 gallons of water and weighing 41 tons 14 cwt 2 qrs. Nos 875–876 were stationed at Doncaster, and earned the name of 'trial trip engines', as part of their duties comprised making trial runs with new rolling stock. A splendid photograph of No. 875, which was specially painted in neutral colours for the purpose, was sent to the Chicago World's Fair in 1893.

In the meantime there was still a continued demand for the useful saddle tank engines with six-coupled wheels, and a further ten were built at Doncaster in the years 1892–93, of the prevailing standard dimensions, in the following order:

Date	Doncaster No.	Engine No.	Date	Doncaster No.	Engine No.
1892	591	921	1893	605	926
1892	597	922	1893	608	927
1893	599	923	1893	612	928
1893	600	924	1893	613	929
1893	603	925	1893	615	930

Of these, however, Nos 921–926 were fitted with appliances for condensing, so as to be capable of working across London through the Underground, and the accompanying illustration, *Fig. 84*, shows No. 922 as so fitted, a noteworthy feature in the apparatus being the casing towards the front of the saddle tank, which for a time led to the rumour that Stirling was introducing the steam dome on his later engines.

Hitherto all locomotives of this class had been built with cylinders of the standard dimensions, 17½ x 26 inches, but at this period the diameter was enlarged to 18 inches, and henceforth up to the present day all new engines of this type have been provided with 18 x 26-inch cylinders. Under Stirling's immediate superintendence twenty engines were built at Doncaster with this increase of tractive force, all other dimensions remaining as before, the dates and numbers being as follows:

Date	Doncaster No.	Engine No.	Date	Doncaster No.	Engine No.
1893	618	961	1894	657	971
1893	619	962	1894	658	972
1893	623	963	1894	659	973
1893	627	964	1894	660	974
1893	629	965	1894	661	975
1893	630	966	1894	662	976
1893	636	967	1895	681	977
1894	640	968	1895	682	978

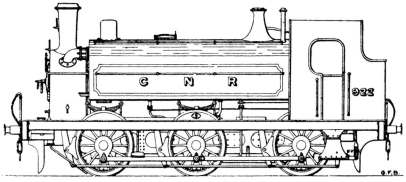

Fig. 84.

| 1894 | 643 | 969 | 1895 | 683 | 979 |
| 1894 | 647 | 970 | 1895 | 684 | 980 |

Of these engines, Nos 971 to 976 were provided with condensing apparatus.

In 1893, two engines of the outside cylinder bogie type were built at Doncaster, which received originally the Nos 264 and 265, but were afterwards renumbered 1001 and 1002. These have already been referred to in the list of 8-foot engines given on page 86.

Stirling added in 1894 another six engines of the same general type, the only difference being a modification in some of the leading dimensions, and an increase in weight and tractive power. Strangely enough, with larger cylinders and more weight available for adhesion, Stirling provided boilers having less heating surface than in previous engines of the type. Indeed, it will be noted with some surprise that the heating surface of the several engines from the beginning of his career on the GNR was on a descending scale, this being particularly noticeable in the large bogie engines. But at the same time, it must be remarked that the firebox and the grate area of the last, about to be mentioned in detail, were larger than before, and it is by these factors, rather than by a huge, but often inefficient, aggregate of tube-surfaces, that the true evaporative power of a boiler is estimated.[1] These six engines, the last express locomotives designed by Stirling, were all built at Doncaster, with the following dates, and works' and running numbers:

Date	*Doncaster No.*	*Engine No.*	*Date*	*Doncaster No.*	*Engine No.*
1894	671	1003	1895	674	1006
1894	672	1004	1895	675	1007
1895	673	1005	1895	676	1008

[1] The apparently larger firebox of the No. 1 class, built in 1870, owed some of its heating surface of 122 sq. ft to the water mid-feather, which was subsequently abandoned in favour of the customary brick arch.

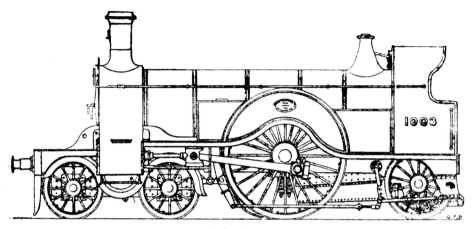

Fig. 85.

In external appearance, as can be seen from the illustration of No. 1003, *Fig. 85*, these engines showed little modification when compared with their predecessors, except with regard, perhaps, to a look of greater compactness caused by an increase of weight and strength in some details, and a trifling alteration of the hitherto prevailing standard pattern of cab, which, in the case under notice, was made to curve backwards some little distance at the top in order to afford a better protection to the engine-men. As will be seen at a later stage, the present locomotive superintendent has still further modified the pattern in the same direction. It will be noticed, moreover, that as the boiler was pitched higher than in preceding engines of this type, Stirling found it necessary to revert to the built-up form of chimney. The leading dimensions of the new engines were as follows: diameter of bogie wheels 3 feet 1½ inches; of the driving wheels 8 feet 1½ inches; and of the trailing wheels 4 feet 7½ inches; wheelbase: bogie-wheel centres 6 feet 6 inches (unequally divided as in previous engines of the class), from hind bogie-wheel to driving wheel centres 7 feet 9 inches, from driving wheel to trailing wheel centres 9 feet, from centre of bogie pin to centre of trailing wheels 19 feet 9 inches, total wheelbase 23 feet 3 inches Cylinders, 19½ inches in diameter with a stroke of 28 inches, except No. 1008, which was built with cylinders only 19 inches in diameter, a measurement she still retains. The boiler barrel had a length of 11 feet 1 inch and a diameter outside the smallest ring of 4 feet, and was pitched with its centre-line 7 feet 6 inches above the level of the rails. It contained 174 tubes, 11 feet 5 inches long with a diameter of 1¾ inches. The boiler-pressure was 170 lbs per sq. inch. An unusually large firebox was provided, the casing having an external length of 6 feet 8 inches, with a breadth at the bottom of 4 feet 0½ inches, while the inside firebox had a length of 5 feet 11½ inches and a breadth of 3 feet 4½ inches, measured at the base. Heating surface: firebox 121.72 sq. ft, tubes 909.98 sq. feet, total 1,031.70 sq. ft; and grate area, 20 sq. ft. When originally built, engines of this class weighed a total of 49 tons 11 cwt, which was distributed as follows: bogie wheels 19 tons 12 cwt, driving wheels 19 tons 4 cwt, and trailing wheels 10 tons 15 cwt. Two of these fine engines, however, achieved an

unenviable notoriety, No. 1006 being in the St. Neots' accident on 10 November, 1895, and No. 1003 in the Little Bytham accident on 7 March of the following year, and the great weight on the driving wheels was thought to have contributed to one or both of these mishaps. Anyhow, a re-adjustment of the load seems to have been effected, for at a later date the weight of No. 1007 was officially given as follows: bogie wheels 19 tons 15 cwt., driving wheels 18 tons, trailing wheels 11 tons, total, 48 tons 15 cwt. The tenders supplied to these engines were of the large type, carrying 3,850 gallons of water and five tons of coal, and weighing, thus loaded, 41 tons 14 cwt 2 qrs.

A modified pattern of the latest standard type of bogie tank engine, fitted for working through the Underground, was brought out in 1895. Four engines were built to this new design in the following order:

Date	Doncaster No.	Engine No.	Date	Doncaster No.	Engine No.
1895	688	941	1895	690	943
1895	689	942	1895	691	944

In external appearance, as can be seen from *Fig. 86*, these engines were very similar to their predecessors, the chief difference being that the side tanks were shorter. The supply of water was, in fact, divided over the two side tanks and a well tank placed at the rear of the footplate, below the coal bunker. In general dimensions these latter engines were almost identical with their forerunners, as will be gathered from the accompanying list. Diameter of driving wheels 5 feet 7½ inches, and of bogie wheels 3 feet Wheelbase: coupled wheels 7 feet 3 inches, from centre of driving axle to centre of leading bogie axle 10 feet 9 inches, centre to centre of bogie wheels 5 feet, total wheelbase 23 feet. Cylinders 18 x 26 inches, inclined downwards, as usual, in the ratio of 1 in 8¾. Boiler barrel 10 feet 1 inch long, with a diameter outside the smallest ring of 4 feet 0½ inches; height of centre above rails 7 feet 3 inches; and of chimney top above rails 12 feet 7 inches. Firebox casing 5 feet 6 inches long outside, with a depth below the centre line of the boiler of 5 feet 2 inches and 4 feet 8 inches, at front and back ends respectively.

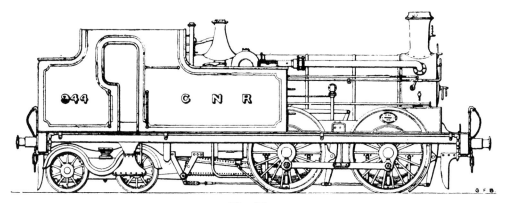

Fig. 86.

The weight was approximately the same as in the earlier engines, but rather differently distributed.

With the introduction of this type of engine, Stirling's career may be said to have finished, for the illness which resulted in his death came about shortly afterwards, on 11 November, 1895. So far as his reputation as a designer of new and successful types of locomotives is concerned, the foregoing brief historical notes will, it is to be hoped, assist in showing him to have been a man of strong convictions and with the courage to put his theories into practice. He deserves, indeed, to rank among the great locomotive superintendents of the age, not perhaps on account of any very startling originality of design or ingenious application of new principles, but certainly in consideration of the uniform excellence of his work and its peculiar aptness for the duty it was intended to perform. To so great an extent was his influence felt in the history of the railway company that to mention the GNR at any time without coupling with consideration of it the name of Patrick Stirling is equivalent to that much-quoted hypothetical case of playing *Hamlet* with the title-role carefully omitted.

THE GREAT NORTHERN RAILWAY. 145

Table II.

List of G.N.R. Locomotives, Designed by Mr. Patrick Stirling, Built in the years 1867-1896.

Date.	Description.	Driving Wheels.	Cylinders.	First of Type.	Reference to Doncaster List.	Number of Engines built.	Where built.
		ft. in.	ft. in.	No.			
1867	Coupled Passenger	6 7	17 ×24	280	—	20 built	Outside
1867	Front-coupled Mixed Traffic	5 7	17 ×24	18	A	46 ,,	Doncaster
1867	Six-coupled Goods	5 1	17 ×24	474	—	20 ,,	Outside
1868	Six-wheel Single	7 1	17 ×24	4	B	12 ,,	Doncaster
1868	Six-coupled Saddle Tank	5 1	17 ×24	392	C	8 ,,	,,
1868	Six-wheel Radial Tank	5 7	17½×24	126	D	13 ,,	,,
1869	Six-coupled Goods	5 1	17 ×24	369	E	17 ,,	,,
1870	Six-wheel Single	7 7	17½×24	92	F	1 ,,	,,
1870	Bogie Single	8 1	18 ×28	1	G	37 ,,	,,
1871	Coupled Passenger	6 7	17 ×24	261	H	2 ,,	,,
1871	Six-coupled Mineral	5 1	19 ×28	174	I	6 ,,	,,
1872	Six-coupled Saddle Tank	4 1	16 ×22	471	J	2 ,,	,,
1872	Bogie Well Tank	5 7	17½×24	120	K	22 ,,	,,
1873	Rebuilds of " Sharpies "	—	—	43	L	4 ,,	,,
1874	Six-coupled Saddle Tank	4 1	16 ×22	136	J2	6 ,,	,,
1874	Six-coupled Goods	5 1	17½×26	372	E2	36 ,,	,,
1874	Coupled Passenger	6 7	17½×26	86	H2	19 ,,	,,
1874	Six-coupled Goods Tank	4 7	17½×26	494	M	35 ,,	,,
1874	Front-coupled Mixed Traffic	5 7	17½×24	74	A2	25 ,,	,,
1875	Front-coupled Mixed Traffic	5 7	17½×24	551	—	50 ,,	Outside
1876	Front-coupled Saddle Tank	5 1	17½×26	501	N	4 ,,	Doncaster
1877	Bogie Well Tank	5 7	17½×24	621	K2	26 ,,	,,
1878	Front-coupled Saddle Tank	5 1	16 ×22	631	N2	2 ,,	,,
1881	Coupled Passenger	6 7	17½×26	208	H3	9 ,,	,,
1881	Six-coupled Goods Tank	4 7	17½×26	672	M2	43 ,,	,,
1881	Bogie Side Tank	5 1	17½×26	658	O	16 ,,	,,
1882	Six-coupled Goods	5 1	17½×26	716	—	35 ,,	Outside
1882	Six-coupled Saddle Tank	4 1	17½×24	684	J3	4 ,,	Doncaster
1882	Front-coupled Mixed Traffic	5 7	17½×24	103	A3	12 ,,	,,
1883	Six-coupled Mineral	4 7	17½×26	374	P	8 ,,	,,
1883	Coupled Passenger	6 7½	17½×26	701	—	15 ,,	Outside
1884	Coupled Passenger	6 7½	17½×26	751	H4	18 ,,	Doncaster
1884	Bogie Single	8 1½	18 ×28	771	G2	10 ,,	,,
1885	Six-wheel Single	7 7½	18½×26	238	Q	2 ,,	,,
1886	Six-wheel Single	7 7½	18½×26	234	Q2	10 ,,	,,
1886	Six-coupled Goods	5 1½	17½×26	791	E3	72 ,,	,,
1887	Front-coupled Mixed Traffic	5 7½	17½×24	10	A4	21 ,,	,,
1888	Coupled Passenger	6 7½	17½×26	210	H5	56 ,,	,,

List of G.N.R. Locomotives, designed by Mr. Patrick Stirling—*continued.*

Date.	Description.	Driving Wheels.	Cylinders.	First of Type.	Reference to Doncaster List.	Number of Engines built.	Where built.
		ft. in.	ft. in.	No			
1889	Bogie Side Tank..........	5 7½	18 × 26	766	**R**	25 built	Doncaster
1890	Six-coupled Saddle Tank..	4 1	17½ × 24	134	**J4**	4 ,,	,,
1891	Six-coupled Goods Tank ..	4 7½	17½ × 26	854	**M3**	7 ,,	,,
1891	Six-coupled Goods Tank ..	4 7½	17½ × 26	901	—	20 ,,	Outside
1892	Six-wheel Single..........	7 7½	18½ × 26	871	**Q3**	11 ,,	Doncaster
1892	Six-coupled Goods Tank	4 7½	17½ × 26	921	**M4**	10 ,,	,,
1893	Six-coupled Goods Tank ..	4 7½	18 × 26	961	**M5**	20 ,,	,,
1894	Bogie Single	8 1½	19½ × 28	1003	**G3**	6 ,,	,,
1895	Bogie Side and Well Tank	5 7½	18 × 26	941	**R2**	4 ,,	,,
1896	Six-coupled Mineral	4 7½	17½ × 26	1021	**P2**	10 ,,	,,
1896	Six-coupled Goods Tank ..	4 7½	18 × 26	1046	—	15 ,,	Outside
1896	Six-coupled Goods........	5 1½	17½ × 26	1031	—	15 ,,	,,
1896	Six-coupled Goods........	5 1½	17½ × 26	1081	**E4**	10 ,,	Doncaster

Harold A. Ivatt was the GNR's Locomotive Superintendent from 1896 until 1910.

H. A. Ivatt, 1896–1902

On the death of Patrick Stirling at the close of the year 1895, H. A. Ivatt was appointed locomotive engineer of the Great Northern Railway. At the time of accepting this new and distinctly honourable post of succeeding so distinguished a locomotive superintendent as Stirling, Ivatt held the same position on the GS&W Railway of Ireland, and the new chief of the GNR loco department brought with him from across the Irish Sea a deservedly high reputation which has certainly suffered in no degree from his change of scene. As some time had necessarily to elapse, however, before he was able completely to relinquish his former duties to take up the newer, it was not until the close of 1896 that any engine exclusively of his design made its appearance on the Great Northern metals. In the interval a certain number of engines were, indeed, placed upon the line, but they were practically built to Stirling's standard patterns.

For example, during the interregnum fifteen engines of the six-coupled goods tank class were ordered from outside, to which were allotted the following numbers:

Date	Engine Nos	Builder	Builder's Nos
1896	1046–60	Neilson & Co.	5017–31

Of these, Nos 1056–1060 were built to condense their own steam.

Other engines in hand between the death of one and the succession of the other locomotive superintendent included ten goods engines similar in almost every respect to the powerful mineral engines introduced on the West Riding service in 1883, having six-coupled wheels 4 feet 7½ inches in diameter, and 17½ x 26 inch cylinders. The outside appearance of these engines is shown in the illustration of No. 1021, *Fig. 87*, and they were all built at the Doncaster Works of the company with the following running and shop numbers:

Date	Doncaster Nos	Engine Nos
1896	692–70	1102–1030

In addition a continuation of the series of standard six-coupled goods engines was in hand, these locomotives having 5 feet 1½ inches driving wheels and 17½ x 26-

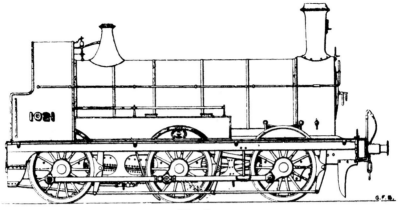

Fig. 87.

inch cylinders. Twenty-five were built, partly at Doncaster and partly 'outside', in the following proportions:

Date	Builder	Builder's Nos	Engine Nos
1896	GNR Co.	702–711	1081–1090
1896	Dübs & Co.	3370–3384	1031–1045

Nearly at the close of the year 1896 Ivatt produced from the Doncaster Works his first passenger engine designed for the GNR, which was allotted the running No. 400, and in its details marked a new departure so far as this particular line was concerned. In reality, however, this locomotive contained no startling novelties. It was not designed for express traffic, but was merely an improved development of the four-coupled passenger engines already in use, having the same size of driving wheels and cylinders as had been adopted by Stirling for many years. Apart from these main characteristics, nevertheless, there was abundant evidence of a change of *regime*, the principal external indications being the employment of a leading bogie and the presence of a steam dome on the boiler barrel. As can be seen from the accompanying *Fig. 88*, No. 400 differed also in external details of lesser importance, changes being made in the shape of the cab, in the driving wheel splashers and in the position of the sandboxes.

This engine had cylinders 17½ inches in diameter with a stroke of 26 inches, their distance apart from centre to centre being 2 feet 4½ inches, thus allowing a fairly generous space for the valves to be placed between them. The steam ports measured 14 inches by 1½ inches, and the exhaust ports 14 x 3½ inches; and the valves had a maximum travel of 4$\frac{1}{8}$ inches, with a lead in full gear of $\frac{5}{32}$ inches and an outside lap of 1$\frac{1}{8}$ inches In nearly every respect this maiden design has constituted a standard for future reproduction. The bogie, of the swing link type, had four wheels each having a diameter on the tread, when new, of 3 feet 7½ inches, the centres of the two axles being 6 feet 3 inches apart, with the bogie pin 1½ inches to the rear of the central position, thereby causing two unequal divisions of 3 feet and 3 feet 3 inches between the bogie pin and the trailing and leading bogie wheels respectively. The two pairs of

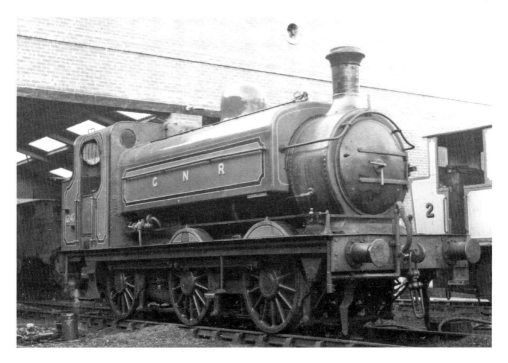

One of Ivatt's very successful J52-class, 0-6-0 saddle tank, built by Sharp, Stewart & Co. in 1899 and illustrated by G. F. Bird in *Fig. 90*.

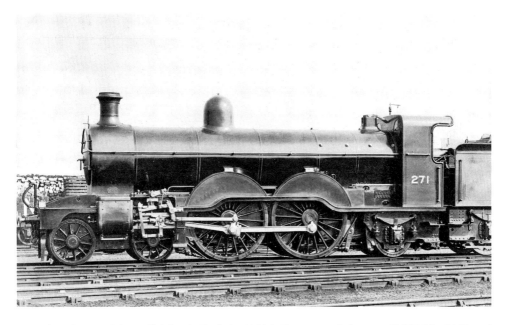

Ivatt class C2, a 4-4-2 'small Atlantic' built in 1902 in Doncaster. It became LNER No. 3271 and was withdrawn in 1936. Known as the 'Klondike' No. 2 was fitted with small cylinders but was not a success and was rebuilt in 1911. *(JC)*

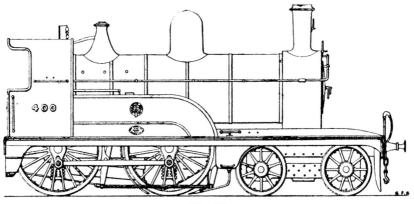

Fig 88.

coupled wheels, 6 feet 7½ inches in diameter, had their centres 8 feet 3 inches apart, and from the driving wheels to the rear pair of bogie wheels there was a distance of 6 feet 9 inches, centre to centre, the total wheelbase of the engine being 21 feet 3 inches Between buffer beams the frame plates measured 27 feet 7 inches, the overhang being 2 feet 5 inches in front, or 5 feet 8 inches reckoned from the bogie pin, and 3 feet 11 inches at the trailing end. It will be noted that Ivatt substituted a steel plate buffer beam at the leading end in place of the 'sandwich' beam adopted by his predecessor.

Apart from the addition of a steam dome, Ivatt has modified the design of the boiler by the reduction of the three telescopic rings standardized by Stirling to two, and the employment of a thicker gauge of plate to stand the increased working pressure of 170 lbs per sq. inch, $^9/_{16}$ inches in place of 0½ inches The barrel of the boiler measured 10 feet 1 inch long, with a diameter outside the smallest ring of 4 feet $3^7/_8$ inches, and it was pitched with its centre line 7 feet 5½ inches above the level of the rails. At the leading end was a smokebox having an external length of 2 feet 10¼ inches and provided with a cast-iron chimney of standard GNR pattern. The firebox casing had an outside length of 5 feet 6 inches, a maximum external width of 4 feet $6^1/_8$ inches at the centre line of the boiler and of 4 feet 0½ inches at the bottom, and was built throughout of $^9/_{16}$ inches plate. The firebox itself was of copper and had a length at the top of 4 feet 9¾ inches, and at the bottom of 5 feet 0¼ inches, a width at the top of 3 feet 8 inches and at the bottom of 3 feet 6¾ inches, and a height in front of 5 feet 11 inches, and at back of 5 feet $5^3/_{16}$ inches, all inside measurements, while the side and back plates were $^9/_{16}$ inches, and the tube plate was 0¾ inches in thickness. Firebox and casing were held together by means of 665 copper stays $^7/_8$ inches in diameter. Within the barrel of the boiler were packed 215 copper tubes 10 feet $4^3/_8$ inches long between plates, and 1¾ inches in outside diameter, with a thickness of 10 s.w.g. (standard wire gauge) at the firebox end and 12 s.w.g. at the smokebox end. The steam dome had an inside diameter of 2 feet. In the matter of heating surface this engine showed a distinct increase on its predecessors, the total being 1,123.8 sq. ft, of which 103.1 sq. ft were contributed by the firebox and 1,020.7 sq. ft by the tubes; the grate area measured 17.8 sq. ft. A total weight in full working order of 44 tons 7 cwt was distributed as

follows: bogie wheels 16 tons 9 cwt, driving wheels 14 tons 9 cwt, and coupled wheels 13 tons 9 cwt. The tender was of a somewhat modified type, having the tank arranged in horseshoe fashion, and with gauge cocks fitted at the footplate end to show the amount of water at any time remaining in the tank. It was carried on six wheels, each 4 feet 1½ inches in diameter, equally spaced over a wheelbase of 13 feet There was a capacity of 3,287 gallons of water and 200 cubic feet of coal, the weight of the tender empty being 18 tons 12 cwt 2 qrs and loaded 38 tons 6 cwt. In all, eleven engines were built at Doncaster to this initial design in the following order:

Date	Doncaster Nos	Engine Nos
1896	712	400
1897	723–732	1071–1080

No. 1080, however, differed from the rest in having a plain cast-iron safety valve cover of the ordinary Ramsbottom pattern in place of the polished brass column adopted throughout by Stirling.

Immediately following the first of the above class came a set of ten engines of similar type and dimensions, except for the fact that they had only a single pair of leading wheels instead of a bogie, and heavy outside plate frames of the Stirling pattern. The leading wheels were 4 feet 1½ inches in diameter and placed in advance of the driving wheels to the extent of 9 feet 8 inches, the total wheelbase being 17 feet 11 inches. The overhang of the frames was 3 feet at the leading end and 3 feet 11 inches at the trailing end. It will be noted from the illustration, *Fig. 89*, that the springs of the leading wheels were placed above the running plate, a position which renders them easier of access for inspection and repairs, though perhaps less neat than Stirling's system of concealing them between the frames. In the same way the removal of the sandboxes from the front of the driving-wheel splashers to a situation below the running plate allows much-desired facilities for getting at the motion. The boilers of these six-wheeled engines were identical in every respect with that of No. 400, already described. In full working order the engines weighed a total of 41 tons 10 cwt, distributed as follows: leading wheels 13 tons, driving wheels 15 tons, trailing wheels 13 tons 10 cwt and the new standard tender was supplied, weighing 38 tons 6 cwt when fully loaded. The numbers of these locomotives are given below:

Date	Doncaster Nos	Engine Nos
1897	713–722	1061–1070

It should be noted that the first three of these engines were built with a plain black beading round the driving splashers, while Nos 1064–1070 had the outer edge finished off with a brass rim.

Ivatt's next contributions to the locomotive stock of the railway consisted of a further supply of the six-coupled goods engines with saddle tanks which had originally been introduced by his predecessor. The new engines, however, presented certain modifications of details, and were heavier though the chief alterations visible to outside observation

consisted in the introduction of a steam dome, and the abolition of the brass column surrounding the Ramsbottom safety valves. Comparatively few of these engines were put in hand at the Doncaster Works, the greater proportion of the total of fifty-two so built under Ivatt's directions being the product of outside firms, as the following list shows:

Date	Builders	Builder's Nos	Engine Nos
1897	GNR Co.	733	111
1897	GNR Co.	734	155
1897	GNR Co.	735–744	1201–1210
1897	Neilson & Co.	5095–5099	1211–1215
1898–9	R. Stephenson & Co.	2921–2930	1216–1225
1899	Sharp, Stewart & Co.	4471–4495	1226–1250

A peculiar feature of the five engines built by Neilson & Co. was that they had no domes, and still retained the safety valve brass column. These engines are shown in *Fig. 90*, which represents No. 1213. The same features were also preserved in Nos 111 and 155, built at Doncaster. It is possible that these particular engines were in reality built to the Stirling specifications, though dated so late as 1897. As regards the others, however, they bear unmistakable signs of a later design, as can be seen from *Fig. 91*, which shows

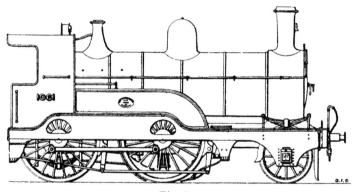

Fig. 89.

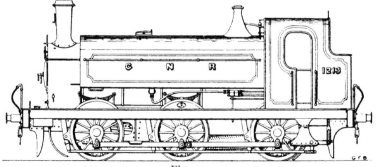

Fig. 90.

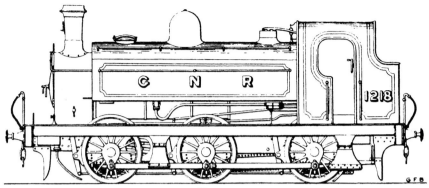

Fig. 91.

No. 1218 of the Stephenson set, and is sufficiently indicative of the appearance of all, except for very trifling differences of detail in such matters as the position and shape of the supplementary step on the running plate, etc. The leading dimensions of Nos 1201–1210, 1216–1250 particularly, were as follows: cylinders 18 inches in diameter with a stroke of 26 inches, diameter of driving wheels 4 feet 7½ inches; wheelbase: leading to driving wheels 7 feet 3 inches, driving to trailing wheels 8 feet 3 inches, total 15 feet 6 inches; length of frame plates 27 feet 6 inches, with an overhang of 5 feet 11 inches and 6 feet 1 inch at leading and trailing ends respectively. The boiler was of Ivatt's standard pattern, consisting of two telescopic rings each of plate $^9/_{16}$ inches thick, the smaller of which had an outside diameter of 4 feet 3$^7/_8$ inches, but forming a barrel measuring slightly more than usual, 10 feet 6 inches The centre of the boiler was pitched at a height of 7 feet l inch above the rail level, and the barrel contained 215 tubes each having an outside diameter of 1¾ inches The firebox was of the standard dimensions already given in detail in describing Ivatt's coupled bogie engine. A total heating surface was provided of 1,164.23 sq. ft, the tubes yielding 1,061.13 sq. ft, and the firebox 103.1 sq. ft, and the grate area measured 17.8 sq. ft. In full working order these engines weighed 51 tons 14 cwt, distributed as follows: leading wheels 16 tons 7 cwt, driving wheels 18 tons, and trailing wheels 17 tons 17 cwt.

Towards the close of 1897 and the beginning of 1898, a series of coupled passenger engines with leading bogies was brought out. As can be seen from the illustration, *Fig. 92*, which shows No. 1312, these were practically the same as No. 400, already described, except for the introduction of the ordinary iron casing to the Ramsbottom safety valves, which had already been adopted on No. 1080, as previously mentioned. In dimensions these engines were throughout identical with their prototype, so that a recapitulation of the figures already given is unnecessary here. The numbers of the engines in question were as follows:

Date	Doncaster Nos	Engine Nos
1897	745–754	1301–1310
1898	759–768	1311–1320

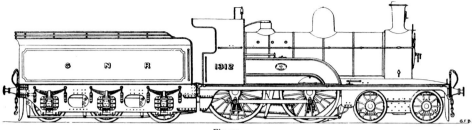

Fig. 92.

Of these the engines built in 1897 had a brass beading round the driving-wheel splashers, while Nos 1311–1320 had a black beading. No. 1320 differed from the rest by having the running plate raised at the driving wheels to clear the coupling rods, a detail which has since been adopted on other engines. This engine is illustrated separately in *Fig. 93*.

A tank engine of quite a new design, intended for local services, was introduced upon the GNR in 1898, having ten wheels, inside cylinders, and side tanks, with a coal bunker at the trailing end. No. 1009, shown in *Fig. 94*, was the finest one of this class, which has so far comprised ten engines having the following dates and numbers:

Date	Doncaster No.	Engine No.	Date	Doncaster No.	Engine No.
1898	755	1009	1898	789	1016
1898	756	1010	1898	790	1017
1898	757	1013	1898	791	1018
1898	758	1014	1898	796	1019
1898	788	1015	1898	797	1020

As originally built, Nos 1009 and 1010 had ordinary rigid axle boxes to the trailing wheels, whilst the rest were provided with radial axle boxes in order to secure greater flexibility of wheelbase. No. 1009 also differed from the others in having its Doncaster

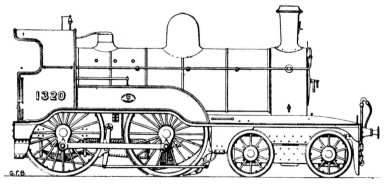

Fig. 93.

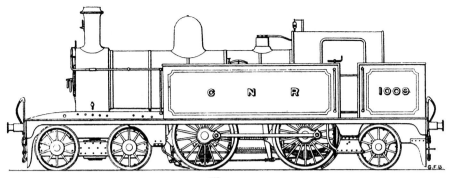

Fig. 94.

number plate at the front end of the tank instead of on the frame. In all other respects the engines of the class were identical, and they were built as nearly as possible to the standard dimensions introduced by Ivatt, according to the following official figures: the bogie and trailing wheels had a diameter of 3 feet 7½ inches, and the coupled wheels had a diameter of 5 feet 7½ inches Wheelbase: bogie wheels, centre to centre 6 feet 3 inches, with the bogie pin only 3 feet in advance of the hind bogie wheel axle; from hind bogie axle to driving axle, centre to centre 6 feet 9 inches; coupled axles, centre to centre 8 feet 3 inches, and from centre of hind coupled axle to centre of trailing axle 6 feet. The frame plates had a total length of 33 feet 3¾ inches, with an overhang of 2 feet 5 inches and 3 feet 7¾ inches at the leading and trailing ends respectively. Cylinders 17½ inches in diameter with a stroke of 26 inches The boiler was pitched with its centre line 7 feet 6 inches above the rail level, and had a barrel measuring 10 feet 1 inches long, and 4 feet 3⅞ inches in diameter outside the smallest ring. It contained 215 tubes of 1¾ inches outside diameter, and was provided with a smoke-box measuring 2 feet 8⅞ inches in length outside, and with a firebox casing having an outside length of 5 feet 6 inches The working pressure of the boiler was 170 lbs per sq. inch, and the heating surface was made up to a total of 1,123.8 sq. ft, of which the firebox contributed 103.1 sq. ft, and the tubes 1,020.7 sq. ft, while the grate area measured 17.8 sq. ft. The capacity of the tanks was 1,350 gallons, and of the coal bunker 50 cwt, and in full working order engines of this class weighed a total of 59 tons 15 cwt, distributed as follows: Bogie wheels 15 tons 10 cwt, driving wheels 16 tons 15 cwt, coupled wheels 17 tons, and trailing wheels 10 tons 10 cwt. These ten engines were not provided with appliances for condensing, and were fitted with cast-iron chimneys of the usual height, so that they were not adapted for Metropolitan traffic involving trips through the Underground; but subsequently other engines of the same general type and dimensions, but with special modifications fitting them for tunnel work, were built.

So far, Ivatt had not designed any locomotives for the express passenger traffic of the line, his coupled engines of the No. 400 class being intended for general work which might include express passenger service, but equally comprised express goods and special traffic. About the middle of 1898, however, he produced from the Doncaster Works a passenger express locomotive of a type novel in this country, and far exceeding in power and capacity any engine so far built for the GNR. This engine, No. 990, of

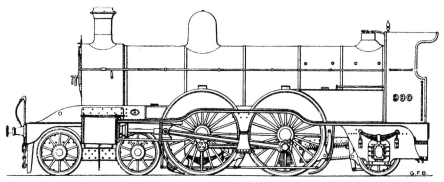

Fig. 95.

which the accompanying illustration, *Fig. 95*, shows the external characteristics, had, as can be seen, outside cylinders and two pairs of coupled driving wheels, with a four-wheeled bogie at the leading end and small pair of trailing wheels under the back end of the firebox, thus embodying the general characteristics of what is now generally known as the 'Atlantic' type. The cylinders, which were placed at a slight inclination, were 18¾ inches in diameter, with a stroke of 24 inches, with their centre lines distant transversely to the extent of 6 feet 5½ inches, and they drove the second pair of coupled wheels by means of connecting rods having the somewhat unusual length of 10 feet between centres. The steam ports measured 1½ x 16 inches, and the exhaust ports 3½ x 16 inches, and the valves had an extreme range of travel of 4½ inches The coupled wheels had a diameter on the tread of 6 feet 7½ inches, and were placed with their centres 6 feet 10 inches apart, and the distance of the centre of the trailing axle from the centre of the driving axle was 8 feet, thus giving a total rigid wheelbase of 14 feet 10 inches In reality, however, the rigid wheelbase is restricted to the distance between the coupled axles, as there is allowance made for lateral play in the trailing-wheel axle-boxes. The bogie was of standard design, having four wheels each of 3 feet 7½ inches diameter spread over a wheelbase of 6 feet 3 inches, with the bogie pin 1½ inches to the rear of the centre, and the second pair of bogie wheels was in advance of the leading pair of coupled wheels to the extent of 5 feet 3 inches centre to centre, the total wheelbase being 26 feet 4 inches The single inside frame plates measured 33 feet 0¾ inches, having an overhang of 2 feet 5 inches and 4 feet 3¾ inches at leading and trailing ends respectively. It will be noted that the trailing axle has outside bearings in a supplementary outside frame plate, thereby ensuring a greater transverse space for the firebox.

Apart from the foregoing, a large degree of interest was centred in the boiler, which was of exceptional pattern and dimensions. The barrel, which was pitched with its centre line 7 feet 11 inches above the rail level, measured 14 feet 8⅝ inches in length, with a diameter outside the smallest ring of 4 feet 8 inches This extreme length, however, was not utilized exclusively for tube heating surface, as the leading end of the barrel was recessed to the amount of 1 feet 11¼ inches, so as to provide an extension of the smokebox capacity, and this arrangement curtailed the length of the tubes to 13 feet between the end plates. The tubes were 191 in number, and were of an outside diameter of 2 inches The firebox

casing had a length of 8 feet and a depth below the centre line of the boiler of 5 feet 6 inches in front, and 5 feet at back, and these ample measurements allowed of the use of a firebox having the very generous heating surface of 140 sq. feet, and with a grate area of 26.75 sq. ft. The total heating surface equalled 1,442 sq. ft, the tubes contributing 1,302 sq. ft, and a working pressure of 175 lbs per sq. inch was provided. It is obvious that a still larger nominal heating surface could have been obtained by reducing the diameter of the tubes and increasing their number, but this would be in opposition to Ivatt's theory and practice. In full working order the engine weighed 58 tons, distributed as follows: bogie wheels 15 tons, first pair of coupled wheels 12 tons, driving wheels 16 tons, and trailing wheels 12 tons. An unusually large tender was provided, having a capacity for 3,670 gallons of water and 5 tons of coal, and weighing 40 tons 18 cwt when thus loaded, the total weight of engine and tender being 98 tons 18 cwt. This engine, which has recently been honoured by receiving the name *Henry Oakley*, was given the running No. 990, its works number being No. 769, and it has proved so successful that ten new engines have been built of practically similar design and dimensions. It may be interesting to note that in these big engines Ivatt has placed the regulator in the steam dome, and has reverted from the standard GNR push and pull handle to the two-armed pattern moving across the back of the firebox in a sector plate.

Following the totally new departure in locomotive design just referred to, Ivatt brought out an enlarged pattern of the eight-wheeled bogie passenger locomotive, its principal features of difference from the No. 400 class being in respect to the use of a larger boiler and firebox, this latter causing a greater length of wheelbase between the coupled axles, while the larger boiler, pitched at a higher level from the rails, produced a return to the 'built-up' form of chimney in place of the standard cast iron pattern which had been in vogue during the later years of Stirling's rule at Doncaster. These features of resemblance and difference are indicated in the illustration, *Fig. 96*, which shows No. 1321, the first of the class. Five engines were built at Doncaster of this modified type with the following numbers:

Date	Doncaster Nos	Engine Nos
1898	770–774	1321–1325

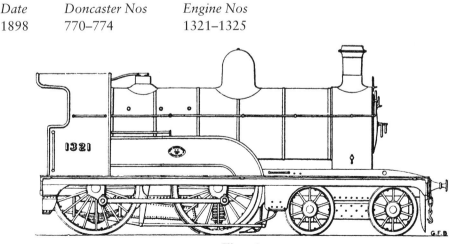

Fig. 96.

The leading dimensions were: cylinders 17½ x 26 inches; diameter of bogie wheels 3 feet 7½ inches, and of coupled wheels 6 feet 7½ inches; wheelbase: bogie 6 feet 3 inches, divided unequally; bogie pin to driving axle, centre to centre 9 feet 9 inches; coupled axles, centre to centre 9 feet; total wheelbase 22 feet; length of frame plates 28 feet 1 inches, with an overhang of 2 feet 5 inches and 3 feet 8 inches at leading and trailing ends respectively. The boiler had a length of barrel of 10 feet 1 inch, its centre line being pitched 7 feet 11 inches above the rail level, and was formed of two rings, that nearest the smokebox having an outside diameter of 4 feet 9⅛ inches, while the second ring, which lapped inside the first ring and the firebox covering, had an outside diameter of 4 feet 8 inches. The smokebox measured 2 feet 10¼ inches long outside and the firebox casing was 6 feet 4 inches long. Inside the boiler barrel were 238 tubes, each 10 feet 4⅜ inches long, with an outside diameter of 1¾ inches. The heating surface was: firebox 119.9 sq. ft, tubes 1,129.9 sq. ft, total 1,249.8 sq. ft, the grate area being 20.8 sq. ft. The safety valves were pressed to 170 lbs. per sq. inch. In working order engines of this class weighed 47 tons 10 cwt, distributed as follows: bogie 16 tons 10 cwt, driving wheels 17 tons, and trailing wheels 14 tons. A standard tender, weighing 40 tons 18 cwt, with its full complement of fuel and water, was provided.

At about this time ten new goods engines built by an 'outside' firm were put to work, their numbers being:

Date	Engine Nos	Builder	Builder's Nos
1897	1091–1095	Dübs & Co.	3546–50
1898	1096–1100	Dübs & Co.	3551–55

They occupied, in appearance, a half-way position between the Stirling and Ivatt regimes, having the late superintendent's pattern of cab and brass safety-valve casing in conjunction with his successor's new design of frame and standard type of boilers, as is shown in the illustration, *Fig. 97*. Their dimensions were as follows: cylinders

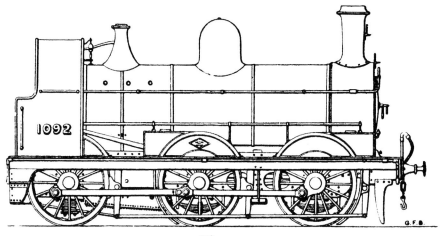

Fig. 97.

17½ x 26 inches; diameter of six-coupled wheels 5 feet 1½ inches; wheelbase: leading to driving wheel centre 7 feet 3 inches, driving to trailing wheel centre 8 feet 3 inches, total wheelbase 15 feet 6 inches, length of frames 24 feet 5½ inches, with an overhang of 5 feet 2 inches and 3 feet 9½ inches at leading and trailing ends respectively. The boiler was of exactly the same dimensions throughout as the standard pattern adopted in No. 400, and was pitched with its centre-line 7 feet 3½ inches above the rail level. In working order these engines weighed a total of 38 tons 8 cwt, distributed as follows: leading wheels 14 tons, driving wheels 15 tons 2 cwt, and trailing wheels 9 tons 6 cwt.

Immediately following these engines came ten built at Doncaster bearing odd numbers:

Date	Doncaster No.	Engine No.
1898	775	315
1898	776	316
1898	777	318
1898	778	329
1898	779	331
1898	780	332
1898	781	334
1898	782	336
1898	783	337
1898	784	338

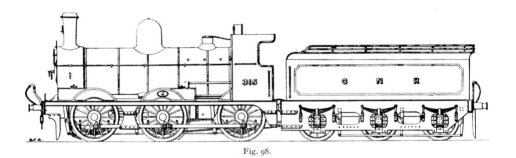

Fig. 98.

As can be seen from the illustration, *Fig. 98*, which shows No. 315 with its tender, these engines had the new standard boiler throughout, even to the iron safety-valve casing and the new cab. The frame was also of the new and modified pattern and differed also in respect to having a cast-iron drag box at the trailing end, which, in adding to the weight of the engine generally, caused a better distribution on the last pair of coupled wheels, the figures being: leading wheels 14 tons 11 cwt, driving wheels 15 tons 4 cwt, and trailing wheels 11 tons 10 cwt, or a total of 41 tons 5 cwt. In general dimensions they were precisely similar to the class last mentioned, so that it is unnecessary to recapitulate the various items.

Coincidently with these engines built at Doncaster, a further thirty-five exactly similar locomotives were under construction 'outside', their numbers being:

Date	Builder	Builder's Nos	Engine Nos
1898	Dübs & Co.	3695–3699	1101–1105
1899	Dübs & Co.	3700–3729	1106–1135

Having obtained satisfactory results from the new and enlarged bogie passenger engines recently described, Ivatt undertook the construction of a number embodying the same general features, but differing somewhat in external appearance, as can be gathered from *Fig. 99*, which illustrates No. 1327. It will be noted that, while in main dimensions these engines were exactly identical with Nos 1321–1325 as regards cylinders, boilers, wheels and frames, and even weight, they had the outside running plate raised to clear the coupling rods, as is shown, this modification having been already tried on No. 1320, one of the smaller bogie engines, as was mentioned at the time. These new locomotives also differed from their five predecessors in having a larger smokebox, measuring 3 feet 5½ inches in length outside. In all, twenty engines were built during 1898–9 (all at Doncaster) to the pattern shown in the accompanying illustration – their dates and numbers being:

Date	Doncaster No.	Engine No.	Date.	Doncaster No.	Engine No.
1898	785	1326	1899	852	1336
1898	786	1327	1899	853	1337
1898	792	1328	1899	854	1338
1898	793	1329	1899	855	1339
1898	794	1330	1899	856	1340
1898	795	1331	1899	857	1361
1898	798	1332	1899	858	1362
1898	799	1333	1899	859	1363
1898	800	1334	1899	860	1364
1898	801	1335	1899	861	1365

No. 1331 was fitted with Marshall's valve gear in order to test that device on passenger work.

Quite a new departure was made at this period by the production of an express locomotive with single driving wheels and a leading bogie, but with cylinders placed inside the frames. As can be seen from *Fig. 100*, this engine, which received the running No. 266 (Doncaster Works No. 787, 1898), was of exceptionally fine appearance. It was built on generous lines and in respect to the aggregate of dimensions seems almost to mark the extreme limits permissible by the English loading gauge to an engine of this type. The driving wheels were 7 feet 7½ inches in diameter and were driven by cylinders 18 inches in diameter with a stroke of 26 inches, with steam and exhaust ports measuring 16 x 1½ inches, and 16 x 3½ inches respectively. The leading end of the engine was earned by a bogie of standard dimensions, having four wheels each 3 feet 7½ inches in diameter, with their axles 6 feet 3 inches apart centre to centre. At the trailing end were a pair of wheels 4 feet 1½ inches in diameter, and it will be noted that the bearings and springs of these wheels were placed outside, the main frames being

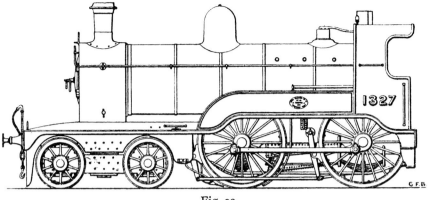

Fig. 99.

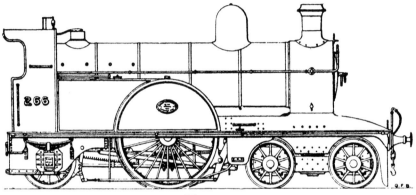

Fig. 100.

adapted at the rear of the driving wheels to secure this end, and thus giving greater stability to the engine as a carriage. The wheelbase was divided as follows: bogie wheels 6 feet 3 inches (as already mentioned), from centre of trailing bogie wheels to centre of driving wheels 7 feet 9 inches, from centre of driving wheels to centre of trailing wheels 9 feet, thus giving a total of 23 feet.

The frames measured 28 feet 8 inches over all, with an overhang of 2 feet 8 inches and 3 feet at the leading and trailing ends respectively, and they were of a very massive character, as can be judged in part from the appended illustration. In the matter of boiler power, Ivatt has throughout been more liberal than his predecessor, and No. 266 was no exception to the rule. Its boiler had a barrel formed of two telescopic rings, having a combined length of 11 feet 4 inches, and a diameter outside the two rings of 4 feet 37/8 inches and 4 feet 5 inches respectively, the plates being 9/16 inches thick to withstand the working pressure of 170 lbs per sq. inch. In order to accommodate this diameter of barrel the boiler was pitched with its centre line 8 feet 3 inches above the level of the rails. At the leading end was a capacious smokebox having an outside length of 3 feet 37/8 inches and the firebox casing measured 7 feet in length. Inside

the barrel of the boiler were 215 copper tubes, 11 feet 7³/₈ inches long between the tube plates and with an outside diameter of 1¾ inches The heating surface reached a total of 1,269.6 sq. ft, of which 125.8 sq. ft were contributed by the firebox, and 1,143.8 sq. ft by the tubes, and the fire grate area was 23.2 sq. ft. In full working order the engine weighed 47 tons 10 cwt, apportioned as follows: bogie wheels 17 tons 10 cwt, driving wheels 18 tons, and trailing wheels 12 tons. The tender was of the large pattern, weighing 40 tons 18 cwt with its complement of 3,670 gallons of water and 5 tons of coal.

Following this came a number of bogie passenger locomotives similar in all respects to the No. 1301 class already illustrated and described. These were built at Doncaster in the following order:

Date	Doncaster Nos	Engine Nos
1898	802–811	1341–1350

These retained the straight form of outside frame in contra-distinction to the curved pattern tentatively adopted on No. 1320, definitely accepted for the No. 1326 class of large passenger engines, and subsequently also taken as the standard for future engines of the smaller type.

To meet the requirements for more engine power for trains in the Metropolitan district twenty new locomotives were built. These were tank engines of the ten-wheel type introduced at the beginning of 1898, slightly modified to render them especially suitable for running through the tunnels of the Underground. In general dimensions they were identical with their forerunners of the No. 1009 class, save that they were all fitted with condensing apparatus, and that all except the first were supplied with short chimneys of the built-up pattern, with a height above the rails of only 12 feet 5⁵/₈ inches, and a corresponding reduction in the height of the steam dome in order to clear the loading gauges of the Metropolitan Railway. These modifications give the engines the appearance of being larger, especially as regards the boiler barrel, than those without condensing arrangements, but the only differences between the two classes are those already stated, and an increase in weight in the condensing engines to a total of 62 tons 2 cwt distributed as follows: bogie wheels 16 tons 10 cwt, driving wheels 18 tons, coupled wheels 16 tons 12 cwt, and trailing radial wheels 11 tons. The capacity of the tanks and bunkers was also the same in the two classes, namely, 1,350 gallons and 2½ tons respectively.

Fig. 101 shows the external appearance of these locomotives, except so far as No. 1501 was concerned, this particular engine having the longer cast-iron chimney and larger steam dome of the earlier non-condensing class; as a consequence it is not employed on the London service. These engines were built at Doncaster in the following order:

Date	Doncaster Nos	Engine Nos
1899	812–821	1501–1510
1899	832–841	1511–1529

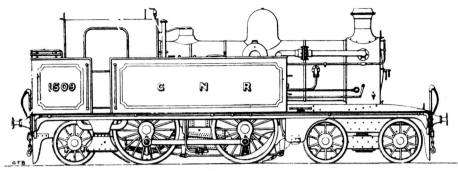

Fig. 101.

At this time a number of the older goods engines on the line were getting past work, and it became necessary to supply their places by new stock, besides making requisite additions to cope with increased traffic. The Doncaster Works being actively employed, it became necessary to give substantial orders to outside firms. It happened that at this time the locomotive builders in this country were fully engaged on orders to a degree that prohibited all idea of early delivery, and to meet the situation it was necessary to look to other sources of manufacture for supply, and accordingly twenty locomotives were ordered from the Baldwin Locomotive Works, Philadelphia, with a more or less free hand as regards general design. These engines were delivered ten at a time with most praiseworthy expedition, being shipped over in parts and put together ready for steam at Ardsley. They were all delivered to the railway company at a very early date in 1900 with one exception, the last of the set of twenty, No. 1200, being sent to Paris by its makers to form part of their noteworthy exhibit in the Exposition of that year. The numbers and dates of these were as follows:

Date	Baldwin Works Nos	Engine Nos
July 1899	16927–16936	1181–1190
January 1900	17321–17325	1191–1195
January 1900	17355–17359	1196–1200

In outside appearance equally with constructive details, these American engines showed a marked difference as compared with the standard GNR goods locomotives. From *Fig. 102* it will be seen that they were of the 'Mogul' type, having outside cylinders, six-coupled driving wheels, a leading pony truck, and a tender carried on two bogies. With the exception of the chimney, buffers and brake pipe fittings and sand boxes, which are below the footboard as in English practice, they were of American type throughout, merely modified to meet the restrictions of loading gauge, and designed to yield as nearly as possible the same efficiency of duty as the standard goods engines on the line. The leading dimensions were as follows: cylinders 18 inches in diameter with a stroke of 24 inches; driving wheels 5 feet 1½ inches in diameter, truck and tender wheels 3 feet in diameter; wheelbase of engine 22 feet 8 inches, divided in the following proportion: centres of truck and leading coupled wheels 7 feet 11 inches, centres of leading coupled

and driving wheels 6 feet 3 inches, centres of driving and trailing coupled wheels 8 feet 6 inches The boiler, which was of the flush-topped pattern, was built of ⅝ inches plates, with a diameter of 4 feet 6¾ inches, and contained 254 tubes measuring 10 feet 11¾ inches long with a diameter of 1¾ inches The safety valves, of the 'pop' pattern, were pressed to blow off at 175 lbs per sq. inch. The firebox was 6 feet long by 2 feet 9¼ inches broad by 6 feet 3½ inches deep, and there was a total heating surface of 1,380 sq. ft, the firebox contributing 120 sq. ft and the tubes 1,260 sq. ft; the grate area measured 16.7 sq. ft. In full working order these engines weighed 44 tons 19 cwt, of which 6 tons 15 cwt 3 qrs were on the truck, and 38 tons 3 cwt 1 qr on the six-coupled wheels. The double bogie tender carried 3,500 gallons of water and 5 tons of coal, and weighed, thus loaded, 37 tons 14 cwt 2 qrs. It is interesting to note that for its capacity the American type of tender possesses less dead weight than the English six-wheeled pattern, a result which is mainly secured by the use of lighter and consequently thinner plates in the building of the tanks.

In the meantime orders for goods engines of Ivatt's standard pattern were being executed both at the Doncaster Works of the railway company, and by Kitson & Co., of Leeds, and Dübs & Co., of Glasgow, two orders of twenty each being in hand at Doncaster during the years 1899 and 1900 respectively, while the 'outside' contingents consisted of twenty-five each. Of those built by Dübs & Co., however, only thirteen were actually delivered to the GNR, the other twelve being transferred to the Midland & Great Northern Joint Railway on completion, receiving that company's running Nos 81–92. Those built by the GNR bore the following numbers:

Date	Doncaster No.	Engine No.	Date	Doncaster No.	Engine No.
1899	822	343	1900	882	165
1899	823	344	1900	883	177
1899	824	345	1900	884	179
1899	825	348	1900	885	180
1899	826	349	1900	886	192
1899	827	350	1900	887	302
1899	828	351	1900	888	303
1899	829	352	1900	889	304
1899	830	353	1900	890	306
1899	831	359	1900	891	308
1899	842	360	1900	892	384
1899	843	361	1900	893	386
1899	844	362	1900	894	387
1899	845	363	1900	895	388
1899	846	364	1900	896	390
1899	847	367	1900	897	392
1899	848	368	1900	898	394
1899	849	371	1900	899	396
1899	850	375	1900	900	398
1899	851	381	1900	901	399

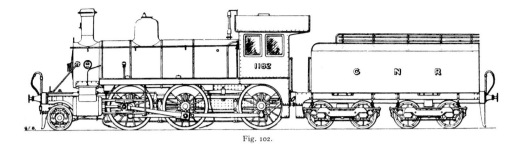

Fig. 102.

The engines built 'outside' bore the following numbers:

Date	Builder	Builder's Nos	Engine Nos
1900	Kitson & Co.	3924–3948	1136–1160
1901	Dübs & Co.	3945–3957	1161–1173

In general dimensions all these goods engines were similar to the earlier Doncaster built engines of the No. 315 class. So far as external appearance is concerned, those locomotives built at the company's works were also identical with No. 315, an illustration of which has already been given, except that the sand boxes used when running tender-first were removed from the middle pair of driving wheels to the trailing pair, and thus are concealed within the cab side plates. The same alteration was made with respect to the engines built 'outside', as can be seen from the accompanying illustration, *Fig. 103*, which shows No. 1138, and these were further distinguished by cast-iron chimneys of the 'built up' pattern, and brass beading round the splashers. In all other details they were practically of standard pattern.

Further engines of the smaller or No. 400 class of coupled passenger engines with a leading bogie were built during 1899. It has already been mentioned that of the preceding series No. 1320 differed from its companions in respect to having the

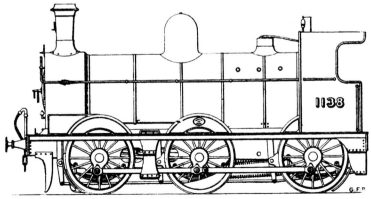

Fig. 103.

running-plate raised to clear the coupling rods, and an illustration of this particular locomotive was given in *Fig. 93*. The latest engines of this class were precisely similar to that illustration, except for the one detail that their chimneys, though of cast-iron, were moulded so as to give the appearance of the 'built up' pattern. Their numbers were:

Date	Doncaster Nos	Engine Nos
1899	862–871	1351–1360

After exhaustive trials of the large ten-wheel passenger engine, No. 990, it was decided to place more locomotives of the same class upon the road. These later engines were generally, in so far as their main dimensions were concerned, exactly similar to their prototype. The chief external points of difference lay in such details as an alteration of the framing at the leading end and a modification of the sanding arrangements. The steam sander delivered the sand under the driving or second pair of coupled wheels from boxes placed between the frames midway between the coupled axles, while the boxes and pipes used in running backwards were, in most cases, done away with. These engines also are fitted with a novel arrangement for locking the reversing gear in any desired position, consisting of a friction lock on the reversing shaft which is actuated by vacuum.

The illustration, *Fig. 104*, showing No. 989 with its tender, also marks a slight modification adopted in the latter, the brake-blocks being applied at the front of the tender wheels instead of at the back, as had previously been the practice. Altogether, in addition to No. 990, ten engines of this class have so far been built, with the following numbers:

Date	Doncaster Nos	Engine Nos
1900	872–873	949–950
1900	874–881	982–989

In the meantime, Ivatt's new single-wheeler, No. 266, had already been running sufficiently long to prove its success in first-class express work, and another engine of a similar type was put in hand. It differed from its forerunner, however, in details of the motion, having cylinders 19 inches in diameter with balanced valves on top, the movement of the link motion being transmitted by means of a rocking shaft. The valves are balanced by strips on the Richardson system, and the exhaust takes place straight through the top. The leading dimensions were as follows: cylinders 19 inches in diameter, with a stroke of 26 inches; diameter of bogie wheels with 3 inches tyres 3 feet 8 inches, of driving wheels 7 feet 8 inches, and of trailing wheels 4 feet 2 inches. Wheelbase: bogie 6 feet 3 inches, from trailing bogie wheel to driving wheel centres 7 feet 9 inches, and from driving to trailing wheel centres, 9 feet. Length of frames 27 feet 8 inches, with an overhang at leading and trailing ends of 2 feet 8 inches and 3 feet respectively. Boiler barrel: length 11 feet 4 inches, diameter outside smallest ring 4 feet 3$7/8$ inches, thickness of plates $9/16$ inches, height of centre above rails 8 feet 3 inches, length of smokebox 3 feet $7/8$ inches, length of

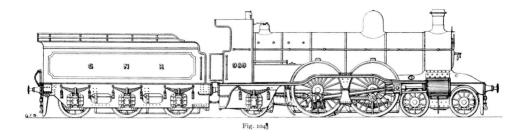

Fig. 104.

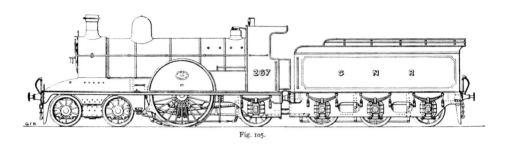

Fig. 105.

outside firebox 7 feet, width 4 feet 0½ inches. Heating surface: firebox 125.8 sq. ft, tubes 1,143.8 sq. ft, total 1,269.6 sq. ft, grate area 23.2 sq. ft, working pressure 175 lbs per sq. inch. Weight of engine in full working order 48 tons 11 cwt, of which 17 tons 15 cwt was available for adhesion. Weight of tender with 3,670 gallons of water and 5 tons of coal 40 tons 18 cwt. The illustration, *Fig. 105*, also shows this engine to have had a deeper frame at the forward end, but with these exceptions it was practically a reproduction of No. 266. So far, eleven engines have been built to the design in the following order:

Date	Doncaster No.	Engine No.
1900	902	267
1901	934	92
1901	935	100
1901	936	261
1901	937	262
1901	938	263
1901	939	264
1901	940	265
1901	941	268
1901	942	269
1901	943	270

It will be noted with regret that these engines have displaced some historic veterans, which now drop into the fatal 'A' list.

Continuing in chronological order, the next locomotives built at Doncaster were twenty of the large four-coupled bogie class, similar to Nos 1321–1325, already described and illustrated. Twenty engines were turned out in the following order:

Date	Doncaster No.	Engine No.	Date	Doncaster No.	Engine No.
1900	903	1366	1900	913	1382
1900	904	1367	1900	914	1383
1900	905	1368	1900	915	1384
1900	906	1369	1900	916	1375
1900	907	1370	1900	917	1376
1900	908	1371	1901	918	1377
1900	909	1372	1901	919	1378
1900	910	1373	1901	920	1379
1900	911	1380	1901	921	1381
1900	912	1374	1901	922	1385

Immediately following the appearance of the engines last referred to, came a new type of goods locomotive which is deserving of extended mention. From time to time, as this brief history has sought to show, the locomotive superintendents of the GNR have produced exceptionally powerful engines for the heavy mineral traffic of the line. Sturrock led off with his famous steam tender engines, and Stirling followed suit with the large mineral engines of 1872. In neither instance, however, was the general traffic management of the line quite ripe for the introduction of such power, and the two classes severally failed owing to their very success. Apparently, however, the time is now suitable for a considerable increase in the tractive capacity of mineral engines on the GNR, and Ivatt has responded by designing a type of locomotive for this work which bids fair to meet all requirements in that direction for some years to come.

Fig. 106, shows the pioneer of the type and presents the chief details of its outside appearance. It will be seen at once that No. 401 is of immense tractive and adhesive power, having cylinders 19¾ x 26 inches, eight-coupled wheels having, with 3 inch tyres, a diameter of only 4 feet 8 inches, and a total weight available for adhesion of more than 54½ tons, while its capacity to raise sufficient steam to supply those big cylinders is evidenced by the ample size of the boiler, which is practically of the same type as that adopted already for the large ten-wheel express engines of the '990' class. The cylinders, whose dimensions as new are stated above, drive the second pair of wheels, towards which they incline downwards at an angle corresponding to a drop of 4 inches in 2 feet 2⅜ inches, the distance from centre of cylinders to centre of driving axle being 9 feet 9 inches, and the connecting rods being 5 feet 7¾ inches long between

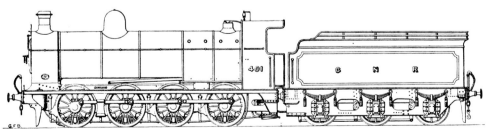

Fig. 106.

centres. The slide valves are of the balanced kind, on top of the cylinders, deriving their motion from the eccentrics and expansion gear through the medium of a rocking shaft. The driving wheels, 4 feet 8 inches in diameter, occupy a total wheel-base of 17 feet 8 inches, of which 5 feet 8 inches separate the middle pairs, with the leading and trailing axles respectively distant to the extent of 6 feet. Overall, the frame plates measure 30 feet, the overhang in front being 6 feet 3 inches, and at back 6 feet 1 inch, while the footplate is 4 feet 2 inches above the rail level. The boiler barrel, pitched with its centre line 8 feet 4 inches above the rails, is built up of three rings of $9/16$ inch steel, the middle ring having an outside diameter of 4 feet $6^7/8$ inches, and the outer rings being 4 feet 8 inches in diameter outside. The length of the barrel is 14 feet $8^5/8$ inches, of which, however, 1 foot $11\frac{1}{4}$ inches is occupied by the rearward extension of the smokebox. The smokebox proper has a length of 3 feet $2^3/8$ inches and a diameter of 5 feet $6\frac{1}{2}$ inches, inside measurements. The firebox casing is 8 feet long outside and 4 feet $0\frac{1}{2}$ inches wide at the bottom, its depths below the centre line of the boiler being 5 feet 6 inches in front and 4 feet 8 inches at back. Within the boiler barrel are 191 tubes 2 inches in diameter and 13 feet long, the total heating surface being 1,438.84 sq. ft, of which the firebox contributes 136.74 sq. ft, and the tubes the remaining 1,302.1 sq. ft. The grate area is 24.5 sq. ft. It should be noted that though the Ramsbottom type of safety valve is retained in these big engines, it is duplicated, and the working pressure is fixed at 175 lbs per sq. inch. In full working order this type of engine weighs a total of 54 tons 12 cwt 1 qr, apportioned as follows: Leading wheels 13 tons 3 cwt 2 qrs, driving wheels 14 tons 18 cwt 3 qrs, intermediate wheels 12 tons 18 cwt 1 qr, and trailing wheels 13 tons 111 cwt 3 qrs. The tender is of the standard large type, weighing, with 3,670 gallons of water and 5 tons of coal, 40 tons 18 cwt 1 qr; thus the total weight of engine and tender is 95 tons 10 cwt 2 qrs; and the total length over buffers is 54 feet $7\frac{1}{2}$ inches.

Following is a list of the eight-coupled mineral engines of the No. 400 class built up to 1906:

Date	Doncaster No.	Engine No.	Date	Doncaster No.	Engine No.
1901	923	401	1903	1009	422
1902	964	402	1903	1010	424
1902	965	405	1903	1011	426
1902	966	406	1903	1012	427
1902	967	407	1903	1013	429
1902	968	403	1903	1014	430
1902	969	408	1903	1015	428
1902	970	409	1903	1016	431
1902	971	410	1904	1027	432
1902	972	404	1904	1028	433
1902	973	411	1904	1029	434
1902	976	412	1904	1050	435
1902	978	414	1904	1051	436
1902	982	413	1904	1052	437

1902	983	415	1904	1053	438
1902	984	417	1904	1054	439
1902	985	416	1904	1055	440
1902	986	418	1906	1139	441
1902	987	419	1906	1140	442
1902	988	420	1906	1141	443
1902	989	421	1906	1142	444
1903	1007	423	1906	1143	445
1903	1008	425			

No. 407 and several others were subsequently fitted with a variable blast pipe, which is automatically worked from the reversing rod, and No. 417 has been fitted with the Schmidt superheater and piston valves, in conjunction with which the Klinger forced system of lubricating the cylinders and valves was introduced.

In succession to the engine last illustrated came a further series of ten-wheeled tank locomotives fitted with condensing apparatus, for working the London suburban traffic through the Underground to Moorgate Street and elsewhere. These were of the type already described, and illustrated by *Fig. 101*, but it should be noted that they differed from their predecessors in having cylinders 18 inches in diameter, with a stroke of 26 inches, and in the absence of rails round the bunker-top. Their numbers were:

Date	Doncaster Nos	Engine Nos
1901	924–933	1521–1530

Two further series of this class of engine have since been built:

Date	Doncaster Nos	Engine Nos
1903	1017–1026	1531–1540
1907	1155–1164	1541–1550

No. 1533 was fitted with brake blocks to the wheels of the bogie, and No. 1514 of the earlier series was also so equipped, while No. 1520 of the earlier series was fitted with Marshall's valve gear.

In 1901 also there arose a need for a further supply of the useful goods locomotives with six-coupled wheels and a saddle tank over the boiler, of which Stirling had built upwards of 150, and Ivatt had already put forty-five on the rails. Accordingly another forty, having six-coupled wheels 4 feet 7½ inches in diameter and cylinders 18 x 26 inches, were constructed at Doncaster:

Date	Doncaster Nos	Engine Nos
1901	944–954	1251–1261
1902	955–963	1262–1270
1905	1087–1096	1271–1280
1908	1216–1225	1281–1290

Nos 1251–1270 differed from the other engines of the same type in having a raised deck to the cab-roof, about 6 inches high, which is fitted with ventilators, and the later engines of the class had fluted coupling rods.

A few years ago almost every locomotive superintendent of note designed a four-cylinder high-pressure engine for express traffic, more or less as a protest against the introduction of the compound system, and in 1902 Ivatt built an engine, No. 271 (Doncaster No. 974), which is shown in *Fig. 107*. It will be seen that No. 271 bears a resemblance to No. 990, in that it has a leading bogie, four-coupled wheels and a small pair of trailing wheels. No. 271 is, however, provided with four cylinders, two outside the frames and two inside, placed in line. These cylinders are each 15 inches in diameter, with a stroke of 20 inches, and drive direct on the first pair of coupled wheels, with connecting rods 5 feet 9¾ inches long, the distance from centre of cylinders to centre of driving axle being 9 feet 3 inches. The bogie and trailing wheels are each 3 feet 7½ inches in diameter, while the four-coupled wheels are 6 feet 7½ inches in diameter, and are placed with their centres 6 feet 3 inches apart, the total wheelbase being 26 feet 9 inches, of which the bogie-wheel centres account for 6 feet 3 inches, and the distance of the trailing wheels from the rearmost coupled axle accounts for 7 feet 6 inches. Overall, the frame-plates measure 33 feet 7¼ inches, the overhang being 2 feet 5 inches and 4 feet 5¼ inches at leading and trailing ends respectively. The original boiler, with its centre 8 feet 1 inch above the rails, had a barrel 15 feet 4¼ inches long, with a diameter outside the smallest, or middle ring, of 4 feet 6⅞ inches. The smokebox had a length externally of 3 feet 3¼ inches, and it was extended within the boiler barrel, but not to the same degree as in the '990' class, the distance between tube plates being 14 feet. The tubes were only 141 in number, 2¼ inches in diameter. The firebox casing measured 8 feet in length, with a breadth at the bottom of 4 feet 0½ inches, giving a heating surface of 140¼ sq. ft, to which was to be added the tube surface of 1,162¾ sq. ft, making a total of 1,303 sq. ft. The grate area was 24½ sq. ft. Duplex safety valves were fitted, pressed to blow off at 175 lbs per sq. inch. In its original state this engine weighed 58 tons 15 cwt, divided as follows: bogie 15 tons 10 cwt, driving wheels 17 tons, coupled wheels 15 tons 15 cwt, and trailing wheels 10 tons 10 cwt; and the tender was of the smaller kind, fitted with water pick-up apparatus, weighing in working order only 38 tons 10 cwt.

In 1904, No. 271 was fitted with the Walschaerts valve gear, and towards the close of 1908 was again overhauled and a boiler of the standard 990 class fitted, having a total heating surface of 1,442 sq. ft.

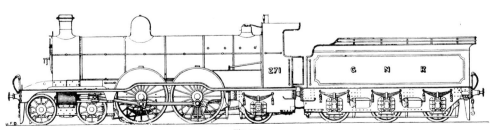

Fig. 107.

The next engines constructed at Doncaster were a further series of bogie four-coupled passenger locomotives of the '1326' class, already described and illustrated, and these have been succeeded by two other series, as the following list shows:

Date	Doncaster No.	Engine No.	Date	Doncaster No.	Engine No.
1902	975	1386	1907	1169	1399
1902	977	1388	1907	1170	1180
1902	979	1391	1908	1226	41
1902	980	1389	1908	1227	42
1902	981	1387	1908	1228	43
1902	990	1390	1908	1229	44
1902	992	1394	1908	1230	45
1902	993	1395	1908	1231	46
1902	994	1392	1908	1232	47
1902	995	1393	1908	1233	48
1907	1165	1396	1908	1234	49
1907	1167	1397	1908	1235	50
1907	1168	1398			

In December 1902, there appeared the first of a class of passenger express engine, which is to the modern Great Northern locomotive equipment what Stirling's famous 8-foot singles were to the same railway's stock of forty years ago. This noteworthy engine, No. 251, which is illustrated in *Fig. 108*, was the prototype of the standard GNR express engine of today, and has so far justified its existence that there are now no fewer than eighty-one of the class.

So far as the general dimensions of cylinders, wheels and length are concerned, it was practically identical with the pioneer British 'Atlantic', No. 990, already described and illustrated, but it was fitted with a much larger boiler, with a total heating surface of 2,500 sq. ft, and this innovation, which also increased the adhesion weight by several tons, has rendered it a far more powerful machine than the earlier engine.

A point not mentioned in connection with No. 990, though the feature is common to all the GNR Atlantic engines, large and small, is the differential throw of the connecting and coupling rod pins. The coupling rod pins of the driving wheels are 6 inches in diameter, and have a throw of 11½ inches, while the connecting rod pins are 5 inches in diameter, turned eccentrically on the larger coupling rod pins, so as to give

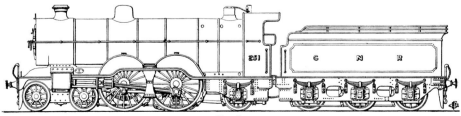

Fig. 108.

a throw of 12 inches. Thus, while the stroke of the pistons is 24 inches, the coupling rods travel in a circle of only 23 inches diameter, a reduction which at high speeds is of considerable importance in reducing the stress on those rods. Another point of interest is the reversing gear, which has a vacuum lock of Ivatt's invention fitted on the middle of the reverse shaft, this holding the gear in any set position.

The boiler was naturally the chief feature of interest in this engine. The barrel consisted of two rings, each of ⅝ inch steel plate, giving a total length of barrel of 16 feet 3⅞ inches, the one nearest the smokebox being 8 feet 6¾ inches long and 5 feet 4¾ inches in diameter outside, and the other 8 feet 1 inch long and 5 feet 6 inches in diameter outside. The smokebox tube-plate was of the drumhead type, set inside the front ring, the actual length of the boiler between tube-plates being 16 feet, and the smokebox was also extended forward, its total internal length being about 5 feet 9 inches, and its internal diameter 5 feet 11¼ inches. The centre of the boiler was 8 feet 8½ inches above the level of the rails, and this height, with the large diameter of the smokebox, reduced the effective outside height of the chimney to 1 foot 7½ inches; this, however, was partly obviated by continuing the inner lining of the chimney 2 feet 1 inch downwards into the smokebox, when it terminated in a bell mouth of 2-foot diameter slightly below the level of the upper row of tubes, and 10⅝ inches above the top of the 5¼ inch blast pipe. The firebox was of a design not hitherto adopted in Great Britain, curving out from the shape of the boiler barrel at top to a wide base resting on the main engine frames. At the foundation ring it had an external length of 5 feet 11 inches, and a width of 6 feet 9 inches. In order to clear the driving wheels both the throat plate and the lower part of the firebox tube-plate were sloped backwards at an appreciable angle. The inside firebox had a length inside at the top of 5 feet 5⁷/₁₆ inches, a width inside at the bottom of 5 feet 11⅝ inches, and a depth in front of 5 feet 0½ inches, and at back of 4 feet 6½ inches. below the centre line of the boiler. The crown plate was 1 foot 2³/₁₆ inches and 1 foot 0¹¹/₁₆ inches above the centre line at front and back respectively. The heating surface of the firebox was 141 sq. ft, and of the 248 tubes, 16 feet long by 2¼ inches diameter, 2,359 sq. ft, giving a total of 2,500 sq. ft, the grate area was 30.9 sq. ft. Four safety valves of the Ramsbottom type, each 3-inches in diameter, were enclosed in a circular casing on the firebox, and were adjusted to blow off at a pressure of 175 lbs per sq. inch. Owing chiefly to the increased size of the boiler, No. 251 weighed considerably more than No. 990, the total weight of the engine in working order being 68 tons 8 cwt, distributed as follows: On bogie wheels 17 tons 6 cwt, on each pair of coupled wheels 18 tons and on trailing wheels 15 tons. The tender was of the standard type, and weighed 40 tons 18 cwt with 3,670 gallons of water and 5 tons of coal. It differed from its predecessors, however, in being fitted with Ivatt's patent water pick-up apparatus which has since been very largely adopted on the GNR tenders.

As has already been mentioned there are at present no fewer than eighty-one engines of the '251' class in service, their dates and numbers being as follows:

Date	Doncaster No.	Engine No.	Date	Doncaster No.	Engine No.
1902	991	251	1904	1040	283
1904	1030	272	1904	1041	285

1904	1031	273	1904	1042	282
1904	1032	274	1904	1043	286
1904	1033	275	1904	1044	284
1904	1034	276	1904	1045	287
1904	1035	277	1904	1046	289
1904	1036	278	1904	1047	288
1904	1037	279	1904	1048	290
1904	1038	280	1904	1049	291
1904	1039	281	1905	1067	293
1905	1068	297	1906	1146	1423
1905	1069	296	1906	1147	1424
1905	1070	294	1906	1148	1425
1905	1071	295	1906	1149	1427
1905	1072	298	1906	1150	1428
1905	1073	299	1906	115I	1426
1905	1074	301	1906	1152	1429
1905	1075	300	1906	1153	1430
1905	1076	1400	1906	1154	1431
1905	1077	1401	1907	1171	1432
1905	1078	1402	1907	1172	1433
1905	1079	1403	1907	1173	1434
1905	1080	1405	1907	1174	1435
1905	1081	1404	1907	1175	1436
1905	1082	1406	1908	1186	1437
1905	1083	1407	1908	1187	1438
1905	1084	1408	1908	1188	1439
1905	1085	1409	1908	1189	1440
1905	1086	1410	1908	1190	1441
1905	1109	1411	1908	1191	1443
1905	1110	1412	1908	1192	1444
1905	1111	1413	1908	1193	1442
1905	1112	1414	1908	1194	1445
1906	1113	1415	1908	1195	1446
1906	1114	1416	1908	1196	1447
1906	1115	1417	1908	1197	1448
1906	1116	1418	1908	1199	1450
1906	1117	1419	1908	1200	1449
1906	1118	1420	1908	1201	1451
1906	1144	1422			

For the purpose of instituting comparative trials with No. 292, a four-cylinder compound 'Atlantic', which will be described in due course, No. 294 was altered to carry a working pressure of 200 lbs per sq. inch. The result of these trials was that the compound engine showed a slight superiority in efficiency and economy, though scarcely to so marked a

degree as to compensate for the enhanced prime cost of construction.

One of the later engines of the class, No. 1442, after running for about 40,000 miles, which included hauling the Royal train conveying the King and Queen to Leeds in the summer of 1908, was temporarily withdrawn from service in the spring of 1909, and was overhauled in the shops and given an 'exhibition finish' prior to being shown in the Machinery Hall at the Imperial International Exhibition at Shepherd's Bush. It was shown standing on the present standard track of the GNR, with 100-lb rails, and a portion of a water-trough in the four-foot, whilst alongside it was Stirling's pioneer 8-foot single, No. 1, which had been withdrawn from service in August, 1907, after completing upwards of 1,400,000 miles. This veteran had then been partially dismantled, and much of its internal gear and fittings removed, but for the purposes of exhibition it was thoroughly overhauled, and not only so, but renovated as far as possible in its original condition, and supplied with an old tender with wooden brake-blocks, as in 1870. It was also shown standing on a specimen of the track of that period, with steel rails weighing 80 lbs per yard.

An interesting series of comparative trials was instituted between engines of this class and standard LNWR express locomotives during the summer of 1909. No. 1449 was 'lent' to the LNWR and put to work on the traffic between Euston and Crewe. The engine was worked by its own driver and fireman, with a LNWR driver as pilot-man. During the same period the LNWR locomotive No. 412, *Marquis*, a four-coupled bogie engine of the 'Precursor' class, was at work on the GNR main line, with its own driver and fireman and a GNR pilot-man, running between King's Cross, Doncaster and Leeds on alternate days, in competition with the Atlantic No. 145. No official figures are forthcoming as to the results of these friendly trials, which naturally aroused considerable interest in the railway world. A somewhat similar test was made some time previously when a standard L&YR express engine was 'lent' to and ran for some time on the GNR, with one of that company's tenders.

The next new class of engine constructed at Doncaster was a large eight-coupled tank locomotive with a pair of trailing wheels. This engine, No. 116, which is illustrated in *Fig. 109*, was, as originally built, so far as boiler, cylinders and wheels were concerned, practically identical in dimensions with the eight-coupled mineral engines of the '401' class, with the addition of side tanks and an end bunker, and condensing apparatus, this last being fitted with the intention that this locomotive should work passenger and goods traffic over the Metropolitan underground section of the GNR, and the chimney and steam dome were of a modified pattern in order to pass the Metropolitan loading gauge. The cylinders were 19¾ inches in diameter, with a stroke of 26 inches. The diameter of the eight-coupled wheels was 4 feet 7½ inches, and of the radial trailing wheels 3 feet 7½ inches. The total wheelbase was 25 feet 2 inches, the two middle pairs of coupled wheels being 5 feet 8 inches apart, centre to centre, and the two extreme pairs being respectively distant from these to the extent of 6 feet, while the trailing axle was 7 feet 6 inch to the rear of the last coupled axle, centre to centre. The engine measured 35 feet 7¼ inch over the buffer beams, the overhang being 6 feet 5 inches and 4 feet 0¼ inches at leading and trailing ends respectively; the total length over all was 38 feet 7¼ inches. The boiler originally supplied was similar to that of the No. 401 class, and its centre line

was 8 feet 4 inches above the rails. As originally built, the side tanks and bunker were of exceptionally large capacity, being built to hold 2,000 gallons of water and 4 tons of coal respectively. In road-worthy condition, the engine weighed a total of 79 tons, the distribution being: on leading coupled wheels, 15 tons; on driving, intermediate and trailing coupled wheels, 17 tons per axle; and on trailing radial wheels, 13 tons.

Almost immediately after being put in service, this powerful and otherwise successful engine was found to be too heavy for the Metropolitan line, and in response to the requirements of the permanent way department, Ivatt undertook so to modify the design as materially to reduce the gross moving load. With this end in view, he removed the boiler originally provided, and replaced it by one having a length of barrel of 11 feet 9 inches, and a minimum diameter, inside, of 3 feet 11¾ inches; the firebox was also reduced to 6 feet 2 inches in length. This new boiler had a total heating surface of 1,043.7 sq. ft, of which the firebox contributed 107.7 sq. ft, and the tubes 936 sq. ft; the grate area was 17.8 sq. ft. At the same time, the side tanks were reduced in length, lessening their capacity to 1,500 gallons, and only 3 tons of coal were carried. As thus modified, the engine weighed 70 tons 5 cwt, distributed as follows: on leading wheels 13 tons 10 cwt, on driving wheels 15 tons 5 cwt, on intermediate coupled wheels 15 tons, on trailing coupled wheels 14 tons 10 cwt, and on trailing radial wheels 12 tons.

No. 116 ran for some time in its modified form, as shown in *Fig. 110*, before being followed by others of the same class, but eventually a series, built in accordance with the revised dimensions, were built at Doncaster in the following order:

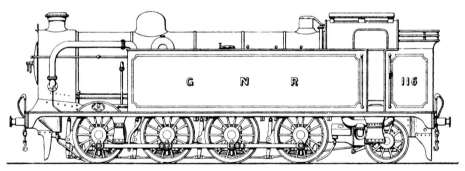

Fig. 109.

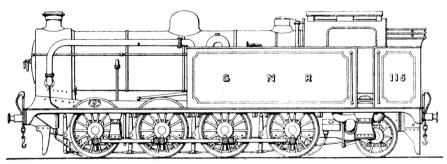

Fig. 110.

Date	Doncaster No.	Engine No.	Date	Doncaster No.	Engine No.
1903	1004	116	1905	1097–1106	127–136
1904	1056–1065	117–126	1906	1119–1138	137–156

Nos 127–136, which had 19¾ inch cylinders, on completion, instead of being sent to the Metropolitan district, were stationed at Colwick, to work coal trains over the Nottinghamshire branch lines, and these were followed to the same depot by Nos 137–141, which began work between Colwick sidings and Pinxton, and later by Nos 142–151, all these having 18-inch cylinders. At the beginning of 1908, Nos 116–126 were removed from London to Colwick, and prior to getting to work there had their cylinders reduced from 19¾ inches to 18 inches diameter, and the condensing gear removed. Nos 127–136 were similarly stripped of their condensing gear and sent to Ardsley (Leeds). Nos 127–136 are the only engines of the class now running with 19¾ inch cylinders. In October, 1909, No. 133 of this class was rebuilt with a boiler similar to that originally fitted to No. 116, bringing the total weight, with tanks full and 2½ tons of coal in the bunker, up to 71 tons 7 cwt.

In the meantime there was completed at Doncaster a series of the new engines of the smaller Atlantic, or '990' class. They differed from their original in having the frames so shaped as to allow of them being fitted with the larger boilers if necessity arose, and they also had the duplicate (four-column) Ramsbottom safety valves which subsequently were fitted to all the Atlantic class, large and small. The dates and numbers of these new engines were:

Date	Doncaster No.	Engine No.	Date	Doncaster No.	Engine No.
1903	996	252	1903	1001	257
1903	997	253	1903	1002	259
1903	998	256	1903	1003	250
1903	999	255	1903	1005	260
1903	1000	254	1903	1006	258

At the beginning of 1905 Ivatt made a notable departure by the introduction of a four-cylinder compound locomotive of the Atlantic type. In general design it is of the '251' type, having the same dimensions of boiler and wheels as that class. The cylinders are placed in line across the engine, and are of proportions that have given rise to some argument. The high-pressure cylinders are outside, 13 inches in diameter with a stroke of 20 inches, with balanced slide valves of the open-backed type placed above them, while the low-pressure cylinders, inside the frames and connected to the leading pair of coupled wheels, are 16 inches in diameter with a stroke of 26 inches, and have their valves placed back to back between them. As can be seen, the outside cylinders are actuated by Walschaerts valve-gear, the low-pressure cylinders being operated by Stephenson link motion. A change valve is fitted over the low-pressure steam chest, worked by a small auxiliary steam cylinder, whereby the low-pressure cylinders can be supplied at will, and for any length of time, with either live steam from the boiler or the exhaust steam from the high-pressure cylinders, thus being worked either as a

'simple' or a compound, according to requirements. There are two reversing levers with sectors placed close together on the footplate, and the two sets of gear can be operated independently or together, as may be desired. Ivatt's vacuum locking device is fitted to the two reversing shafts, this device having the advantage of locking the gear close up to its work, thereby obviating any slackness in the fittings between the shaft and the footplate. Apart from the cylinder arrangement, and the construction of the boiler shell with slightly thicker plates to stand an enhanced working pressure of 200 lbs per sq. inch, No. 292 was practically identical with the 'simple' Atlantics of the '251' class. The modifications here chronicled, however, increased the total weight of the engine to 69 tons, which were distributed as follows: On bogie wheels 18 tons 10 cwt, on each pair of coupled wheels 18 tons 5 cwt, and on trailing wheels 14 tons. The tender is of the standard type, carrying 5 tons of coal and 3,670 gallons of water, and provided with Ivatt's pick-up apparatus for filling the tank *en route*. No. 292 bears Doncaster Works No. 1066, and is shown in *Fig. 111*. In a series of tests made with this engine and No. 294 'simple' Atlantic, already referred to, the advantage was slightly in favour of the compound engine.

Almost simultaneously with the advent of No. 292, a further trial of compounding was made on the Great Northern Railway. With the consent of his directors Ivatt invited the leading firms of locomotive builders in the country to submit tenders for the building of locomotives of their own design, and an engine designed by the Vulcan Foundry, Ltd., of Newton-le-Willows, was accepted and built. No. 1300, which bears the maker's No. 2025 and the date 1905, is a four-cylinder compound, approximating in arrangement with the well-known and successful system of M. de Glehn, but with certain specialities of the builders. For example, the engine is provided with the 'Vulcan' patent starting valve, which admits steam at a reduced pressure to the receiver at starting, the supply being automatically cut off as soon as the steam has reached the low-pressure cylinders. Another feature is the 'Vulcan' patent reversing gear, which allows one reversing screw to operate both high and low-pressure valve gear at the same time, giving a variable cut-off for the two sets of motion, which can be adjusted to suit requirements while the engine is running. Thus the high-pressure motion can, for instance, be notched up at will without interfering with the cut-off of the low-pressure cylinders, or *vice versa*. These two devices were fully illustrated and described in *The Locomotive Magazine* of 14 September, 1907. As can be seen from the accompanying illustration, *Fig. 112*, this engine differed in external appearance from the general type

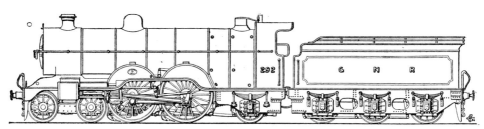

Fig. 111.

of GNR designs, though in certain details the practice of the railway was adhered to, notably in the framing and details of the leading bogie and the trailing wheels; and the tender was of the standard GNR pattern, being, in fact, built at Doncaster.

No. 1300 differed from the Doncaster-built compound already described in most of its leading dimensions, and notably in the size and proportions of its cylinders, the discrepancy being, of course, all the more noticeable since both engines have the same diameter of coupled wheels, 6 feet 8 inches. No. 1300 has two high-pressure cylinders, 14 inches in diameter with a stroke of 26 inches, placed outside the frames and driving direct on the trailing pair of coupled wheels, and actuated by Walschaerts valve gear and piston valves. The low-pressure cylinders are in the usual position below the smoke box, and are 23 inches in diameter with a stroke of 26 inches; they are also actuated by Walschaerts gear and piston valves. The bogie is of the standard GNR swing-link pattern, with a wheelbase of 6 feet 3 inches, the leading axle being 3 feet 3 inches in advance of the centre pivot, but it is fitted with wheels only 3 feet 2 inches in diameter. The driving wheels are 6 feet 8 inches in diameter, and the trailing wheels 3 feet 8 inches. The total wheelbase of the engine is 28 feet 2 inches, divided as follows: Bogie, 6 feet 3 inches; trailing bogie wheels to leading coupled wheels, 6 feet 9 inches; coupled wheels, centre to centre, 8 feet 6 inches; trailing coupled to trailing carrying wheels, 6 feet 8 inches. The boiler is of ample size; it has a barrel 11 feet 11 inches long with an outside diameter of 5 feet 1⅝ inches, and is pitched with its centre 8 feet 10 inches above the rail level. It contains 149 'Serve' steel tubes, 12 feet 4 inches long by 2¾ inches in diameter. The outside firebox measures 10 feet in length, and is of the round-topped pattern, the restriction of the loading gauge preventing the Belpaire firebox originally intended from being adopted. The copper inside firebox measures 9 feet long, 4 feet 10½ inches wide at the centre line of the boiler, and 6 feet 4½ inches and 4 feet 9 inches high at front and back respectively. The total heating surface is 2,514 sq. ft, of which the firebox contributes 170 sq. ft, and the tubes 2,344 sq. ft; the grate area is 31 sq. ft. The boiler carries a working pressure of 200 lbs per sq. inch. The engine as originally designed would have weighed 72 tons, but this was subsequently reduced to 71 tons, the distribution of weights being as follows: On bogie wheels 20 tons 5 cwt, on each pair of coupled wheels 18 tons 10 cwt, and on trailing wheels 13 tons 15 cwt. The tender is of GNR standard dimensions, with capacities for 3,670 gallons of water and 5 tons of coal respectively, and weighs 40 tons 18 cwt full. The total wheelbase of engine and tender is 49 feet 6 inches, and the total length over buffers 58 feet 10½ inches. This engine has worked the

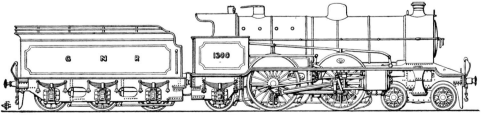

Fig. 112.

express services of the GNR in conjunction with No. 292 (Doncaster compound) and the 'simple' Atlantics of the '251' class without demonstrating any marked superiority in either efficiency or economy of operation, but the introduction of an engine so obtained and built to the designs of a firm of locomotive builders in place of the Company's own locomotive engineer, was an experiment deserving of note.

In 1904 Ivatt began to turn his attention to the provision of rail motor coaches suitable for local traffic, and designed some steam coaches which were built at Doncaster and elsewhere. Before these were completed, however, he made experiments with a petrol motor coach, which began work by making a series of trial trips between Hatfield and Hertford. Two other petrol coaches, Nos 3 and 4, built by Kerr, Stuart & Co., Ltd., worked the service until early in 1909, when they were withdrawn.

Early in 1905 orders were booked with the Avonside Engine Co., Ltd., and Kitson & Co., Ltd., for two steam rail motor coaches from each firm. In the meantime Ivatt put two in order at the Doncaster works, as follows:

Date	Doncaster No.	Rail Motor No.
1905	1107	No. 2
1905	1108	No. 1

The design of these coaches consisted in making the locomotive and carriage body detachable, thus rendering it easy to withdraw either part for repairs, so that should the engine of one complete coach, and the body of another, be laid aside at one time, the other sections might be utilised together during the interval. The engine bogie was therefore made complete in itself as a small four-wheeled locomotive with a loco-type boiler 4 feet 0½ inches in diameter, containing 178 tubes, and working at a pressure of 175 lbs per sq. inch; the firebox measures 3 feet 6 inches long by 4 feet 0½ inches wide. The total heating surface is 382 sq. ft, and the grate area 9½ sq. ft. The cylinders are placed outside the bogie frames, and are 10 inches in diameter by 16-inch stroke, actuated by Walschaerts valve gear, and the coupled driving wheels are 3 feet 8 inches in diameter. The car body is 49 feet long, and is carried at the other end on a standard GNR four-wheeled carriage bogie. It is divided into a luggage compartment next to the engine, third-class smoking and non-smoking compartments, a first-class saloon (the total seating accommodation being for fifty-three passengers), and a guard's compartment, which is fitted with duplicate controlling gear so that the car can be operated from that end when running carriage first.

Some of these engines were first put to work on the Louth–Grimsby section of the GNR, a section of 14 miles in all with four intermediate stations, to which were added six additional 'haltes', at Fotherby, Utterby, Grainsby, Holton Village, Weelsby Road and Hainton Street. Others were intended for the local services between Finchley and Edgware, Hatfield and Hertford, Hatfield and St Albans, Hitchin and Baldock, etc.

The coaches built by outside makers differed in some details from those built by the railway company itself. Thus, Nos 5 and 6, the locomotive bogies of which were built by Kitson & Co., Ltd., and the carriage bodies by the Birmingham Carriage & Wagon Co., Ltd., had the following leading dimensions: Cylinders, 10 x 16 inches;

heating surface of boiler, 505.64 sq. ft; working pressure, 200 lbs per sq. inch; diameter of coupled wheels, 3 feet 7 inches; length over buffers, 66 feet 5½ inches; extreme width over step boards, 8 feet 10½ inches; extreme height, 12 feet 6 inches; seating accommodation for fifty-seven passengers; total weight, 40 tons 2 cwt.

Nos 7 and 8, built by the Avonside Engine Co., Ltd., have the following leading particulars: Cylinders, 10 x 16 inches; diameter of coupled wheels, 3 feet 8 inches, with 3 x 5½ inch tyres; wheel-base of engine bogie, 8 feet; heating surface: firebox 60 sq. ft, tubes 330 sq. ft, total 390 sq. ft; grate area, 10.3 sq. ft; working pressure, 200 lbs per sq. inch; total wheelbase of coach, 53 feet 9 inches; total length over buffers, 66 feet 1⁵/₈ inches; extreme width over carriage body, 8 feet 6 inches; accommodation for ten first-class and forty third-class passengers; total weight, 40 tons 9¾ cwt. The water tanks are placed below the carriage body, and contain 650 gallons of water. These coaches are fitted with the automatic vacuum brake, having two 18-inch cylinders. The tractive effort with a 70 % cut-off is 5,500 lbs, and a motor of this type and power is capable of taking a trailer car as well up gradients of 1 in 40, and of averaging a speed of 20 miles per hour up gradients of 1 in 50.

Having found that the large 0-8-2 tank engines of the No. 116 class, which were originally intended to deal with the heavy suburban passenger and goods traffic into and out of the Metropolitan Railway's underground lines, were even in their reduced dimensions still too much for the permanent way and works of that system, Ivatt transferred them elsewhere, as has already been noted, and proceeded to substitute for them a powerful type of tank engine, which should, however, be lighter on the track. Accordingly, in 1906, he built a locomotive with six-coupled wheels and a trailing radial pair, which had the following leading dimensions: Cylinders, 18 inches by 26 inches; diameter of six-coupled wheels, 5 feet 8 inches, and of trailing wheels, 3 feet 8 inches; wheelbase: leading to driving wheels 7 feet 3 inches, driving to trailing coupled wheels 9 feet, trailing coupled to trailing radial wheels 7 feet, total 23 feet 3 inches; boiler: length of barrel 10 feet 1 inch, diameter (outside) 4 feet 8 inches; height of centre above rails, 8 feet 0³/₈ inches; working pressure, 170 lbs per sq. inch; heating surface: firebox 120 sq. ft, tubes 1,130 sq. ft, total 1,250 sq. ft; grate area, 19 sq. ft; capacity of tanks 1,600 gallons, and of bunker 4 tons; weight of engine in working order, 64 tons 14 cwt, of which 51 tons 4 cwt rested on the six-coupled wheels.

This engine, No. 190, was succeeded by ten others of the same general design, but slightly modified in one or two details, the chief object of the change being to effect a more equable distribution of weight over the four pairs of wheels in view of the fact that some of the 'foreign' lines south of London, on which these engines would be expected to run, did not allow the same maximum load per wheel as the GNR itself. Accordingly, the side tanks were shortened, and the end tank enlarged, and the wheelbase slightly lengthened behind the coupled wheels. These modified engines, one of which is shown in *Fig. 113*, had the following dimensions: Wheelbase: leading to driving wheels 7 feet 3 inches, driving to trailing coupled 9 feet, trailing coupled to trailing radial 7 feet 6 inches, total 23 feet 9 inches; boiler; length of barrel, 10 feet 1 inch; capacity of tanks 1,600 gallons, and of bunker 4 tons; weight of engine in working order, 65 tons 17 cwt, distributed as follows: on leading wheels, 16 tons 2

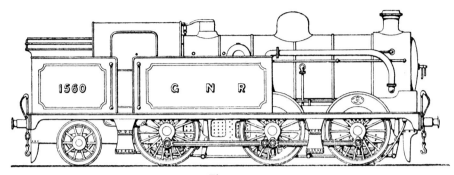

Fig. 113.

cwt; on driving wheels, 18 tons; on trailing coupled wheels, 17 tons 5 cwt; and on trailing radial wheels, 14 tons 10 cwt. All the engines of this class were, of course, fitted with condensing gear.

Below are given the dates, works numbers and running numbers of the series, including ten built this year:

Date	Doncaster No.	Engine No.
1906	1145	190
1907	1176–1185	1551–1560
1910	2256–1265	1561–1570

Interposed in the series of large Atlantic type locomotives already referred to, Ivatt allocated one of the numbers in the '1400s' to an engine which stood apart from the rest. No. 1421 (Doncaster No. 1166, 1907) was a four-cylinder compound, in general design resembling the earlier compound engine, No. 292, already described and illustrated, but differing in details. For example, whilst the high-pressure cylinders were of the same dimensions, 13 x 20 inches, the low-pressure had 2 inches greater diameter, 18 x 26 inches and they were operated by Walschaerts valve gear instead of the ordinary Stephenson link-motion adopted in the earlier engine. The leading coupled axle was of a built-up, balanced type, patented by Ivatt. The boiler was also of a modified pattern, the smokebox being extended backwards instead of in advance of the chimney. Consequently the distance between the tubeplates was reduced from 16 feet to 14 feet 6 inches, with a proportionate reduction in the heating surface, the total being 2,351.8 sq. ft, of which the firebox contributed 143.6 sq. ft, and the tubes 2,208.2 sq. ft; the grate area was 31 sq. ft. Otherwise the engine, which is illustrated by *Fig. 114*, was practically identical with No. 292, and in general dimensions with the '251' class. No. 1421 weighed in working order 69 tons 2 cwt, distributed as follows: On bogie wheels 18 tons 2 cwt, on each pair of coupled wheels 18 tons, and on trailing wheels 15 tons. It was provided with the standard tender, fitted with Ivatt's patent water pick-up apparatus.

It may be interesting to note in this place that engine No. 265, 7-foot 8-inch bogie

single, was fitted with Ivatt's patent flexible balanced crank axle, and Joy's valve gear in place of the Stephenson link motion, in 1910, and that No. 866, a Stirling four-coupled passenger engine, has also been rebuilt with another form of balanced crank axle of Ivatt's design.

In 1908 Ivatt introduced a new class of six-coupled goods tender engines, with wheels of exceptionally large diameter, 5 feet 8-inches. These engines are, in respect to their boilers, cylinders, motion and wheels, practically interchangeable with the 0-6-2 suburban tank locomotives of the '190' class, and were intended to work express goods and mixed traffic on the main line. They are illustrated in *Fig. 115*. Following are the leading dimensions: Cylinders, 18 x 26 inches; diameter of coupled wheels, 5 feet 8 inches; wheelbase: leading to driving 7 feet 3 inches, driving to trailing 9 feet, total 16 feet 3 inches; boiler: length of barrel 10 feet 5 inches between tube plates, diameter (outside) 4 feet 8 inches, height of centre above rails 8 feet $0^{3}/_{8}$ inches; heating surface: firebox 120 sq. ft, tubes 1,130 sq. ft, total 1,250 sq. ft; grate area, 19 sq. ft; working pressure, 170 lbs per sq. inch. The tender was of a new pattern with unequally spaced wheelbase, 7 feet between leading and middle, and 6 feet between middle and trailing wheels respectively, this arrangement bringing more weight to bear on the leading wheels; the capacity of the tender was 3,500 gallons of water and 6½ tons of coal. In working order the engine weighed 46 tons 14 cwt., distributed as follows: on leading wheels, 16 tons; on driving wheels, 17 tons 4 cwt; and on trailing wheels, 13 tons 10 cwt; the tender weighed 43 tons 2 cwt. The total wheelbase of engine and tender was 37 feet 8 inches, and the extreme length over buffers 50 feet 5½ inches.

So far fifteen engines of this class have been built at Doncaster, in the following order:

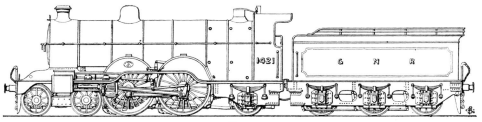

Fig. 114.

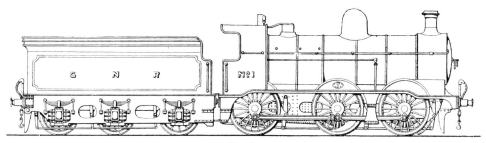

Fig. 115.

Date	Doncaster No.	Engine No.
1908	1198	1
1908	1201–1215	2–15

A new series of eight-coupled mineral engines was put in order at Doncaster in 1909. They differed from their prototype, No. 401, in having fluted coupling rods and larger crank pins and were fitted with the exhaust steam injector on the left-hand side. They bear the following numbers:

Date	Doncaster No.	Engine No.	Date	Doncaster No.	Engine No.
1909	1236	446	1909	1241	451
1909	1237	447	1909	1244	452
1909	1238	448	1909	1245	453
1909	1239	449	1909	1248	454
1909	1240	450	1909	1250	455

Nos 451–455 were fitted with the Schmidt superheater, piston valves and 21-inch cylinders. They also had other features slightly different from those of their predecessors. In order to accommodate the tail rods of the piston valves, the overhang at the leading end was increased by about 9 inches, and the centre of the boiler was raised 2 inches, to 8 feet 6 inches. The heating surface was as follows: firebox 137 sq. ft, tubes 1,027 sq. ft, total 1,164 sq. ft; superheater surface 343 sq. ft; grate area 24½ sq. ft. The working pressure in these superheater engines was reduced to 160 lbs per sq. inch. The total weight of the engine in working order was increased by these various modifications to 58 tons 5 cwt, distributed as follows: On leading wheels 14 tons 6 cwt, on driving wheels 15 tons 9 cwt, on intermediate wheels 14 tons 4 cwt, and on trailing wheels 14 tons 6 cwt. The tender was of the new type, as adopted on the No. 1 class, weighing 43 tons 2 cwt.

A new type of six-coupled goods engines with standard wheels was brought out in 1909, and is illustrated in *Fig. 116*. Following are the leading dimensions: Cylinders 18-inches in diameter by 26-inch stroke; diameter of six-coupled wheels 5 feet 2 inch; wheelbase: leading to driving 7 feet 3 inches, driving to trailing 9 feet, total 16 feet 3 inches; boiler: length of barrel 10 feet 1 inch, diameter (outside) 4 feet 8 inches; height of centre above rails 7 feet 9³/₈ inches; heating surface: firebox 120 sq. ft, tubes 1,130

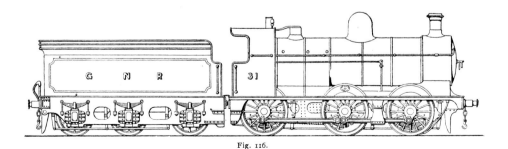

Fig. 116.

sq. ft., total 1,250 sq. ft; grate area 19 sq. ft; working pressure 170 lbs per sq. inch; weight of engine in working order 47 tons 6 cwt, distributed as follows: on leading wheels 15 tons 14 cwt, on driving wheels 17 tons and on trailing wheels 14 tons 12 cwt. The tender is of the new type, weighing 43 tons 2 cwt.

Twenty engines of this class have been built so far, bearing the following numbers:

Date.	Doncaster No.	Engine No.	Date	Doncaster No.	Engine No.
1909	1242	31	1910	1266	21
1909	1243	32	1910	1267	22
1909	1246	33	1910	1268	23
1909	1247	34	1910	1269	24
1909	1249	35	1910	1270	25
1909	1251	37	1910	1271	26
1909	1252	36	1910	1272	27
1909	1253	38	1910	1273	28
1909	1254	39	1910	1274	29
1910	1255	40	1910	1275	30

In May, 1909, one of the smaller Atlantic engines, No. 988, was rebuilt with the Schmidt superheater, and fitted with new cylinders 20 inches in diameter by 24-inch stroke, with 8-inch piston valves. The working pressure of the boiler was reduced to 160 lbs per sq. inch, and the distribution of heating surface was modified as follows: firebox 137 sq. ft, tubes 1,027 sq. ft, total 1,164 sq. ft; superheater surface 343 sq. ft; grate area 24½ sq. ft. The weight of the engine was increased to 60 tons, as follows: on bogie wheels 16 tons, on leading coupled wheels 15 tons 12 cwt, on driving wheels 16 tons 12 cwt, and on trailing wheels 11 tons 16 cwt. It received one of the new tenders.

Subsequently, in 1910, No. 1383, four-coupled bogie, was fitted with a Baldwin smokebox superheater, which necessitated the provision of an extended smokebox. The weight of the engine in working order thereby increased to 50 tons 9 cwt.

Following on these trials of superheating, Ivatt has put in hand a new series of the large Atlantic type of express engine, fitted with the Schmidt superheater. This class is provided with 20 x 24 inch cylinders fitted with tail rods, and piston valves, lubricated by means of Wakefield's mechanical lubricator. Externally the boiler is of the same dimensions as in the 251 class, the only noticeable difference being that the chimney is placed further forward so that the blast should clear the 'header' or steam collector on the smokebox tube plate. The working pressure is only 150 lbs per sq. inch, and the heating surface is apportioned as follows: firebox 143.5 sq. ft, tubes 1,909½ sq. ft, total 2,053 sq. ft; superheater surface 343 sq. ft; grate area, 31 sq. ft. There are at present ten of this series in course of construction at Doncaster:

Date	Doncaster No.	Engine No.
1910	1276–1285	1452–1461

7

Ivatt's Rebuilds

While the foregoing pages have dealt with Ivatt's new locomotives, a small space may be devoted to the matter of rebuilds of older engines which have been carried out by the present capable locomotive superintendent. No practical end can be served by going into the matter in the closest detail, as in some cases the engines thus rebuilt have already completed their sphere of usefulness, but sufficient may be said to show the lines on which it was necessary to proceed in order to enhance for a brief period the capabilities of some of the stock that was becoming obsolete, though not at the time of rebuilding quite ready for the scrapheap.

Stirling's bogie singles were the first engines of his predecessors on which Ivatt had to place his improving hand, and in these the most novel feature, judged from outside, was the introduction of the steam dome, which had been absent from all new designs on the GNR for nearly thirty years. No. 93 was the first engine to undergo alteration, and it was almost immediately followed by the exhibition veteran No. 776. Though differing in a few minor details, as for instance in the size of the dome and the steam pressure carried, *Fig. 117*, which shows No. 93, may be accepted as illustrating the transformed engines. They both received new boilers having larger fireboxes than formerly, and carrying a higher pressure of steam –170 lbs in No. 93 and 175 lbs in No. 776. The heating surface worked out to: Firebox 114 sq. feet, tubes 969 sq. ft, total 1,083 sq. ft; grate area 23¼ sq. ft. According to figures given to the writer by Mr Ivatt, these changes altered the weight of the engines, No. 776 being given with the following distribution: bogie 17 tons 6 cwt, driving wheels 18 tons, trailing wheels 10 tons 14 cwt, total 46 tons. The tenders were altered, the tanks being converted to 'horse-shoe' form. The driver's toolbox was brought to the front, so as to be within reach from the footplate, and gauge cocks were fitted to the tanks at the footplate end. As altered, the weight of the tender was officially given as 41 tons 14 cwt 2 qrs.

Other engines of the class were also rebuilt and modified, with a view to extending their spheres of usefulness. But the traffic requirements of the GNR have become so much more exacting within the last few years that these fine single-wheelers have for some time been hopelessly outclassed in express work. It was inevitable, therefore, though regrettable, that the doom of the eight-footers should be pronounced, and they have been gradually withdrawn from service until in July, 1910, there were only nine left in service;

Nos 95, 1006 and 1007 stationed at Grantham, Nos 668, 776, 1001, 1003 and 1004 at Peterborough, and No. 1008 at Lincoln. As mentioned on a previous page, No. 1 is still in existence, though not in service, and is now, after having been removed from the Imperial International Exhibition, standing in the erecting shop at King's Cross.

Next among the rebuilds came Stirling's old 7-foot singles. No. 21 (as can be seen from the accompanying illustration, *Fig. 118*) was supplied with a new boiler, having 1,119 sq. ft of heating surface and 16¼ sq. ft of grate area. To adapt this larger boiler to the 7-foot wheels it was necessary to pitch it with its centre line 7 feet 10 inches above the rails. So far as the frames and wheels were concerned, the principal alteration consisted in placing the leading springs, of a longer span than formerly, outside and above the frames instead of in the inaccessible position previously adopted. Another change welcomed by enginemen concerned the removal of the sandboxes from the front of the splashers, where they prevented ready access to the motion, to a position below the running plate. Other engines of the same class also underwent a process of rebuilding; but they have since been subjected to the same fate as the bogie engines, until now there are few, if any, remaining.

Several 7-foot 6-inch engines were rebuilt with new boilers carrying 170 lbs pressure and possessing a heating surface of 1,083 sq. feet apportioned as: firebox 114 sq. ft, tubes 969 sq. feet. As will be seen from *Fig. 119*, the nature of other alterations effected

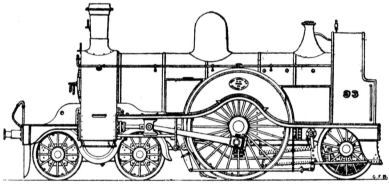

Fig. 117.

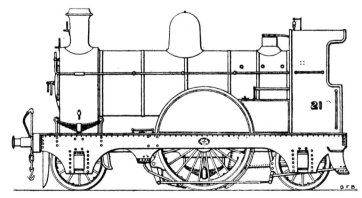

Fig. 118.

was practically identical with that already detailed in regard to No. 21. Others were also rebuilt. From *Fig. 120* it will be seen that by adoption of Ivatt's standard boiler and cab, and the effecting of sundry alterations to the leading springs and sandboxes, these rebuilds closely resembled the coupled engines completed by Ivatt shortly after he took charge at Doncaster. Some, however, retained the old form of cab.

An interesting rebuild was effected with regard to No. 708, one of the coupled passenger engines built by Kitson & Co., Ltd., in 1884. This engine was equipped in 1903 with the Druitt Halpin thermal storage apparatus.

Several of the 5-foot 1½-inch and 5-foot 7-inch front-coupled bogie tank engines have been rebuilt in the manner shown in *Fig. 121*. They were supplied with Ivatt's standard boiler, which is of greater diameter than that originally fitted, so that the wing tanks had to be placed rather wider apart during the process of reconstruction in order to accommodate this larger boiler. Otherwise the engines remain much as they were, except for slight alterations on the footplate.

One of Stirling's well-tank bogie engines, No. 533, was rebuilt as a crane engine for handling material at the Doncaster works. Various alterations were made to suit the new service. The well-tank underneath the coal bunker at the trailing end was removed, and two side tanks on either side of the smokebox substituted for it. Other modifications included new sandboxes to the leading driving wheels necessitated by the addition of the side tanks, steam sanding gear, and a new boiler and cab. The crane was adapted for dealing with a maximum load of 5 tons at a radius of about 11 feet 6 inches, and was so designed as to be able to make a complete revolution on its pivot. The engine retains its continuous brake gear, which is used for the testing of new rolling stock.

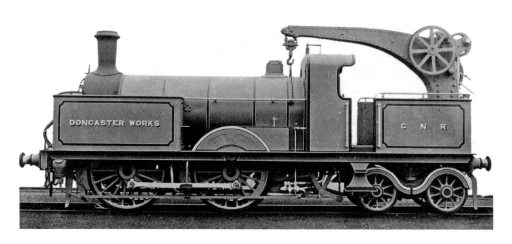

Probably the most unusual engine rebuild to emerge from the Doncaster works, this Stirling well-tank No. 533 was fitted as a crane with a max load of 5 tons and used at Doncaster. Note the side tanks which have been positioned at the front of the frame. *(CMcC)*

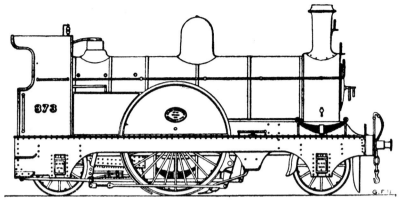

Fig. 119.

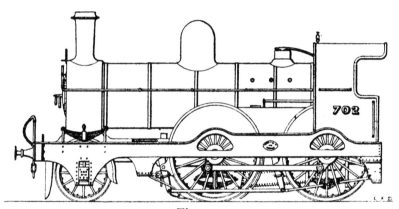

Fig. 120.

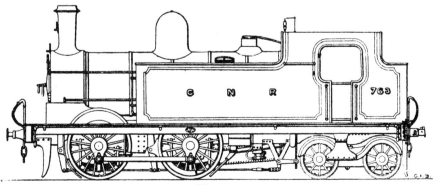

Fig. 121.

Several of Stirling's six-wheeled front-coupled radial passenger tank engines, notably Nos 116, 120 and 122, and a number of his front-coupled tender engines for mixed traffic were rebuilt with new boilers, but on the other hand a number of these one-time useful engines have been removed from service.

Similarly, a large number of Stirling goods engines were rebuilt, and special mention may be made of one, No. 743, which was also fitted with Marshall's valve gear, concerning which the untechnical press predicted such phenomenal properties. The ten-wheeled passenger tank engine No. 1520 was also so fitted, but the gear has in both cases been removed.

Various saddle-tank goods engines have been rebuilt, with new boilers of the domeless pattern, in order to avoid alteration to the tanks.

As regards the older good engines on the line, built during Sturrock's regime, and rebuilt by Stirling, historians will perhaps be sorry to learn that these have now all disappeared.

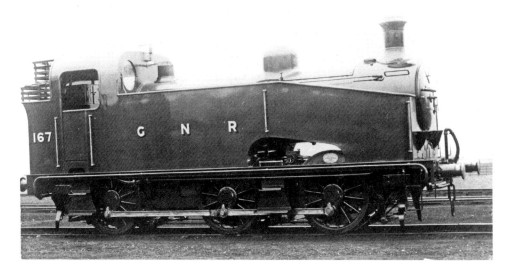

1873 C-class 0-6-0, No.167 with Works No. 96. Designed by Nigel Gresley and re-designated by the LNER as the J51/1 class. *Below*: The unmistakable lines of the 4-6-2 Pacific, in this case No.1470 built at Doncaster; the basis for the LNER's big express locos. *(CMcC)*

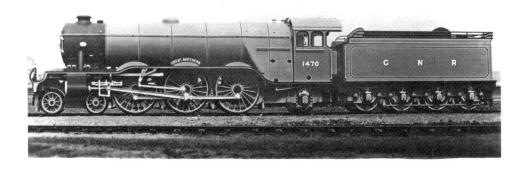

THE GREAT NORTHERN RAILWAY.
Table III.
List of G.N.R. Locomotives, Designed by Mr. H. A. Ivatt, Built in the years 1896-1910.

Date.	Description.	Driving Wheels.	Cylinders.	First of Type.	Reference to Doncaster List.	Number of Engines built.	Where built.
		ft. in.	ft. in.	No.			
1896	Coupled Bogie Passenger..	6 7½	17¼ × 26	400	S	11 built	Doncaster
1897	Coupled Passenger........	6 7½	17¼ × 26	1061	H6	10 ,,	,,
1897	Six-coupled Goods Tank ..	4 7½	18 × 26	111	M6	12 ,,	,,
1897	Six-coupled Goods Tank ..	4 7½	18 × 26	1201	—	40 ,,	Outside
1897	Coupled Bogie Passenger..	6 7½	17½ × 26	1301	S2	20 ,,	Doncaster
1897	Ten-wheel Bogie Tank	5 7½	17½ × 26	1009	T	10 ,,	,,
1898	Atlantic Passenger........	6 7½	18¾ × 24	990	U	1 ,,	,,
1898	Coupled Bogie Passenger..	6 7½	17½ × 26	1321	V	5 ,,	,,
1897	Six-coupled Goods	5 1½	17½ × 20	1091	—	10 ,,	Outside
1898	Six-coupled Goods	5 1½	17½ × 26	315	E5	10 ,,	Doncaster
1898	Six-coupled Goods	5 1½	17½ × 26	1101	—	35 ,,	Outside
1898	Coupled Bogie Passenger..	6 7½	17½ × 26	1326	V2	20 ,,	Doncaster
1898	Bogie Single	7 7½	18 × 26	266	W	1 ,,	,,
1898	Coupled Bogie Passenger..	6 7½	17½ × 26	1341	S3	10 ,,	,,
1898	Ten-wheel Bogie Tank	5 7½	17½ × 26	1501	X	20 ,,	,,
1899	Mogul Goods	5 1	18 × 24	1181	—	20 ,,	U.S.A.
1899	Six-coupled Goods	5 1½	17½ × 26	343	E6	20 ,,	Doncaster
1900	Six-coupled Goods	5 1½	17½ × 26	1136	—	38 ,,	Outside
1899	Coupled Bogie Passenger..	6 7½	17½ × 26	1351	S4	10 ,,	Doncaster
1900	Atlantic Passenger	6 7½	18¾ × 24	949	U2	10 ,,	,,
1900	Bogie Single..............	7 8	19 × 26	267	W2	11 ,,	,,
1900	Coupled Bogie Passenger..	6 7½	17½ × 26	1366	V3	20 ,,	,,
1901	Eight coupled Mineral	4 7½	19¾ × 26	401	Y	55 ,,	,,
1901	Ten-wheel Bogie Tank	5 7½	18 × 26	1521	X2	30 ,,	,,
1901	Six-coupled Goods Tank ..	4 7½	18 × 26	1251	M7	40 ,,	,,
1902	Ten-wheel 4-cylr. Passenger	6 7½	(4) 15 × 20	271	Z	1 ,,	,,
1902	Coupled Bogie Passenger..	6 7½	17½ × 26	1386	V4	10 ,,	,,
1902	Atlantic Passenger........	6 8	18¾ × 24	251	LU	81 ,,	,,
1903	Atlantic Passenger........	6 8	18¾ × 24	252	U3	10 ,,	,,
1903	Eight-coupled Radial Tank	4 8	19¾ × 26	116	YT	41 ,,	,,
1905	Atlantic Compound	6 8	{ 13 × 20 / 16 × 26 }	292	ZZ	1 ,,	,,
1905	Atlantic Compound	6 8	{ 14 × 26 / 23 × 26 }	1300	—	1 ,,	Outside
1905	Rail Motor Coach	3 7	10 × 16	2	MC	2 ,,	Doncaster
1905	Rail Motor Coach	3 7	10 × 16	5	—	4 ,,	Outside
1906	Six-coupled Radial Tank ..	5 8	17½ × 26	190	MM	21 ,,	Doncaster
1907	Coupled Bogie Passenger..	6 8	17½ × 26	1396	V5	15 ,,	,,
1907	Atlantic Compound	6 8	{ 13 × 20 / 18 × 26 }	1421	ZZ2	1 ,,	,,
1908	Six-coupled Goods........	5 8	17½ × 26	1	EE	15 ,,	,,
1909	Six-coupled Goods........	5 2	17½ × 26	31	EE2	20 ,,	,,
1910	Superheater Atlantic	6 8	20 × 24	1452	LUS	10 bldg.	,,

Table IV.

List of Locomotives built at Doncaster Works, 1867-1910.

Works No.	Date.	Engine No.	Class.	Works No.	Date.	Engine No.	Class.	Works No.	Date.	Engine No.	Class.
1	1867	18	A	49	1870	92	F	97	1873	158	I
2	,,	23	,,	50	,,	1	G	98	,,	16	A
3	,,	40	,,	51	,,	39	B	99	,,	50	,,
4	1868	6	B	52	,,	15	A	100	,,	151	E
5	,,	222	,,	53	,,	25	,,	101	,,	43	L
6	,,	41	,,	54	,,	65	,,	102	,,	145	I
7	,,	392	C	55	,,	122	D	103	,,	10	L
8	,,	4	B	56	,,	190	E	104	,,	152	E
9	,,	21	,,	57	,,	200	A	105	,,	5	G
10	,,	124	C	58	,,	35	,,	106	,,	508	A
11	,,	14	B	59	,,	64	,,	107	,,	7	G
12	,,	44	A	60	,,	132	D	108	,,	504	K
13	,,	162	C	61	,,	8	G	109	,,	509	A
14	,,	126	D	62	,,	366	E	110	,,	505	K
15	,,	49	A	63	1871	85	A	111	,,	186	E
16	,,	9	,,	64	,,	395	C	112	,,	77	A
17	,,	38	,,	65	,,	398	,,	113	,,	171	E
18	,,	127	D	66	,,	33	G	114	,,	81	A
19	,,	218	A	67	,,	32	A	115	,,	335	E
20	,,	220	,,	68	,,	116	D	116	,,	193	,,
21	1869	125	D	69	,,	118	,,	117	,,	506	K
22	,,	76	A	70	,,	30	A	118	1874	146	I
23	,,	205	,,	71	,,	261	H	119	,,	510	K
24	,,	11	,,	72	,,	203	A	120	,,	22	G
25	,,	31	,,	73	,,	68	A	121	,,	372	E2
26	,,	55	B	74	,,	262	H	122	,,	373	,,
27	,,	61	,,	75	,,	117	D	123	,,	507	K
28	,,	19	A	76	,,	83	A	124	,,	73	A
29	,,	369	E	77	,,	2	G	125	,,	164	I
30	,,	123	D	78	,,	119	D	126	,,	219	A
31	,,	131	,,	79	,,	174	I	127	,,	86	H2
32	,,	63	B	80	1872	148	E	128	,,	89	,,
33	,,	17	A	81	,,	46	A	129	,,	511	K
34	,,	215	B	82	,,	3	G	130	,,	494	M
35	,,	82	A	83	,,	376	I	131	,,	512	K
36	,,	377	E	84	,,	311	E	132	,,	354	E2
37	,,	396	C	85	,,	13	A	133	,,	198	,,
38	,,	184	E	86	,,	333	E	134	,,	495	M
39	,,	27	A	87	,,	52	A	135	,,	496	,,
40	,,	129	D	88	,,	197	E	136	,,	136	J2
41	1870	169	E	89	,,	471	J	137	,,	137	,,
42	,,	56	A	90	,,	71	A	138	,,	138	,,
43	,,	54	,,	91	,,	75	,,	139	,,	20	L
44	,,	380	E	92	,,	470	J	140	,,	513	K
45	,,	58	A	93	,,	120	K	141	,,	84	H2
46	,,	121	D	94	,,	128	,,	142	,,	42	L
47	,,	59	A	95	,,	166	C	143	,,	497	M
48	,,	37	B	96	1873	167	C	144	,,	514	K

List of Locomotives built at Doncaster Works, 1867-1910.

Works No.	Date.	Engine No.	Class.	Works No.	Date.	Engine No.	Class.	Works No.	Date.	Engine No.	Class.
145	1874	498	M	193	1876	543	H2	241	1878	631	N2
146	,,	90	H2	194	,,	552	K	242	,,	641	E2
147	,,	515	K	195	,,	62	G	243	,,	625	K2
148	,,	74	A2	196	,,	526	A2	244	,,	632	N2
149	,,	399	J2	197	,,	45	,,	245	,,	549	G
150	,,	48	G	198	,,	533	K	246	,,	626	K2
151	,,	499	M	199	,,	312	E2	247	,,	60	G
152	,,	516	K	200	,,	314	,,	248	,,	550	,,
153	,,	517	,,	201	,,	534	A2	249	,,	642	E2
154	,,	36	A2	202	,,	527	,,	250	,,	244	K2
155	,,	196	E2	203	,,	130	K	251	,,	57	A2
156	1875	173	,,	204	,,	535	A2	252	,,	643	E2
157	,,	519	A2	205	,,	536	,,	253	,,	246	K2
158	,,	518	,,	206	,,	159	K	254	.,	616	M
159	,,	340	E2	207	,,	538	A2	255	1879	617	,,
160	,,	520	A2	208	,,	501	N	256	,,	66	A2
161	,,	365	E2	209	,,	502	,,	257	,,	263	H2
162	,,	521	A2	210	,,	537	A2	258	,,	644	E2
163	,,	141	E2	211	,,	539	,,	259	,,	241	K2
164	,,	26	A2	212	,,	221	G	260	,,	618	M
165	,,	34	G	213	,,	606	M	261	,,	243	K2
166	,,	28	A2	214	,,	607	,,	262	,,	619	M
167	,,	163	E2	215	,,	94	G	263	,,	51	H2
168	,,	522	A2	216	,,	503	N	264	,,	645	E2
169	,,	339	E2	217	1877	608	M	265	,,	250	K2
170	,,	47	G	218	,,	161	N	266	,,	245	,,
171	,,	187	E2	219	,,	69	G	267	,,	160	E2
172	,,	523	A2	220	,,	98	,,	268	,,	620	M
173	,,	528	K	221	,,	609	M	269	,,	646	E2
174	,,	24	A2	222	,,	610	,,	270	,,	133	,,
175	,,	605	J2	223	,,	611	,,	271	,,	96	H2
176	,,	604	,,	224	,,	72	H2	272	,,	627	K2
177	,,	500	M	225	,,	80	,,	273	,,	168	E2
178	,,	529	K	226	,,	612	M	274	,,	99	H2
179	,,	29	A2	227	,,	614	,,	275	,,	628	K2
180	,,	601	M	228	,,	613	,,	276	,,	633	M
181	,,	328	E2	229	,,	615	,,	277	,,	247	K2
182	,,	194	,,	230	,,	544	G	278	,,	154	E2
183	,,	602	M	231	,,	545	,,	279	,,	249	K2
184	,,	530	K	232	,,	546	,,	280	,,	634	M
185	,,	53	G	233	,,	547	,,	281	,,	93	G
186	,,	540	H2	234	,,	621	K2	282	1880	635	M
187	,,	524	A2	235	1878	622	,,	283	,,	629	K2
188	,,	541	H2	236	,,	623	,,	284	,,	630	,,
189	,,	531	K	237	,,	310	E2	285	,,	95	G
190	,,	603	M	238	,,	624	K2	286	,,	636	M
191	,,	525	A2	239	,,	393	E2	287	,,	640	E2
192	,,	542	H2	240	,,	548	G	288	,,	637	M

List of Locomotives built at Doncaster Works, 1867-1910.

Works No.	Date	Engine No.	Class	Works No.	Date	Engine No.	Class	Works No.	Date	Engine No.	Class
289	1880	242	K2	337	1882	683	O	385	1885	764	O
290	,,	248	,,	338	,,	78	H3	386	,,	765	,,
291	,,	223	H2	339	,,	88	,,	387	,,	781	M2
292	,,	647	E2	340	,,	681	M2	388	,,	782	,,
293	,,	638	M	341	,,	668	G	389	,,	238	Q
294	,,	97	H2	342	,,	669	,,	390	,,	232	,,
295	,,	648	E2	343	,.	201	H3	391	,,	107	A3
296	,,	153	M	344	,,	202	,,	392	,,	108	,,
297	,,	652	K2	345	,,	103	A3	393	,,	773	G2
298	,,	653	,,	346	,,	104	,,	394	,,	774	,,
299	,,	472	M	347	,,	684	J3	395	,,	185	P
300	,,	207	H2	348	,,	685	,,	396	,,	189	,,
301	,,	649	E2	349	,,	670	G	397	,,	109	A3
302	,,	639	M	350	,,	671	,,	398	,,	110	,,
303	,,	662	G	351	1883	699	H3	399	,,	783	M2
304	,,	650	E2	352	,,	700	,,	400	,,	784	,,
305	,,	473	M	353	,,	688	M2	401	,,	785	,,
306	1881	654	K2	354	,,	689	,,	402	1886	786	,,
307	,,	655	,,	355	,,	690	,,	403	,,	787	,,
308	,,	651	E2	356	,,	374	P	404	,,	788	,,
309	,,	226	H2	357	,,	172	,,	405	,,	211	H4
310	,,	212	,,	358	,,	691	M2	406	.,	217	,,
311	,,	208	H3	359	,,	692	,,	407	,,	224	,,
312	,,	663	G	360	,,	693	,,	408	,,	228	,,
313	,,	656	K2	361	,,	112	A3	409	,,	234	Q2
314	,,	657	,,	362	,,	113	,,	410	,,	229	,,
315	,,	672	M2	363	1884	694	O	411	,,	791	E3
316	,,	673	,,	364	,,	686	J3	412	,,	792	,,
317	,,	227	H3	365	,,	695	O	413	,,	793	,,
318	,,	658	O	366	,,	687	J3	414	,,	794	,,
319	,,	674	M2	367	,,	751	H4	415	,,	795	,,
320	,,	664	G	368	,,	752	,,	416	,,	796	,,
321	,,	665	,,	369	,,	696	O	417	,,	797	,,
322	,,	91	H3	370	,,	114	A3	418	,,	798	,,
323	,,	666	G	371	,,	115	,,	419	,,	799	,,
324	,,	667	,,	372	,,	697	O	420	,,	800	,,
325	,,	675	M2	373	,,	105	A3	421	,,	216	H4
326	,,	676	,,	374	,,	106	,,	422	,,	225	,,
327	,,	659	O	375	.,	698	O	423	,,	755	,,
328	,,	660	,,	376	,,	761	,,	424	,,	756	,,
329	,,	102	E2	377	,,	206	H4	425	,,	757	,,
330	,,	101	,,	378	,,	209	,,	426	,,	758	,,
331	,,	661	O	379	,,	771	G2	427	,,	775	G2
332	1882	677	M2	380	,,	772	,,	428	1887	237	Q2
333	,,	678	,,	381	,,	762	O	429	,,	789	M2
334	,,	679	,,	382	,,	753	H4	430	,,	790	,,
335	,,	680	,,	383	,,	754	,,	431	,,	322	E3
336	,,	682	O	384	1885	763	O	432	,,	307	,,

List of Locomotives built at Doncaster Works, 1867-1910.

Works No.	Date.	Engine No.	Class.	Works No.	Date.	Engine No.	Class.	Works No.	Date.	Engine No.	Class.
433	1887	776	G2	481	1889	805	M2	529	1891	833	E3
434	,,	230	Q2	482	,,	806	,,	530	,,	810	M2
435	,,	10	A4	483	,,	813	H5	531	,,	829	R
436	,,	12	,,	484	,,	814	,,	532	,,	861	H5
437	,,	759	H4	485	,,	815	,,	533	,,	834	E3
438	,,	760	,,	486	,,	816	,,	534	,,	862	H5
439	,,	779	M2	487	,,	330	E3	535	,,	830	R
440	,,	780	,,	488	,,	135	,,	536	,,	851	M2
441	,,	777	G2	489	,,	817	H5	537	,,	835	E3
442	,,	778	,,	490	,,	818	,,	538	,,	852	M2
443	,,	199	E3	491	,,	819	,,	539	,,	385	E3
444	,,	320	,,	492	,,	820	,,	540	,,	863	H5
445	,,	236	Q2	493	,,	170	E3	541	,,	836	E3
446	,,	239	,,	494	,,	195	,,	542	,,	864	H5
447	,,	142	P	495	,,	191	,,	543	,,	379	E3
448	,,	188	,,	496	,,	383	,,	544	,,	853	M2
449	,,	176	E3	497	,,	213	H5	545	,,	837	E3
450	,,	183	,,	498	,,	214	,,	546	,,	951	A4
451	,,	389	,,	499	,,	766	R	547	,,	839	E3
452	,,	147	,,	500	1890	767	,,	548	,,	854	M3
453	1888	801	M2	501	,,	342	E3	549	,,	865	H5
454	,,	802	,,	502	,,	347	,,	550	,,	838	E3
455	,,	231	Q2	503	,,	175	,,	551	,,	855	M3
456	,,	233	,,	504	,,	768	R	552	,,	840	E3
457	,,	156	P	505	,,	391	E3	553	,,	866	H5
458	,,	157	,,	506	,,	769	R	554	,,	841	E3
459	,,	803	M2	507	,,	770	,,	555	,,	856	M3
460	,,	178	E3	508	,,	79	H5	556	,,	845	E3
461	,,	309	,,	509	,,	397	M2	557	,,	952	A4
462	,,	150	,,	510	,,	87	H5	558	,,	842	E3
463	,,	324	,,	511	,,	139	M2	559	,,	857	M3
464	,,	181	,,	512	,,	821	R	560	,,	846	E3
465	,,	321	,,	513	,,	822	,,	561	,,	843	,,
466	,,	20	A4	514	,,	378	E3	562	1892	871	Q3
467	,,	326	,,	515	,,	370	,,	563	,,	847	E3
468	,,	804	M2	516	,,	134	J4	564	,,	858	M3
469	,,	235	Q2	517	,,	140	,,	565	,,	844	E3
470	,,	240	,,	518	,,	823	R	566	,,	872	Q3
471	,,	210	H5	519	,,	824	,,	567	,,	848	E3
472	,,	204	,,	520	,,	825	,,	568	,,	859	M3
473	,,	42	A4	521	,,	807	M2	569	,,	849	E3
474	,,	43	,,	522	,,	831	E3	570	,,	860	M3
475	1889	323	E3	523	,,	808	M2	571	,,	873	Q3
476	,,	382	,,	524	,,	832	E3	572	,,	850	E3
477	,,	811	H5	525	,,	826	R	573	,,	874	Q3
478	,,	812	,,	526	1891	827	,,	574	,,	317	E3
479	,,	300	E3	527	,,	809	M2	575	,,	341	,,
480	,,	301	,,	528	,,	828	R	576	,,	875	Q3

List of Locomotives built at Doncaster Works, 1867-1910.

Works No.	Date	Engine No.	Class.	Works No.	Date	Engine No.	Class.	Works No.	Date	Engine No.	Class.
577	1892	144	J4	625	1893	953	A4	673	1895	1005	G3
578	,,	867	H5	626	.,	954	,,	674	,,	1006	,,
579	,,	868	,,	627	,, .	964	M5	675	,,	1007	,,
580	,,	149	J4	628	,,	890	H5	676	,,	1008	,,
581	,,	881	H5	629	,,	965	M5	677	,,	997	H5
582	,,	931	R	630	,,	966	,,	678	,,	998	,,
583	,,	932	,,	631	,,	1001	G2	679	,,	999	,,
584	,,	882	H5	632	,,	1002	,,	680	,,	1000	,,
585	,,	869	,,	633	,,	891	H5	681	,,	977	M5
586	,,	143	E3	634	,,	319	E3	682	,,	978	,,
587	,,	346	,,	635	,,	892	H5	683	,,	979	,,
588	,,	870	H5	636	,,	967	M5	684	,,	980	,,
589	,,	933	R	637	,,	327	E3	685	,,	958	A4
590	,,	883	H5	638	,,	893	H5	686	,,	959	,,
591	,,	921	M4	639	,,	894	,,	687	,,	960	,,
592	,,	313	E3	640	1894	968	M5	688	,,	941	R2
593	,,	884	H5	641	,,	1011	E3	689	,,	942	,,
594	,,	934	R	642	,,	895	H5	690	,,	943	,,
595	,,	182	E3	643	,,	969	M5	691	,,	944	,,
596	,,	885	H5	644	,,	896	H5	692	1896	1021	P2
597	,,	922	M4	645	,,	1012	E3	693	,,	1022	,,
598	,,	935	R	646	,,	897	H5	694	,,	1023	,,
599	1893	923	M4	647	,,	970	M5	695	,,	1024	,,
600	,,	924	,,	648	,,	898	H5	696	,,	1025	,,
601	,,	936	R	649	,,	899	,,	697	,,	1026	,,
602	,,	325	A4	650	,,	900	,,	698	,,	1027	,,
603	,,	925	M4	651	,,	876	Q3	699	,,	1028	,,
604	,,	355	A4	652	,,	877	,,	700	,,	1029	,,
605	,,	926	M4	653	,,	878	,,	701	,,	1030	,,
606	,,	886	H5	654	,,	879	,,	702	,,	1081	E4
607	,,	937	R	655	,,	880	,,	703	,,	1082	,,
608	,,	927	M4	656	,,	981	,,	704	,.	1083	,,
609	,,	356	A4	657	,,	971	M5	705	,,	1084	,,
610	,,	938	R	658	,,	972	,,	706	,,	1085	,,
611	,,	357	A4	659	,,	973	,,	707	,,	1086	,,
612	,,	928	M4	660	,,	974	,,	708	,,	1087	,,
613	,,	929	,,	661	,,	975	,,	709	,,	1088	,,
614	,,	939	R	662	,,	976	,,	710	,,	1089	,,
615	,,	930	M4	663	,,	955	A4	711	,,	1090	,,
616	,,	358	A4	664	,,	956	,,	712	,,	400	S
617	,,	940	R	665	,,	991	H5	713	1897	1061	H6
618	,,	961	M5	666	,,	992	,,	714	,,	1062	,,
619	,,	962	,,	667	,,	993	,,	715	,,	1063	,,
620	,,	957	A4	668	,,	994	,,	716	,,	1064	,,
621	,,	887	H5	669	,,	995	,,	717	,,	1065	,,
622	,,	888	,,	670	,,	996	,,	718	,,	1066	,,
623	,,	963	M5	671	,,	1003	G3	719	,,	1067	,,
624	,,	889	H5	672	,,	1004	,,	720	,,	1068	,,

List of Locomotives built at Doncaster Works, 1867-1910.

Works No.	Date.	Engine No.	Class.	Works No.	Date.	Engine No.	Class.	Works No	Date.	Engine No.	Class.
721	1897	1069	H6	769	1898	990	U	817	1899	1506	X
722	,,	1070	,,	770	,,	1321	V	818	,,	1507	,,
723	,,	1071	S	771	,,	1322	,,	819	,,	1508	,,
724	,,	1072	,,	772	,,	1323	,,	820	,,	1509	,,
725	,,	1073	,,	773	,,	1324	,,	821	,,	1510	,,
726	,,	1074	,,	774	,,	1325	,,	822	,,	343	E6
727	,,	1075	,,	775	,,	315	E5	823	,,	344	,,
728	,,	1076	,,	776	,,	316	,,	824	,,	345	,,
729	,,	1077	,,	777	,,	318	,,	825	,,	348	,,
730	,,	1078	,,	778	,,	329	,,	826	,,	349	,,
731	,,	1079	,,	779	,,	331	,,	827	,,	350	,,
732	,,	1080	,,	780	,,	332	,,	828	,,	351	,,
733	,,	111	M6	781	,,	334	,,	829	,,	352	,,
734	,,	155	,,	782	,,	336	,,	830	,,	353	,,
735	,,	1201	,,	783	,,	337	,,	831	,,	359	,,
736	,,	1202	,,	784	,,	338	,,	832	,,	1511	X
737	,,	1203	,,	785	,,	1326	V2	833	,,	1512	,,
738	,,	1204	,,	786	,,	1327	,,	834	,,	1513	,,
739	,,	1205	,,	787	,,	266	W	835	,,	1514	,,
740	,,	1206	,,	788	,,	1015	T	836	,,	1515	,,
741	,,	1207	,,	789	,,	1016	,,	837	,,	1516	,,
742	,,	1208	,,	790	,,	1017	,,	838	,,	1517	,,
743	,,	1209	,,	791	,,	1018	,,	839	,,	1518	,,
744	,,	1210	,,	792	,,	1328	V2	840	,,	1519	,,
745	,,	1301	S2	793	,,	1329	,,	841	,,	1520	,,
746	,,	1302	,,	794	,,	1330	,,	842	,,	360	E6
747	,,	1303	,,	795	..	1331	,,	843	,,	361	,,
748	,,	1304	,,	796	,,	1019	T	844	,,	362	,,
749	,,	1305	,,	797	,,	1020	,,	845	,,	363	,,
750	,,	1306	,,	798	,,	1332	V2	846	,,	364	,,
751	,,	1307	,,	799	,,	1333	,,	847	,,	367	,,
752	,,	1308	,,	800	,,	1334	,,	848	,,	368	,,
753	,,	1309	,,	801	,,	1335	,,	849	,,	371	,,
754	,,	1310	,,	802	,,	1341	S3	850	,,	375	,,
755	1898	1009	T	803	,,	1342	,,	851	,,	381	,,
756	,,	1010	,,	804	,,	1343	,,	852	,,	1336	V2
757	,,	1013	,,	805	,,	1344	,,	853	,,	1337	,,
758	,,	1014	,,	806	,,	1345	,,	854	,,	1338	,,
759	,,	1311	S2	807	,,	1346	,,	855	,,	1339	,,
760	,,	1312	,,	808	,,	1347	,,	856	,,	1340	,,
761	,,	1313	,,	809	,,	1348	,,	857	,,	1361	,,
762	,,	1314	,,	810	,,	1349	,,	858	,,	1362	,,
763	,,	1315	,,	811	,,	1350	,,	859	,,	1363	,,
764	,,	1316	,,	812	1899	1501	X	860	,,	1364	,,
765	,,	1317	,,	813	,,	1502	,,	861	,,	1365	,,
766	,,	1318	,,	814	,,	1503	,,	862	,,	1351	S4
767	,,	1319	,,	815	,,	1504	,,	863	,,	1352	,,
768	,,	1320	,,	816	,,	1505	,,	864	,,	1353	,,

List of Locomotives built at Doncaster Works, 1867-1910.

Works No.	Date.	Engine No.	Class.	Works No.	Date.	Engine No.	Class.	Works No.	Date.	Engine No.	Class.
865	1899	1354	S4	913	1900	1382	V3	961	1902	1268	M7
866	,,	1355	,,	914	,,	1383	,,	962	,,	1269	,,
867	,,	1356	,,	915	,,	1384	,,	963	,,	1270	,,
868	,,	1357	,,	916	,,	1375	,,	964	,,	402	Y
869	,,	1358	,,	917	,,	1376	,,	965	,,	405	,,
870	,,	1359	,,	918	1901	1377	,,	966	,,	406	,,
871	,,	1360	,,	919	,,	1378	,,	967	,,	407	,,
872	1900	949	U2	920	,,	1379	,,	968	,,	403	,,
873	,,	950	,,	921	,,	1381	,,	969	,,	408	,,
874	,,	982	,,	922	,,	1385	,,	970	,,	409	,,
875	,,	983	,,	923	,,	401	Y	971	,,	410	,,
876	,,	984	,,	924	,,	1521	X2	972	,,	404	,,
877	,,	985	,,	925	,,	1522	,,	973	,,	411	,,
878	,,	986	,,	926	,,	1523	,,	974	,,	271	Z
879	,,	987	,,	927	,,	1524	,,	975	,,	1386	V4
880	,,	988	,,	928	,,	1525	,,	976	,,	412	Y
881	,,	989	,,	929	,,	1526	,,	977	,,	1388	V4
882	,,	165	E6	930	,,	1527	,,	978	,,	414	Y
883	,,	177	,,	931	,,	1528	,,	979	,,	1391	V4
884	,,	179	,,	932	,,	1529	,,	980	,,	1389	,,
885	,,	180	,,	933	,,	1530	,,	981	,,	1387	,,
886	,,	192	,,	934	,,	92	W2	982	,,	413	Y
887	,,	302	,,	935	,,	100	,,	983	,,	415	,,
888	,,	303	,,	936	,,	261	,,	984	,,	417	,,
889	,,	304	,,	937	,,	262	,,	985	,,	416	,,
890	,,	306	,,	938	,,	263	,,	986	,,	418	,,
891	,,	308	,,	939	,,	264	,,	987	,,	419	,,
892	,,	384	,,	940	,,	265	,,	988	,,	420	,,
893	,,	386	,,	941	,,	268	,,	989	,,	421	,,
894	,,	387	,,	942	,,	269	,,	990	,,	1390	V4
895	,,	388	,,	943	,,	270	,,	991	,,	251	LU
896	,,	390	,,	944	,,	1251	M7	992	,,	1394	V4
897	,,	392	,,	945	.,	1252	,,	993	,,	1395	,,
898	,,	394	,,	946	,,	1253	,,	994	,,	1392	,,
899	,,	396	,,	947	,,	1254	,,	995	,,	1393	,,
900	,,	398	,,	948	,,	1255	,,	996	1903	252	U3
901	,,	399	,,	949	,,	1256	,,	997	,,	253	,,
902	,,	267	W2	950	,,	1257	,,	998	,,	256	,,
903	,,	1366	V3	951	,,	1258	,,	999	,,	255	,,
904	,,	1367	,,	952	,,	1259	,,	1000	,,	254	,,
905	,,	1368	,,	953	,,	1260	,,	1001	,,	257	,,
906	,,	1369	,,	954	,,	1261	,,	1002	,,	259	,,
907	,,	1370	,,	955	1902	1262	,,	1003	,,	250	,,
908	,,	1371	,,	956	,,	1263	,,	1004	,,	116	YT
909	,,	1372	,,	957	,,	1264	,,	1005	,,	260	U3
910	,,	1373	,,	958	,,	1265	,,	1006	,,	258	,,
911	,,	1380	,,	959	,,	1266	,,	1007	,,	423	Y
912	,,	1374	,,	960	,,	1267	,,	1008	,,	425	,,

List of Locomotives built at Doncaster Works, 1867-1910.

Works No.	Date.	Engine No.	Class.	Works No.	Date.	Engine No.	Class.	Works No.	Date.	Engine No.	Class.
1009	1903	422	Y	1057	1904	118	YT	1105	1905	135	YT
1010	,,	424	,,	1058	,,	119	,,	1106	,,	136	,,
1011	,,	426	,,	1059	,,	120	,,	1107	,,	No. 2	MC
1012	,,	427	,,	1060	,,	121	,,	1108	,,	No. 1	,,
1013	,,	429	,,	1061	,,	122	,,	1109	,,	1411	LU
1014	,,	430	,,	1062	,,	123	,,	1110	,,	1412	,,
1015	,,	428	,,	1063	,,	124	,,	1111	,,	1413	,,
1016	,,	431	,,	1064	,,	125	,,	1112	,,	1414	,,
1017	,,	1531	X	1065	,,	126	,,	1113	1906	1415	,,
1018	,,	1532	,,	1066	1905	292	ZZ	1114	,,	1416	,,
1019	,,	1533	,,	1067	,,	293	LU	1115	,,	1417	,,
1020	,,	1534	,,	1068	,,	297	,,	1116	,,	1418	,,
1021	,,	1535	,,	1069	,,	296	,,	1117	,,	1419	,,
1022	,,	1536	,,	1070	,,	294	,,	1118	,,	1420	,,
1023	,,	1537	,,	1071	,,	295	,,	1119	,,	137	YT
1024	,,	1538	,,	1072	,,	298	,,	1120	,,	138	,,
1025	,,	1539	,,	1073	,,	299	,,	1121	,,	139	,,
1026	,,	1540	,,	1074	,,	301	,,	1122	,,	140	,,
1027	1904	432	Y	1075	,,	300	,,	1123	,,	141	,,
1028	,,	433	,,	1076	,,	1400	,,	1124	,,	142	,,
1029	,,	434	,,	1077	,,	1401	,,	1125	,,	143	,,
1030	,,	272	LU	1078	,,	1402	,,	1126	,,	144	,,
1031	,,	273	,,	1079	,,	1403	,,	1127	,,	145	,,
1032	,,	274	,,	1080	,,	1405	,,	1128	,,	146	,,
1033	,,	275	,,	1081	,,	1404	,,	1129	,,	147	,,
1034	,,	276	,,	1082	,,	1406	,,	1130	,,	148	,,
1035	,,	277	,,	1083	,,	1407	,,	1131	,,	149	,,
1036	,,	278	,,	1084	,,	1408	,,	1132	,,	150	,,
1037	,,	279	,,	1085	,,	1409	,,	1133	,,	151	,,
1038	,,	280	,,	1086	,,	1410	,,	1134	,,	152	,,
1039	,,	281	,,	1087	,,	1271	M8	1135	,,	153	,,
1040	,,	283	,,	1088	,,	1272	,,	1136	,,	154	,,
1041	,,	285	,,	1089	,,	1273	,,	1137	,,	155	,,
1042	,,	282	,,	1090	,,	1274	,,	1138	,,	156	,,
1043	,,	286	,,	1091	,,	1275	,,	1139	,,	441	Y
1044	.,	284	,,	1092	,,	1276	,,	1140	,,	442	,,
1045	,,	287	,,	1093	,,	1277	,,	1141	,,	443	,,
1046	,,	289	,,	1094	,,	1278	,,	1142	,,	444	,,
1047	,,	288	,,	1095	,,	1279	,,	1143	,,	445	,,
1048	,,	290	,,	1096	,,	1280	,,	1144	,,	1422	LU
1049	,,	291	,,	1097	,,	127	YT	1145	,,	190	MM
1050	,,	435	Y	1098	,,	128	,,	1146	,,	1423	LU
1051	,,	436	,,	1099	,,	129	,,	1147	,,	1424	,,
1052	,,	437	,,	1100	,,	130	,,	1148	,,	1425	,,
1053	,,	438	,,	1101	,,	131	,,	1149	1907	1427	,,
1054	,,	439	,,	1102	,.	132	,,	1150	,,	1428	,,
1055	,,	440	,,	1103	,,	133	,,	1151	,,	1426	,,
1056	,,	117	YT	1104	,,	134	,,	1152	,,	1429	,,

List of Locomotives built at Doncaster Works, 1867-1910.

Works No.	Date.	Engine No.	Class.	Works No.	Date.	Engine No.	Class.	Works No.	Date.	Engine No.	Class.
1153	1907	1430	LU	1199	1908	1450	LU	1245	1909	453	Y
1154	,,	1431	,,	1200	,,	1449	,,	1246	,,	33	EE2
1155	,,	1541	X	1201	,,	1451	,,	1247	,,	34	,,
1156	,,	1542	,,	1202	,.	2	EE	1248	,,	454	Y
1157	,,	1543	,,	1203	,,	3	,,	1249	,,	35	EE2
1158	,,	1544	,,	1204	,,	4	,,	1250	,,	455	Y
1159	,,	1545	,,	1205	,,	5	,,	1251	,,	37	EE2
1160	,,	1546	,,	1206	,,	6	,,	1252	,,	36	,,
1161	,,	1547	,,	1207	,,	7	,,	1253	,,	38	,,
1162	,,	1548	,,	1208	,,	8	,,	1254	,,	39	,,
1163	,,	1549	,,	1209	,,	9	,,	1255	1910	40	,,
1164	,,	1550	,,	1210	,,	10	,,	1256	,,	1561	MM
1165	,,	1396	V5	1211	,,	11	,,	1257	,,	1562	,,
1166	,,	1421	ZZ2	1212	,,	12	,,	1258	,,	1563	,,
1167	,,	1397	V5	1213	,,	13	,,	1259	,,	1564	,,
1168	,,	1398	,,	1214	,,	14	,,	1260	,,	1565	,,
1169	,,	1399	,,	1215	,,	15	,,	1261	,,	1566	,,
1170	,,	1180	,,	1216	,,	1281	M9	1262	,,	1567	,,
1171	,,	1432	LU	1217	,,	1282	,,	1263	,,	1568	,,
1172	,,	1433	,,	1218	,,	1283	,,	1264	,,	1569	,,
1173	,,	1434	,,	1219	,,	1284	,,	1265	,,	1570	,,
1174	,,	1435	,,	1220	1909	1285	,,	1266	,,	21	EE2
1175	,,	1436	,,	1221	,,	1286	,,	1267	,,	22	,,
1176	,,	1551	MM	1222	,,	1287	,,	1268	,,	23	,,
1177	,,	1552	,,	1223	,,	1288	,,	1269	,,	24	,,
1178	,,	1553	,,	1224	,,	1289	,,	1270	,,	25	,,
1179	,,	1554	,,	1225	,,	1290	,,	1271	,,	26	,,
1180	,,	1555	,,	1226	,,	41	V6	1272	,,	27	,,
1181	,,	1556	,,	1227	,,	42	,,	1273	,,	28	,,
1182	,,	1557	,,	1228	,,	43	,,	1274	,,	29	,,
1183	1908	1558	,,	1229	,,	44	,,	1275	,,	30	,,
1184	,,	1559	,,	1230	,,	45	,,	1276	,,	1452	LUS
1185	,,	1560	,,	1231	,,	46	,,	1277	,,	1453	,,
1186	,,	1437	LU	1232	,,	47	,,	1278	,,	1454	,,
1187	,,	1438	,,	1233	,,	48	,,	1279	,,	1455	,,
1188	,,	1439	,,	1234	,,	49	,,	1280	,,	1456	,,
1189	,,	1440	,,	1235	,,	50	,,	1281	,,	1457	,,
1190	,,	1441	,,	1236	,,	446	Y	1282	,,	1458	,,
1191	,,	1443	,,	1237	,,	447	,,	1283	,,	1459	,,
1192	,,	1444	,,	1238	,,	448	,,	1284	,,	1460	,,
1193	,,	1442	,,	1239	,,	449	,,	1285	,,	1461	,,
1194	,,	1445	,,	1240	,,	450	,,	1286	,,		
1195	,,	1446	,,	1241	,,	451	,,	1287	,,		
1196	,,	1447	,,	1242	,,	31	EE2	1288	,,		
1197	,,	1448	,,	1243	,,	32	,,	1289	,,		
1198	,,	1	EE	1244	,,	452	Y	1290	,,		

Postscript
GNR Locomotive Legacy

George Frederick Bird's account of the locomotives of the GNR covers the period from 1847 up to 1910 when it was published in its second and revised form. At that time Henry Alfred Ivatt was still in the post of Locomotive Superintendent, although he would retire the following year, in December 1911. Ivatt's son, George, was also a locomotive engineer and after the Second World War he was Chief Mechanical Engineer for the London Midland & Scottish Railway (LMS). His daughter, Marjorie, married Oliver Bulleid, the CME of the Southern Railway. Henry Ivatt died in 1923, the year of the grouping of Britain's disparate independent railway companies into the 'Big Four'.

Ivatt's successor at the GNR in 1911 was, of course, Nigel Gresley (he was knighted by Edward VIII in 1936). Born in Edinburgh, Gresley served his apprenticeship at the Crewe works of the London & North Western Railway, and also worked at the Lancashire & Yorkshire Railway under John Aspinall, eventually rising to the position of Works Manager at the Newton Heath depot before becoming Assistant Superintendent of the Carriage & Wagon Department of the LNWR in 1904. He joined the GNR in 1905 as Carriage & Wagon Superintendent, and succeeded Henry Ivatt as CME in October 1911. Gresley was responsible for a number of classes during the final twelve years of the GNR: These include the 536 class 0-6-0 (1911), class K1 2-6-0 (1912), J2 0-6-0 (1912), O3 2-8-0 (1913), H3 (LNER class K2) 2-6-0 (1914), J51 0-6-0T (1915), H4 (LNER class K3) 2-6-0 (1920), N2 0-6-2T (1920), O2 2-8-0 (1921), J50 0-6-0T (1922) and the iconic A1 4-6-2 (1922). He built upon Ivatt's Atlantics to create the A1 and A3 Pacifics which were designed for the GNR's heavier main line passenger express services. The first of these iconic locomotives was No. 1470, appropriately named the *Great Northern*. Altogether, fifty-two A1s were built at Doncaster, starting in 1922, and these included the famous Flying Scotsman. Following the grouping of the railways in 1923, Gresley became the CME of the LNER. All of the A1 locomotives continued in service with the LNER and were rebuilt to A3 specs. The change in class from A1 to A3 reflects the fitting to the same chassis a higher pressure boiler with greater superheating surface and a small reduction in cylinder size and loco weight.

Sir Nigel Gresley died in 1941 following a short illness.

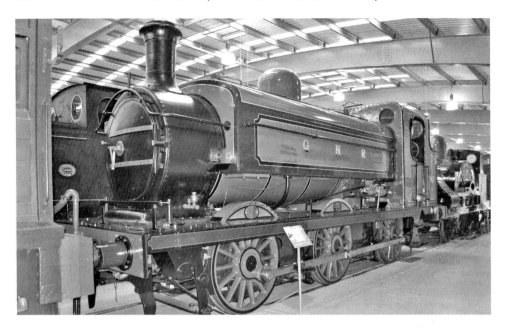

Preserved GNR locomotives

No. 1 4-2-2, 8-footer built at Doncaster in 1870. National Railway Museum.
No. 990 4-4-2, *Henry Oakley*, built at Doncaster in 1898. National Railway Museum.
No. 251 4-4-2, built at Doncaster in 1902. National Collection, Bressingham.
No. 1247 0-6-0ST, Sharp, Stewart & Co., 1899. National Railway Museum *(above)*.
No. 1744 0-6-2T, North British Locomotive Co., 1921. Serviceable.

Acknowledgements

Thanks to Campbell McCutcheon *(CMcC)* and Tony Hisgett *(TH)* for additional photographs of the GNR's locomotives. Images of King's Cross come from the editor's collection *(JC)*. The line drawings are by G. F. Bird.

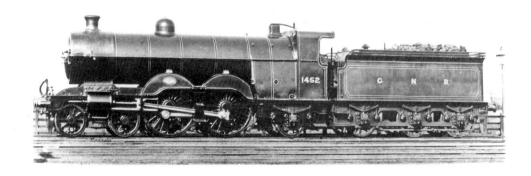